Americans in Spain

PAINTING AND TRAVEL, 1820-1920

Americans in Spain

PAINTING AND TRAVEL, 1820–1920

Brandon Ruud and Corey Piper

With contributions by

Eugenia Afinoguénova
M. Elizabeth Boone
Valerie Ann Leeds
Francesc Quílez Corella

MILWAUKEE ART MUSEUM

CHRYSLER MUSEUM OF ART

DISTRIBUTED BY YALE
UNIVERSITY PRESS,
NEW HAVEN AND LONDON

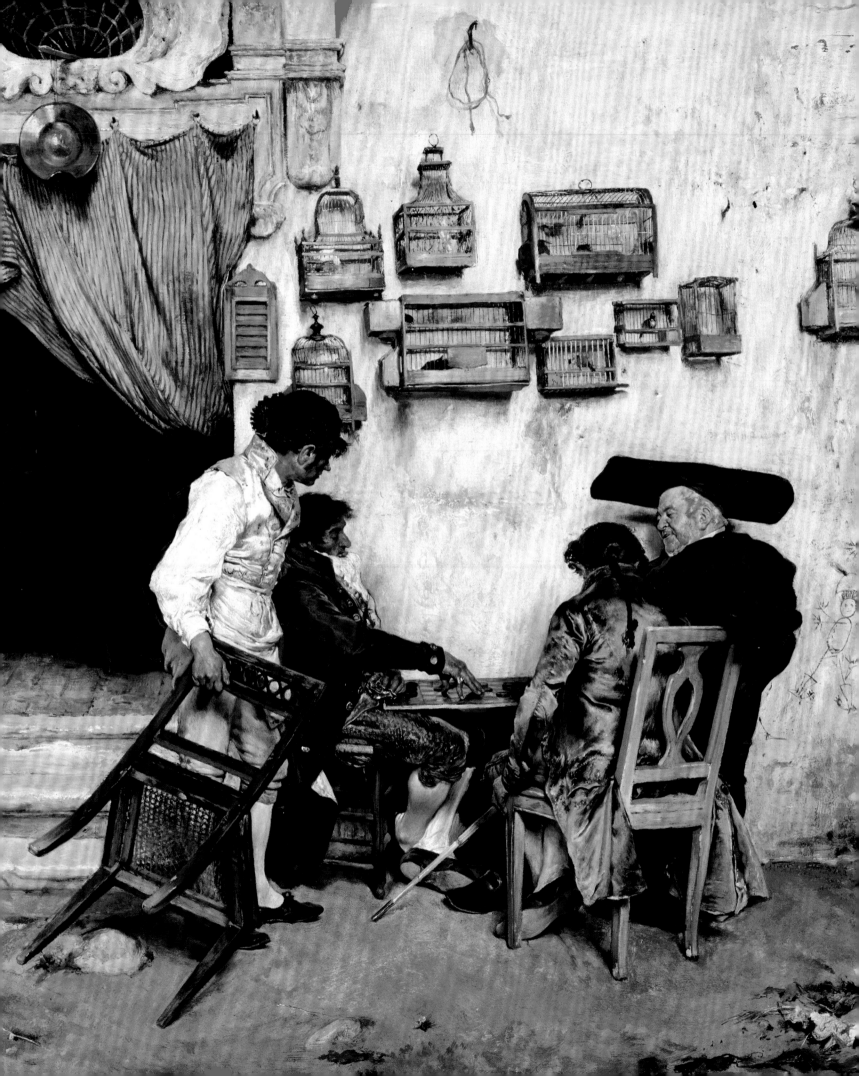

Contents

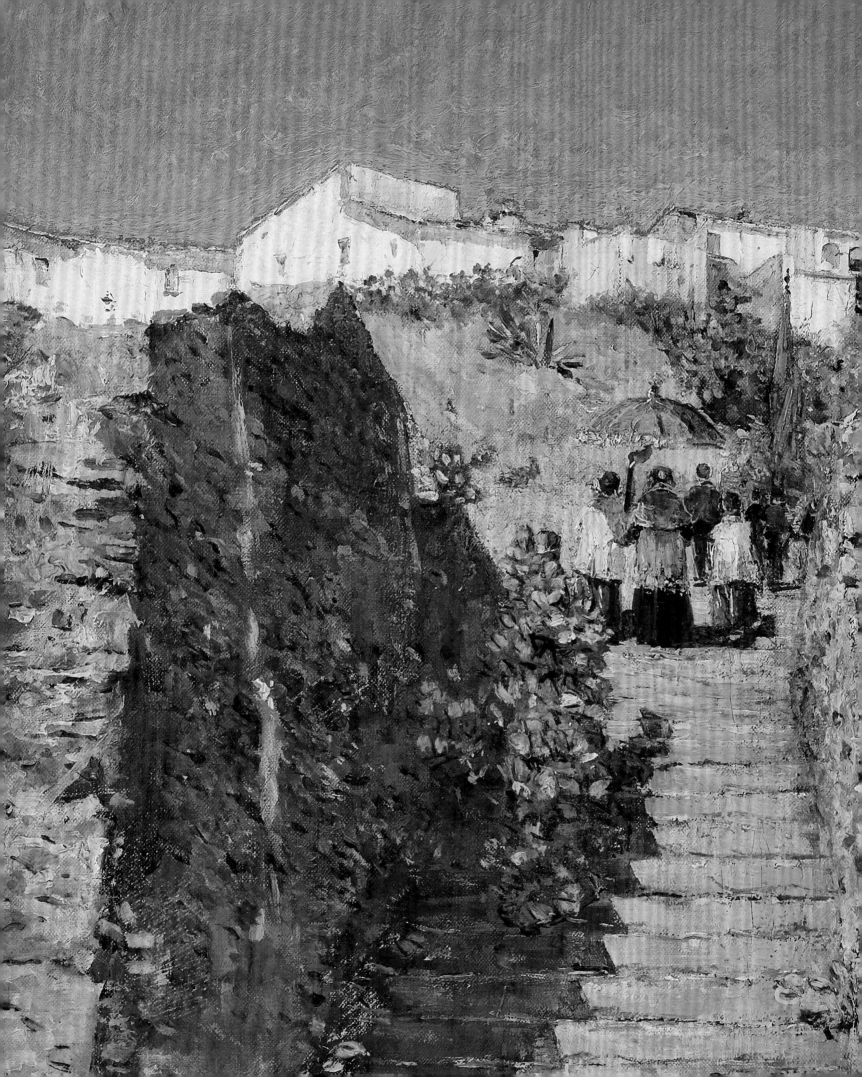

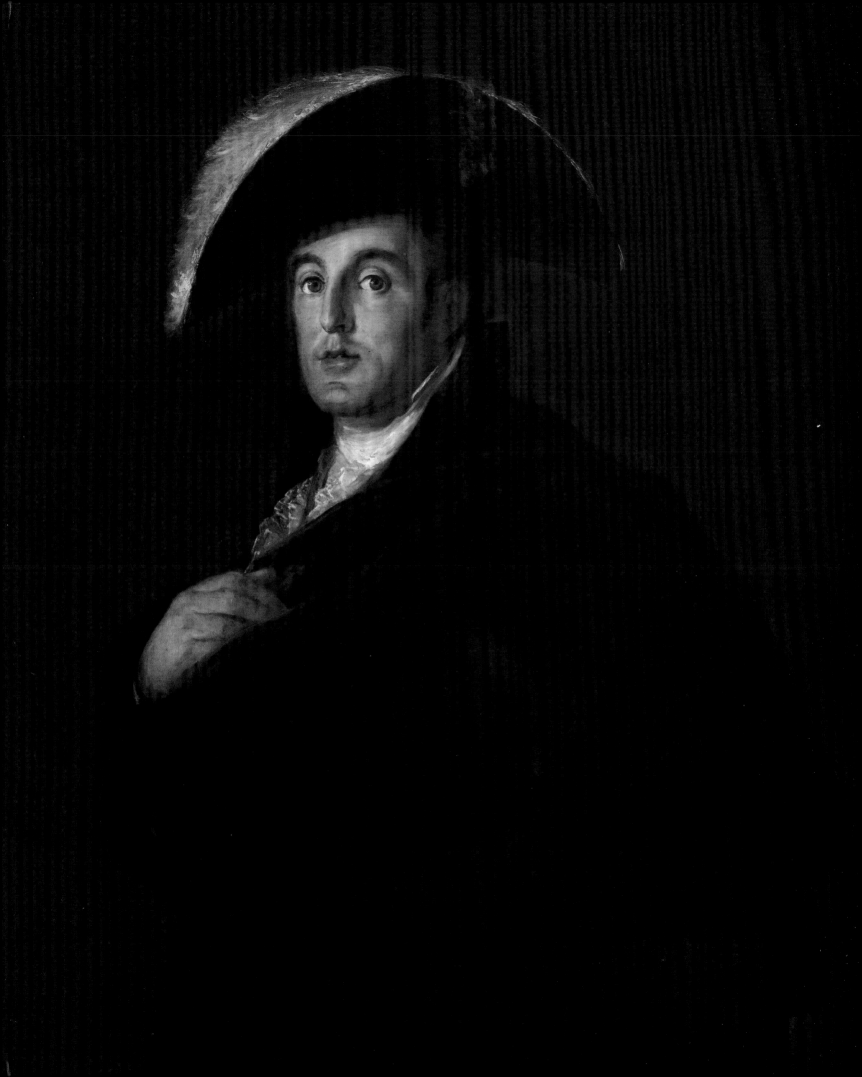

Directors' Foreword

FOR MORE THAN TWO HUNDRED YEARS, SPAIN HAS exerted a powerful hold over artists and tourists alike. These two audiences merge in the exhibition *Americans in Spain: Painting and Travel, 1820–1920*, which highlights a century of artistic fascination with the country. Although Spain is often overlooked as a creative European destination when compared to London or Paris, the firsthand experience of Spanish art and culture shaped—and even launched—careers, serving as continued inspiration for works created back in the United States. Indeed, many artists who never visited the seemingly forbidding and remote Iberian Peninsula firsthand managed to take inspiration from photographs of its art, architecture, and scenery, as well as from romantic narratives, both fictional and nonfictional.

It is an honor for the Milwaukee Art Museum and the Chrysler Museum of Art to collaborate in presenting the first major museum exhibition devoted to the artistic relationship between Spain and the United States, a project born of the history, people, and resources of our respective cities and regions—what nineteenth-century poet Walt Whitman called, and scholar M. Elizabeth Boone recently cited as, "the Spanish Element in our nationality." *Americans in Spain* began with conversations between the Milwaukee Art Museum; the Department of Languages, Literatures, and Cultures at Marquette University; and the American Geographical Society Library at the University of Wisconsin-Milwaukee. Our goal was to find collaborative ways of integrating the Museum's diverse collections and exhibitions program with the digital initiatives and research underway at Marquette and the library's impressive cartographic and printed resources. Plans were elaborated and enriched through early discussions with the Chrysler, which was attracted to the project because it resonates with the strengths of its important American and Spanish collections, and because of its location in Norfolk, Virginia, a military center whose residents regard global travel as a key fact of life.

In addition to the rich academic and institutional resources surrounding Spanish culture and learning in Milwaukee, the city has historic connections to the country's art, links that have remained unexplored—and in many ways hidden—until now. Like many industrializing cities in the nineteenth-century Midwest, it held a series of expositions that featured displays devoted to mechanization, as well as to the fine and decorative arts, which introduced Milwaukeeans and Wisconsinites to old master and contemporary Spanish art. Many of these older canvases depicted religious subjects and were created by Spain's premier painter of Catholic themes, Bartolomé Esteban Murillo (see cat. 76). Contemporary works included paintings by artists such as Antonio Gisbert, director of Madrid's Museo del Prado from 1868 until 1873, whose painting of the Puritans disembarking at Plymouth Rock made a splash—and controversy—at the 1876 Philadelphia Centennial, as well as ones by Luis Jiménez Aranda, brother of José Jiménez Aranda, whose work is featured in this exhibition (see cat. 45). The expositions also showcased paintings by Americans who traveled through Spain, which were loaned by local collectors

Fig. 1 Joaquín Sorolla y Bastida (Spanish, 1863–1923), *Drawing in the Sand*, ca. 1911. Oil on canvas. Milwaukee Art Museum, Gift of Samuel O. Buckner Collection, M1919.30

and the artists themselves. Arthur Bridgman and William Sartain were particular favorites, and in 1886 prominent patron Frederick Layton contributed Spanish desert scenes by Edwin Lord Weeks from his own collection. The 1897 Milwaukee Industrial Exposition included Pierre Carrier-Belleuse's painting of the famed Sevillian dancer Carmencita, who had earlier captured the attention of both William Merritt Chase and John Singer Sargent (see cats. 16 and 17). Later expositions even included paintings by Mexican artists.

Milwaukee also had connections to the exhibitions and programs that created the feverish Hispanism that briefly swept the country, focusing Americans' attention on Joaquín Sorolla and Ignacio Zuloaga, Spain's most famous artists in the early years of the twentieth century. After an exhibition of Zuloaga's work at the Arts Club of Chicago in 1920, the Milwaukee Art Institute (as our museum was then called) hosted the same show, which the *Milwaukee Sentinel* praised as possessing "dominating power." During his visits to the Midwest for his exhibitions in Chicago and Saint Louis, Sorolla befriended—and painted—numerous artists (cat. 1), taught classes at the School of the Art Institute, and then had his work presented to the Eagles Nest Art Colony in Oregon, Illinois, just across the Wisconsin state line. One of his students at that time was Wisconsin native Dudley Crafts Watson, the Museum's first director. After Sorolla's painting *Drawing in the Sand* (fig. 1), was shown at the Art Institute in 1911,

it was later part of an exhibition inaugurating the Museum's new building, after which the board's then-president, Samuel Buckner, donated it to the permanent collection. This enthusiasm also informed Alice G. Chapman's acquisition and later gift of *Segovian Peasants* by Valentín de Zubiaurre (1879–1963). Then considered one of the Museum's treasures, the painting was said to have been purchased directly from the artist in Spain for a princely sum, and, after it was featured on the cover of its quarterly magazine, people stood in line to see it (fig. 2). It is no wonder, then, that when the Museum sought to acquire its first major old master painting after moving permanently into the Eero Saarinen–designed War Memorial Building in 1955, the leadership selected Francisco de Zurbarán's *Saint Francis of Assisi in His Tomb* (fig. 3). These often unexplored connections to Spanish art continued with the formation of the Ashcan Circle collection in Milwaukee, a group of artists for whom Spain played an outsize role in shaping their art.

At its height, the Spanish empire encompassed half the North American continent, including borderlands along the Mississippi River. Norfolk itself resides in an area once part of the Ajacán Mission, an early settlement on the Virginia Peninsula that predated Jamestown by nearly thirty-six years. These Spanish legacies continue to shape Norfolk's culture and history today. Through much of the nineteenth century, Norfolk's connections with Spain were largely mercantile and martial rather than artistic. Due to its status as a vital port city, Spain established a consular presence in Norfolk as early as 1795. By the century's close, Hampton Roads would serve as a staging ground for much of the United States' military buildup leading up to and following the Spanish-American War. Norfolk's international ambitions around the turn of the twentieth century were most fully expressed through the 1907 Jamestown Ter-Centennial Exposition. The fair drew millions of visitors to Norfolk, and, though mounted in celebration of the first

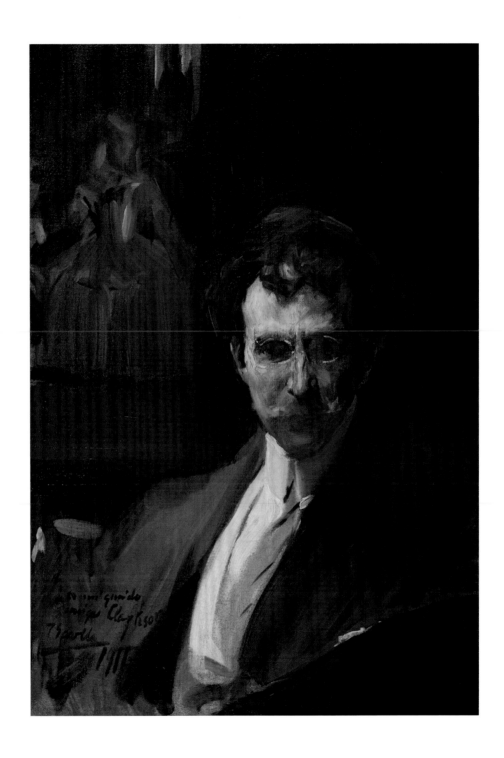

1

JOAQUÍN SOROLLA Y BASTIDA

SPANISH, 1863–1923

Ralph Clarkson

1911 · Oil on canvas · 32 × 23 in. (81.3 × 58.5 cm)

Courtesy of the Oregon Public Library and Gallery

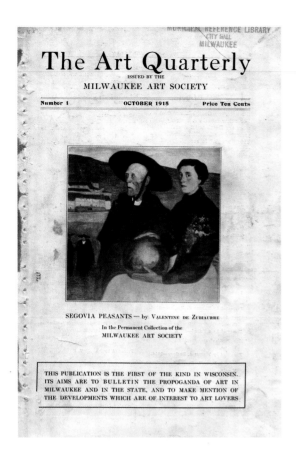

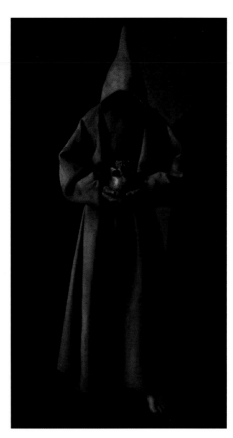

Fig. 2 Cover, *The Art Quarterly*, issued by the Milwaukee Art Society (October 1915), no. 1. Milwaukee Art Museum Research Center

Fig. 3 Francisco de Zurbarán (Spanish, 1598–1664), *Saint Francis of Assisi in His Tomb*, 1630/34. Oil on canvas. Milwaukee Art Museum, Purchase, M1958.70

permanent English settlement in Virginia, it also featured an international roster of exhibitors and positioned Hampton Roads as an American gateway to the world. Following the close of the exposition, the U.S. Navy established a permanent base on the site, which would eventually become Naval Station Norfolk, the world's largest naval base.

International travel played a pivotal role in the formation of Norfolk's art museum. In 1891 Irene Leache and Anna Cogswell Wood, who ran a school for young women in Norfolk, embarked on extensive travels through the Middle East and Europe, including Spain—a journey the two women documented in a lavish photographic album now in the Chrysler's collection (fig. 4). These travels inspired a love of the arts and collecting, and, following Leache's death in 1900, Wood founded the Irene Leache Memorial Foundation, dedicated to the promotion of arts education and the establishment of a fine arts museum in Norfolk. The Memorial's collection of European art, supported by the tireless efforts of community leaders under the auspices of the Norfolk Society of Arts, would form the basis for the Norfolk Museum of Arts and Sciences, established in 1933. The Museum slowly added to its

wide-ranging collections examples of Spanish old master paintings and prints, as well as nineteenth-century American paintings. In 1971 the Museum was wholly transformed by the generosity of Walter P. Chrysler, Jr., who gifted his encyclopedic collection with its particular strengths in European old masters and American paintings, including important examples of the Spanish Baroque. This gift included several of the works in the present exhibition by Édouard Manet, Claudio Coello, and Robert Henri (see cats. 71, 88, and 99). In celebration of Chrysler's seventy-fifth birthday in 1984, he donated another superlative group of paintings, which included Diego Velázquez's *Portrait of a Man* (see cat. 93).

At both Chrysler and Milwaukee, we are appreciative of the backing of our institutional leaders, most notably from the chair and the president of our board of trustees, Lelia Graham Webb and Joel Quadracci, respectively. We are also indebted to the institutions and private collectors whose generosity made this project possible. Their enthusiastic participation and support have been essential to our success, and the number of both domestic and international lenders is testimony not

Fig. 4 Page from photo album compiled by Irene Leache and Anna Cogswell Wood with photographs from Seville, ca. 1890s. Albumen prints mounted in bound volume. Chrysler Museum of Art, Gift of the Irene Leache Memorial Foundation

only to the transnational nature of the subject, but also to its popularity. We hope the exhibition and catalogue will add to the appreciation of and scholarship on this understudied yet essential moment in American art history. We are deeply indebted to the National Endowment for the Humanities, who provided the lead grant for the project, as well as to those individuals and organizations that provided financial support to make the exhibition, its digital initiatives, and the catalogue possible, including the Henry Luce Foundation, the Wyeth Foundation for American Art, the Milwaukee Art Museum's American Arts Society, the Gladys Krieble Delmas Foundation, and Furthermore, a program of the J. M. Kaplan Fund; we are equally grateful to the Arts and Artifacts Indemnity Program administered by the Federal Council on the Arts and the Humanities.

Like all undertakings of this scale, *Americans in Spain* was many years in the making, and we owe particular thanks to its curators, Brandon Ruud, Abert Family Curator of American Art at Milwaukee, and Corey Piper, Brock Curator of American Art at Chrysler. That they realized this ambitious project with such elegance is truly a testament to their passion. The essays by noted scholars, including Eugenia Afinoguénova, M. Elizabeth Boone, Francesc Quílez Corella, and Valerie Ann Leeds, are significant contributions to the subject, and we are grateful to them for sharing their expertise. Dr. Afinoguénova, whose research into Spain and the Prado's cultural history is particularly valuable, received indispensable support from the team at Marquette University; their work has added tremendously to the exhibition experience and brought nineteenth-century Spain to life, so to speak.

It is our deep desire that this exhibition and catalogue will encourage scholars, students, and visitors to better understand this important aspect of American art and to foster greater appreciation for the significance of these objects in their communities.

Marcelle Polednik, PhD
DONNA AND DONALD BAUMGARTNER DIRECTOR
MILWAUKEE ART MUSEUM

Erik H. Neil, PhD
DIRECTOR AND CEO
CHRYSLER MUSEUM OF ART

Acknowledgments

THIS EXHIBITION COULD NOT HAVE BEEN REALIZED without the collaboration and assistance of many colleagues across several countries and numerous institutions. The project centers on the partnership between our two museums, the Milwaukee Art Museum and Chrysler Museum of Art, and we are grateful to the leadership of our institutions for their steadfast support and commitment to this relationship. We owe a special thanks to the directors and senior staff who have helped guide the project: at Milwaukee, Marcelle Polednik, Donna and Donald Baumgartner Director, and Margaret Andera, Curator of Contemporary Art and Interim Chief Curator, and at the Chrysler, Erik H. Neil, Director, Seth Feman, Deputy Director for Art and Interpretation and Curator of Photography, and Lloyd DeWitt, Chief Curator and Irene Leache Curator of European Art, have provided critical leadership that brought the exhibition to fruition.

The success of the exhibition depended upon the generous participation of the lenders to whom we are enormously grateful. Our deepest gratitude is extended to the museums and private lenders who graciously parted with their treasures. We also thank those colleagues who aided our efforts to secure loans through encouragement, advice, and assistance: Dana E. Cowen at the Ackland Art Museum; Ellen Rudolph and Chrissy Marquardt at the Akron Art Museum; Marcy Bidney at the American Geographical Society Library; Sarah Kelly Oehler at the Art Institute of Chicago; Graham Boettcher and Kate Crawford at the Birmingham Museum of Art; Margarita Karasoulas at the Brooklyn Museum; Frederick Ilchman at the MFA Boston; Francesc Quílez Corella at the Museu Nacional d'Art de Catalunya; Julie Aronson at the Cincinnati Art Museum; Esther Bell and Regina Noto at the Sterling and Francine Clark Art Institute; Beth Finch and Justin McCann at the Colby College Museum of Art; Jonathan Walz at the Columbus Museum; Richard Rand, Scott Allan, and James A. Ganz at the Getty Museum; Laura Fry at the Gilcrease Museum; A. Cassandra Albinson and Jennifer Atkinson at the Harvard Art Museums; Peter Osborne at the Robert Henri Museum and Gallery; Kathleen Burnside at Hirschl and Adler; Evelyn Hankins at the Hirshhorn Museum and Sculpture Garden; Jenny Sponberg at the Myron Kunin Collection/Curtis Galleries; Ilene Susan Fort at the Los Angeles County Museum of Art; Sylvia Yount, Stephanie Herdrich, and Lillian Paulson at the Metropolitan Museum of Art; Robert Cozzolino and Heather Everhart at the Minneapolis Institute of Arts; Gail Stavitsky at the Montclair Art Museum; Sarah Cash and David Essex at the National Gallery of Art; Stephanie Fox Knappe at the Nelson-Atkins Museum; Simon Lake at the New Walk Museum and Art Gallery; Linda Ferber, Margi Hofer, and Wendy Ikemoto at the New-York Historical Society; Lyle Humphrey at the North Carolina Museum of Art; Hilaree Lombardo at the Oregon Public Library District; Sylvie Patry at the Musée d'Orsay; Javier Portús at the Museo del Prado; Maureen O'Brien at the RISD Museum; Regina Palm at the San Diego Museum of Art; Wally Mason at the Sheldon Museum of Art; Lorena Delgado and Luis Alberto Pérez Velarde at the Museo Sorolla; Melissa Wolfe and Amy Torbert at the St. Louis Art Museum; Paloma

Alarcó, Marta Ruis del Árbol, and Clara Marcellán at the Museo Nacional Thyssen-Bornemisza; Marta Weiss, Erika Lederman, and Juliet Ceresole at the Victoria and Albert Museum; Leo Mazow and Chris Oliver at the Virginia Museum of Fine Arts; Erin Monroe at the Wadsworth Atheneum; Jessica Burlingame at Wake Forest University; Jo Briggs at the Walters Art Museum; and Mark Mitchell at Yale University Art Gallery. We are also indebted to the numerous private collectors who so generously made their art available for loan and study: Fred Baker, Joan Brock, Steven Israel, Julius Linn, Catherine and Louis Pietronuto, Manuel Piñanes García-Olías, Stephen and Miriam Seidel, Lois and Arthur Stainman, and Joel Strote and Elisa Ballestas, as well as to the collectors who chose to remain anonymous. For their assistance in introducing collectors, and in many cases securing images, we are especially grateful to Reagan Upshaw and to Christie's.

For a project encompassing so many different artists, periods, and geographic locations, this exhibition and catalogue have benefitted immensely from the research of many distinguished academics and curators, several of whom we had the privilege of working with. We owe a debt of gratitude to the scholars who have served as advisors and catalogue authors: Eugenia Afinoguénova, M. Elizabeth Boone, Valerie Ann Leeds, and Francesc Quílez Corella. We are especially thankful for the collaboration on this project with Marquette University and those who have contributed to the exhibition's digital initiatives working on Dr. Afinoguénova's diverse and capable teams. The Virtual Reality experience "The Gallery of Queen Isabel at the Prado Museum in Madrid According to a Photograph by Jean Laurent (1875-1877)" was created by Chris Larkee at the Marquette University Visualization Lab (MarVL) based on the research by Dr. Afinoguénova and Pierre Géal (Université Grenoble Alpes) in consultation with Museo Nacional del Prado, and on the textures and the 3D visualization by Giuseppe Mazzone at the School of Architecture, University of Notre Dame. In collaboration with the Milwaukee Art Museum, Dr. Afinoguénova also led the development of the app that accompanies the exhibition, which was designed by Shiyu Tian at Marquette University, and mentored Tim Korolev, who created the interactive maps in consultation with Andrea Ballard and Stephen Appel from the American Geographical Society Library (University of Wisconsin-Milwaukee Libraries). These digital projects were finalized and brought to life through the expertise of Milwaukee's audio visual, design, and IS teams, including Ted Brusubardis, Dustin Dupree, and Tim Hapeman. The work on the app and the maps was generously funded by an Explorer Challenge Grant from Marquette University.

The exhibition was made possible thanks to the generous support of a number of sponsors. The National Endowment for the Humanities provided the lead grant for the project and the Henry A. Luce Foundation contributed critical early financial support. We would like to thank David Weinstein at the NEH and Teresa A. Carbone at Luce for their assistance and counsel. A grant from the Wyeth Foundation for American Art helped bring the catalogue to fruition as did one from Furthermore, a program of the

J. M. Kaplan Fund; the Milwaukee Art Museum's American Arts Society and the Gladys Krieble Delmas Foundation also supported the exhibition and its education programs. The exhibition was further supported by an indemnity from the Federal Council on the Arts and Humanities, and we are thankful for the assistance of Indemnity Administrator Patricia Loiko and of Erica Byun, Katherine Drake, Deborah Robertson, Ben Whine, and the department experts at Christie's who assisted with the application. The catalogue came together under the editorial guidance of Melissa Duffes at Lucia | Marquand, and the catalogue's visual smarts are the result of Ryan Polich's wonderful design sense. Our thanks go out to Melissa and Ryan and the team at Lucia | Marquand, including Adrian Lucia and Kestrel Rundle, as well as to Patricia Fidler at Yale University Press.

From its outset this entire undertaking has been a team endeavor, and we owe a special thanks to the staff at both Milwaukee and Chrysler for their contributions. Devon Dargan, chief registrar at the Chrysler expertly coordinated the registration for the project in concert with Rachel Brechbuehler and Lydelle Abbott Janes at Milwaukee. Key contributions from curatorial and administrative colleagues ensured the successful presentation of the exhibition, and we salute the efforts of curatorial assistants aryn kresol and Chyna Bounds, as well as Liz Flaig, Curatorial Department Administrator at Milwaukee, and Debbie Ramos, Elise Duncan, Ali Reynolds, and Amanda Gamble at Chrysler. Chyna Bounds, along with Rebekah Morin, Milwaukee's Rights and Reproductions Coordinator, and Beret Balestrieri Kohn, Audio Visual Librarian, undertook collection photography. Both Chrysler's and Milwaukee's librarians and archivists provided valuable research assistance and secured a number of the volumes for the exhibition, so we are indebted to the Dickson Librarian and Archivist at Chrysler, Allison Termine, and to the Milwaukee Art Museum Research Center's Heather Winter. Robust educational programs enhanced the exhibition's impact, and these efforts were led by Brigid Globensky, Amy Kirschke, and Emily Sullivan at Milwaukee and Allison Taylor, Emily Shield, and Cody Long at the Chrysler. The expert conservation, exhibition, and prep teams contributed immensely to the successful presentation of the exhibition, and we gratefully acknowledge the contributions of David Russick, Chris Niver,

Richard Knight, Arthur Mohagen, and Ryan Woolgar in Milwaukee and Mark Lewis, Clark Williamson, Anita Pope, Richard Hovorka, Mensah Bey, and Ed Pollard in Norfolk. The development teams worked tirelessly to support this exhibition, and we appreciate the efforts in Milwaukee of Abby Ashley, Kathy Emery, Therese Palazzari, Kim Theno, and Sara Tomilin and in Norfolk of Emily Zak, Heather Sherwin, Kate Sanderlin, and Caitlin Blomstrom. Each museum's marketing and design teams contributed greatly to the project, led by Meredith Gray, Megan Frost, DeAnne Williams, Beatriz Lange, Cassie Rangel, and Desi Mihaylov at Chrysler and Josh Depenbrock, Christina Dittrich, Rachel Stinebring, and Erin Aeschbacher in Milwaukee.

Like all travelers, as we embarked on this exhibition and catalogue we benefited immeasurably from the hospitality and kindness of colleagues, friends, and families along the way. Our deepest and most heartfelt thanks are due to our respective partners for their constant support and steadfast encouragement.

Brandon Ruud
ABERT FAMILY CURATOR OF AMERICAN ART
MILWAUKEE ART MUSEUM

Corey Piper
BROCK CURATOR OF AMERICAN ART
CHRYSLER MUSEUM OF ART

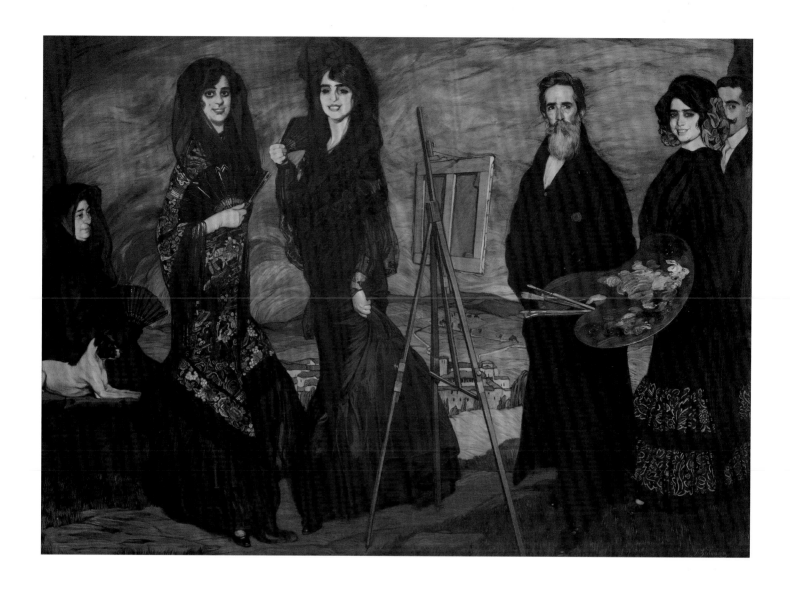

IGNACIO ZULOAGA Y ZABALETA

SPANISH, 1870–1945

My Uncle Daniel and His Family

1910 · Oil on canvas · 80¾ × 114 in. (205.1 × 289.5 cm)

Museum of Fine Arts, Boston, Caroline Louisa Williams French
Fund, 17.1598

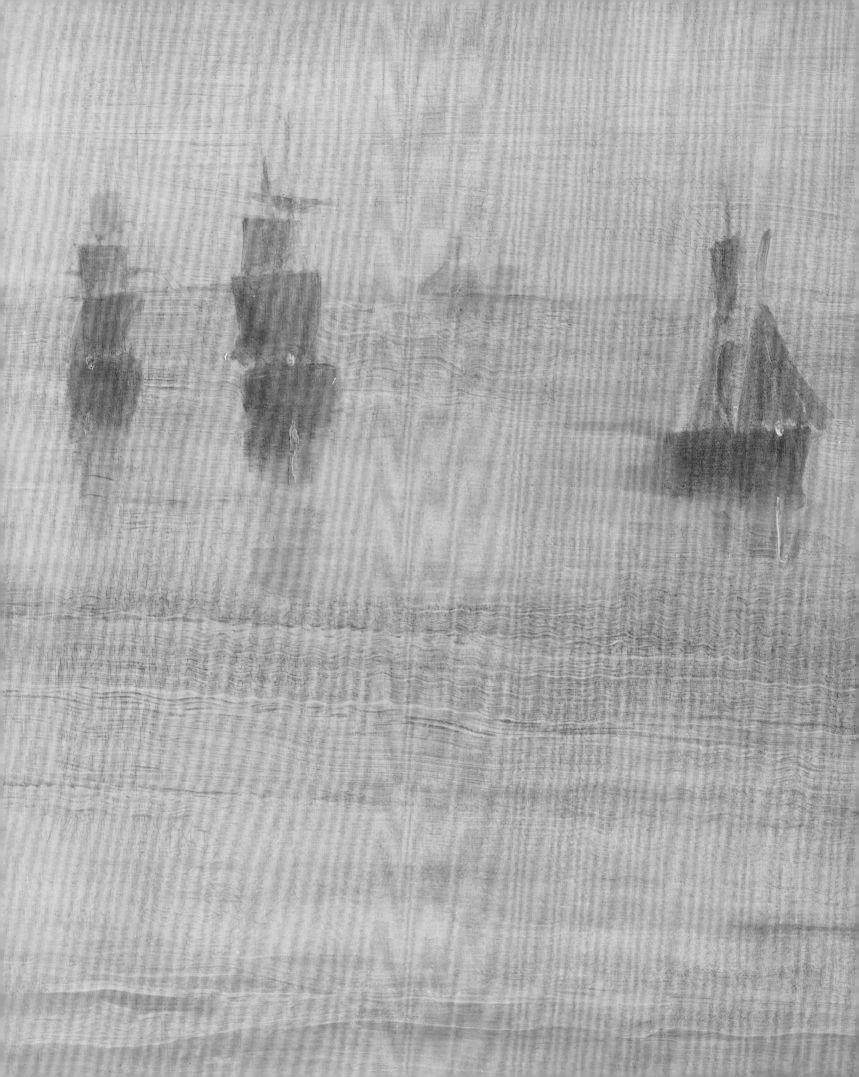

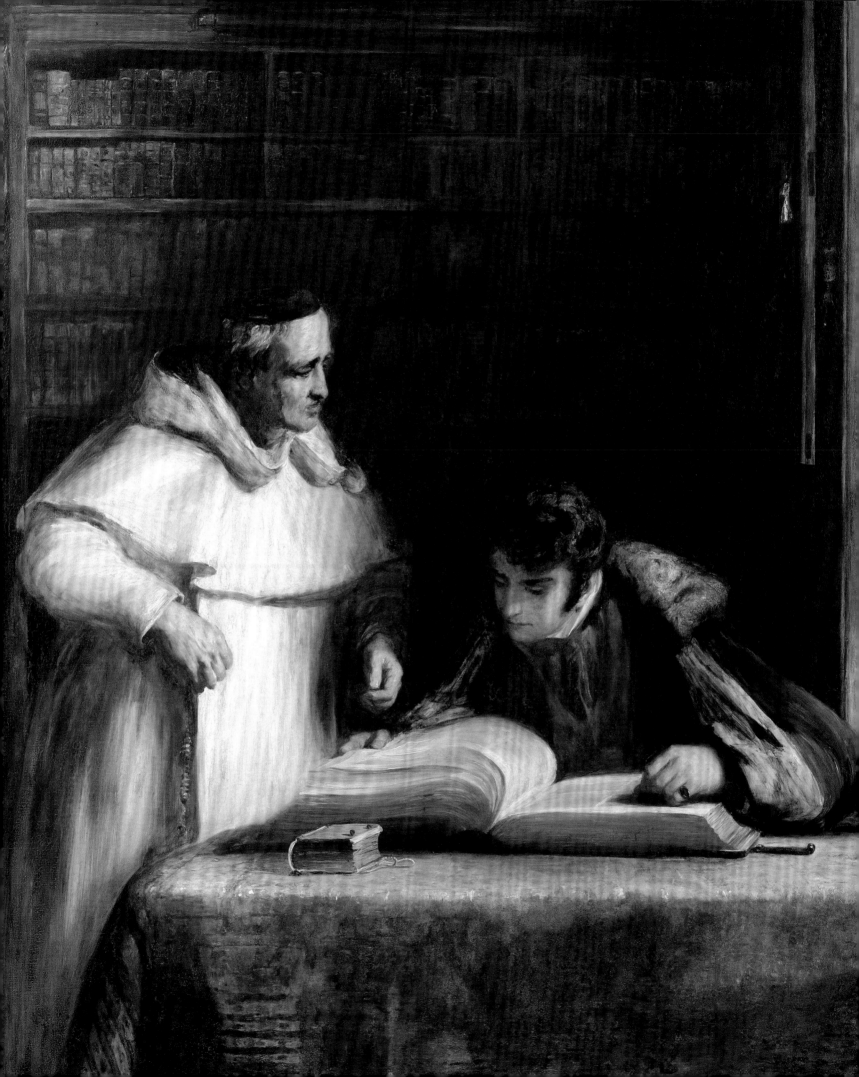

"A Triangulation of Interests"

THE UNITED STATES,
GREAT BRITAIN, AND SPAIN

Brandon Ruud and Corey Piper

WRITING DECADES AFTER HER 1901 TRIP THROUGH Spain, prominent American art collector, philanthropist, and suffragist Louisine Havemeyer bluntly summarized Spain's cultural and political status at the turn of the century and the United States' attitude toward it: "Mr. Havemeyer always maintained that after the Spanish War we should have demanded the Prado as an indemnity instead of taking over the Philippines, and he lived long enough to know that he was right. We did not need the Philippines, and the Prado would have been inestimable to us as a young nation, young in the art sense."[1] Influenced by both geopolitics and national chauvinism, Havemeyer's words illustrate the exalted regard for Spain's art and culture at the time, on the one hand, and its declining empire and political fortunes on the other. Equally, her assessment acknowledges America's cultural insecurity yet growing economic and martial superiority. As US-Spanish relations shifted and evolved over the course of the long nineteenth century, these attitudes informed many American artists, and in their works they revealed religious anxieties and prejudices; a strong desire to acquaint themselves with Spanish customs and people (which often resulted in a reliance on and appropriation of popular culture); and the impulse that Spanish art was something to be both admired and exploited.

These intersecting concerns influenced Havemeyer's collecting and are perhaps on full display in a painting of the Duke of Wellington now attributed to the Workshop of Francisco de Goya (cat. 3). Havemeyer purchased the canvas on the advice of her art agent, painter Mary Cassatt,

who admired both Goya and Bartolomé Esteban Murillo.[2] Goya painted this version around 1812, after the Duke of Wellington's decisive victory over Napoleon's forces at the battle of Salamanca. In her memoirs, Havemeyer recalled the history of the Goya portrait that she and Cassatt found while hunting for an El Greco:

> It seems the Spanish Duke of Montalava was a great friend of Wellington's and it was he who asked Goya to paint the portrait for him. When it was nearly finished, Wellington became dissatisfied with it and insisted that it did not resemble him and that Goya must change his face. He counted without his host; Goya was first, second and for all time a painter, and cared nothing for Wellington, nor Waterloos, nor anything else but his art, and he hotly replied that he would not change a brush stroke on the portrait. Words ran high and weapons were drawn, but fortunately the two great men were separated before they could do greater harm than to express their opinion of each other.[3]

Conflict and diplomacy and, along with them, the consequences of cultural property in fact were instrumental in shaping Spain in the American popular imagination, and in how and what images were seen by visitors and armchair tourists alike. Havemeyer's account of the snit between sitter and subject thus serves as a microcosm for the reception of Spanish art, and, especially, what historian Rolena Adorno has called "a triangulation

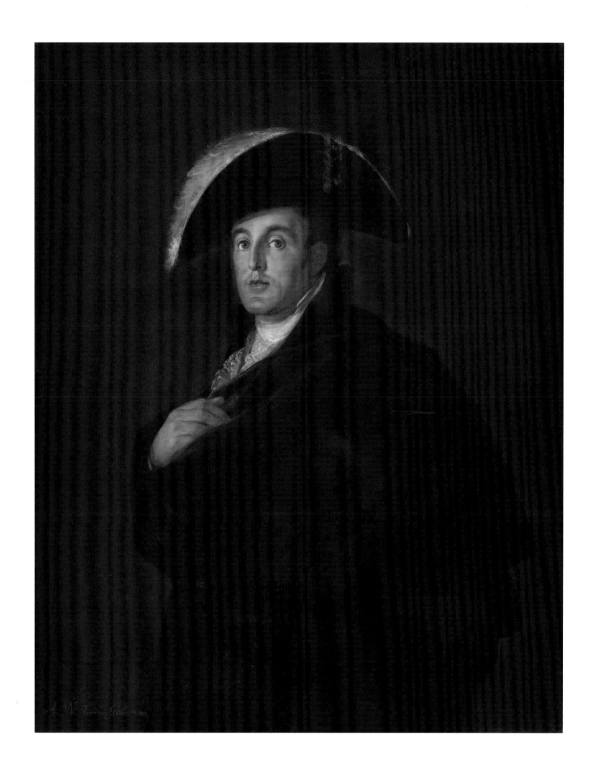

3

WORKSHOP OF FRANCISCO DE GOYA

SPANISH, 1746–1828

The Duke of Wellington

ca. 1812 · Oil on canvas · 41⁹⁄₁₆ × 32¹⁵⁄₁₆ in. (105.6 × 83.7 cm)

National Gallery of Art, Gift of Mrs. P.H.B. Frelinghuysen, 1963.4.1

of interests and influences that embraced Spain, England, and the United States": wealthy American collectors, securing the portrait of an English soldier and politician by a Spanish master.[4] Havemeyer's memoir also points to two overall threads that inform the entirety of this catalogue and exhibition and the nineteenth-century American experience in Spain: the growth of travel to the country and how word and image in guidebooks not only informed understanding, but also directed much of the art produced and lent authenticity to firsthand accounts and experiences.

As the essays in this catalogue suggest, tourism and travelogues provided a wealth of information—both visual and written—and much of the production of these books and guides began in England and were disseminated to American audiences. The friendship between Scottish artist David Wilkie and American author and diplomat Washington Irving, for example, helped form some of the earliest impressions of that country to western audiences. Wilkie was one of the most popular artists in Britain during the first half of the nineteenth century and specialized in a wide variety of subjects, but it was his paintings based on his travels through Spain and the Middle East that gained him the most widespread recognition.[5] The artist and author first met in London in 1823, spent the winter of 1827 together in Madrid, and then reconnected the following spring in Seville, where Irving was researching his multivolume history of Christopher Columbus and looking for source material on a new work on the conquest of Granada, while Wilkie was looking to expand his knowledge of Murillo. Back in London in 1829, Irving served as the secretary to the American Legation and secured publishers for the British editions of his Spanish-themed books, including *A History of the Life and Voyages of Christopher Columbus* (1828) and his romantic history, *Tales of the Alhambra* (1832).[6] Irving's early stories provided source material to both American and European travelers alike, who for decades either cited his prosaic *Tales* in their own accounts, illustrated the multiple editions of his books, or used the romantic nonfiction as source material for their paintings. Irving's influence spread to Spanish painters as well, as in Mariano Fortuny's *Slaughter of the Abencerrajes* (cat. 52), depicting a family or faction that is said to have held a prominent position in the Kingdom of Granada in the fifteenth century, who became the subject of a popular yarn retold by Irving and portrayed by artists throughout the nineteenth century.[7]

While in London, Wilkie executed several portraits of Irving, including *Washington Irving in the Archives of Seville* (cat. 4), a printed version of which he featured as the frontispiece to his posthumously published 1846 portfolio, *Sketches, Spanish and Oriental* (cat. 5), a fitting tribute to their mutual love for Spanish art and culture. Wilkie also painted several fantastic scenes based on Irving's biography of Columbus, including *Christopher Columbus in the Convent of La Rábida* (cat. 6). Although problematic as subjects, these paintings nonetheless show a shared history, and delivered Spain to America via London in what Adorno described as "giving Columbus to the United States"; in her words, it was "British North America" that "brought the development of a widening consciousness about Spanish culture."[8]

Although Wilkie was one of the earliest British artists to travel extensively through Spain, he was by no means the only one, and several others followed his example: Scotsman David Roberts, first in 1832 and then again in 1833; John Frederick Lewis, between 1832 and 1834; and John Phillip in 1851. Like Wilkie before them, all three painters became famous for their images of Spain, and each produced either lavish portfolios of their most popular works or contributed images to popular guidebooks. Roberts in particular achieved a great level of success, and many of his paintings were done on commission for royal households, including his *Fortress of the Alhambra* (cat. 7) for Lord Northwick and his *Fountain on the Prado, Madrid* (1841; Royal Collections Trust, London) for Queen Victoria as a Christmas gift to Prince Albert.[9] Roberts issued an 1837 portfolio of lithographs under the title *Picturesque Sketches in Spain*, but earlier, and perhaps more importantly, his paintings were reproduced in *The Tourist in Spain*, a popular series of travel books distributed by London publisher Robert Jennings under the heading The Landscape Annual.[10] As Eugenia Afinogué-nova's essay in this volume demonstrates, Jennings's Landscape Annual was the first instance where travelers to Spain were defined as tourists, as well as the first case of a popular guidebook doubling as "an artistic album": Roberts made colored versions of his prints available to the wealthy, and black-and-white versions for the less-so, and

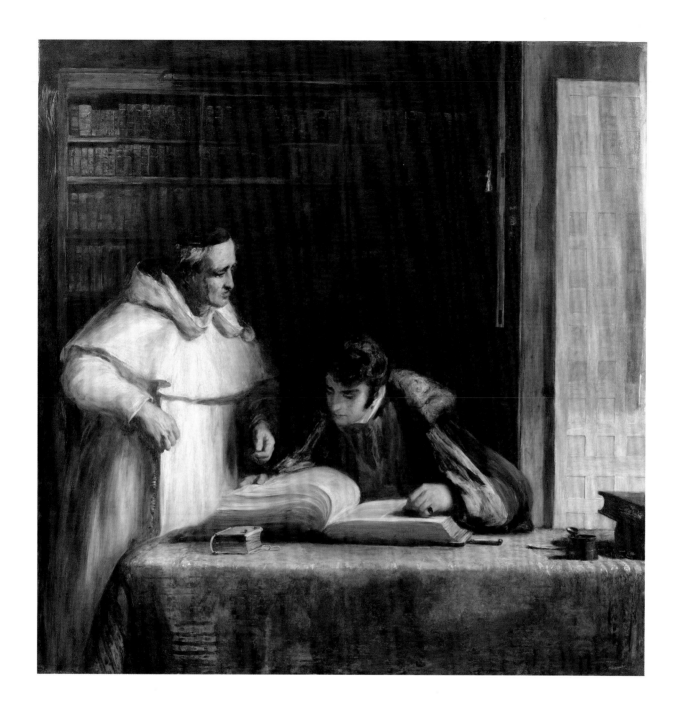

4

DAVID WILKIE

SCOTTISH, 1785–1841

Washington Irving in the Archives of Seville

1828-29 · Oil on canvas · 48¼ × 48¼ in. (122.6 × 122.6 cm)

New Walk Museum & Art Gallery, Leicester, purchased from
Mr. Thomas McLean, 1890, L.F2.1890.0.0

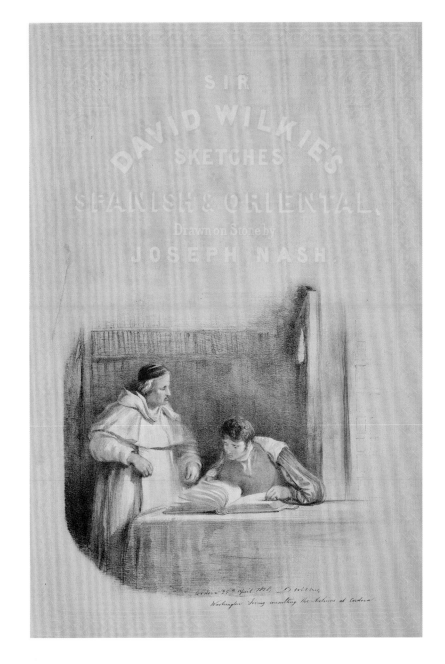

5

JOSEPH NASH

ENGLISH, 1809–1878

AFTER DAVID WILKIE

SCOTTISH, 1785–1841

Washington Irving Examining the Spanish Records

1846 · Lithograph · 21¾ × 14¼ in. (55.25 × 36.2 cm) ·
From *Sir David Wilkie's Sketches, Spanish & Oriental*.
London: H. Graves, Pall Mall

Milwaukee Art Museum, Decorative Arts Deaccession Fund,
M2019.106.1

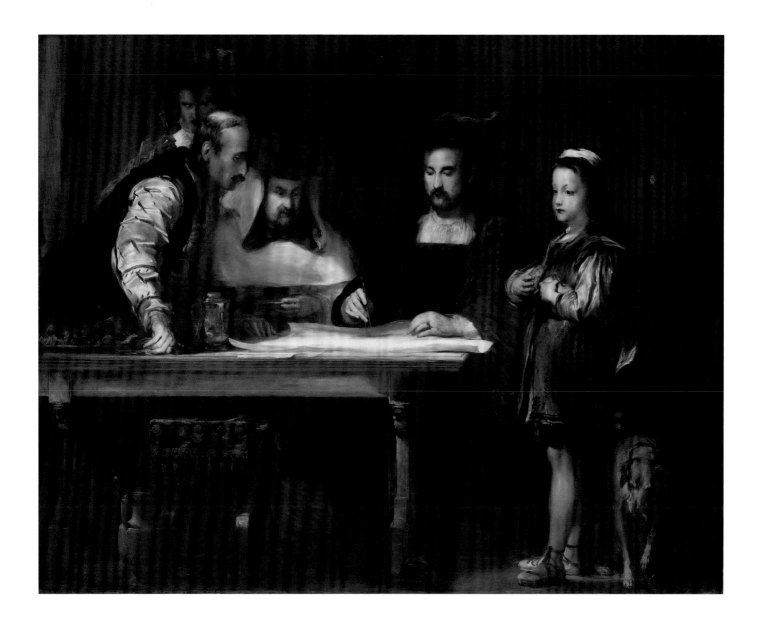

DAVID WILKIE

SCOTTISH, 1785–1841

Christopher Columbus in the Convent of La Rábida Explaining His Intended Voyage

1834 · Oil on canvas · 58½ × 74¼ in. (148.6 × 188.6 cm)

North Carolina Museum of Art, gift of Hirschl & Adler Galleries,
G.57.17.1

the Jennings Landscape Annual for 1837 devoted to the Biscay and the Castile regions sold over 12,000 copies in the first two months alone.[11] As such, Roberts's images in these volumes served as models for artists long into the future, including those who had visited Spain and had firsthand experience of its landscapes and peoples.

At the same time that Roberts and Jennings were issuing their portfolios and guidebooks, John Frederick Lewis published two sets of lithographs based on his time in Spain, *Sketches and Drawings of the Alhambra Made During a Residence in Granada* in 1835 and *Sketches of Spain and Spanish Subjects* in 1836. The color lithographs in *Sketches and Drawings* walk the tightrope between Orientalist fantasy and reportage. As the subtitle of the portfolio implies, the emphasis was on the Alhambra, though the compositions and subjects move beyond its boundaries. In images such as *Part of the Alhambra from the Alameda del Darro* or *The Mosque at Cordova* (cats. 8 and 9), Islamic architecture is employed merely as backdrop to the Catholic rituals on display in the foreground: a Catholic procession in the former, a Christian funeral in the latter. Lewis's lithographs nonetheless show a more complex,

multilayered experience of Spain during that time, one in which both the Alhambra and the Mosque–Cathedral of Córdoba had long histories of multiple uses. By contrast, Edwin Lord Weeks's *Interior of a Mosque at Cordova* from around 1880 (cat. 61) shows the building frozen in amber, "a fabricated story given the appearance of verisimilitude," the painter's utilization of historic photographs and travel guides lending credence to the anachronistic scene of an imam preaching holy war.[12]

The Catholicism in Lewis's images also points to an abiding interest of British audiences of the time, one that Americans wrestled with during the nineteenth century: the vogue for Murillo. As Betsy Boone has previously demonstrated, Murillo was a popular figure in England and his art a collectible resource in the eighteenth and nineteenth centuries, but "his association with the Catholic Church was problematic for Americans struggling to integrate large numbers of Catholic immigrants into a national body."[13] Painters like John Phillip (called "Spanish Phillip" because of the fame of his works based on the country) merged both ideas into paintings, like his *The Early Career of Murillo 1634* (fig. 5). Here, the young

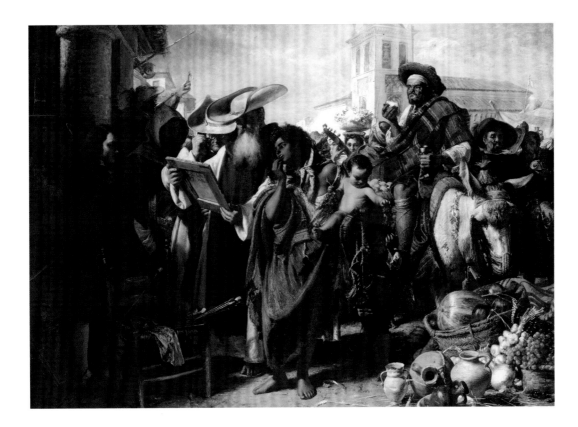

Fig. 5 John Phillip (Scottish, 1817–1867), *The Early Career of Murillo 1634*, 1865. Oil on canvas. Private Collection

DAVID ROBERTS

SCOTTISH, 1796–1864

The Fortress of the Alhambra, Granada

1836 · Oil on canvas · 18¼ × 44⁷⁄₁₆ in. (46.3 × 112.8 cm)

Harvard Art Museums/Fogg Museum, Gift of Richard L. Feigen,
1967.72

8

JOHN FREDERICK LEWIS

ENGLISH, 1804–1876

Part of the Alhambra from the Alameda del Darro

1835 · Lithograph · 21½ × 15⅝ in. (54.61 × 39.69 cm) ·
From *Lewis's Sketches and Drawings of the Alhambra, made
during a Residence in Granada in the Years 1833–34*.
London: Hodgson, Boys & Graves

Victoria and Albert Museum, E.240-1932

9

JOHN FREDERICK LEWIS

ENGLISH, 1804–1876

The Mosque at Cordova

1835 · Lithograph · 21½ × 15⅝ in. (54.61 × 39.69 cm) ·
From *Lewis's Sketches and Drawings of the Alhambra, made
during a Residence in Granada in the Years 1833-34.*
London: Hodgson, Boys & Graves

Victoria and Albert Museum, E.1863-1927

painter shows off his achievements to an admiring group of peasants and prelates at an outdoor market dominated by Seville's Giralda, a veritable catalogue of the Spanish experience at midcentury. George Henry Hall, an American painter who early on visited Spain, channeled both Phillip's composition and Murillo's style in his *La Feria de Jueves* (*The Thursday Fair of Seville*; see cat. 11), where a group of Catholic priests inspects books at an outdoor flea market; surrounded by fruit vendors in the foreground and Seville's architecture in the background, the hazy atmosphere and rosy palette a reminder of the great Catholic painter.

Murillo's presence in London also provided inspiration and models for American painters who visited that city, never setting foot on the Iberian Peninsula. In London they saw Spanish old masters at the Dulwich Picture Gallery and their offshoots at the Royal Academy, as well as in early compendiums of Spanish art, like William Stirling-Maxwell's *Annals of the Artists of Spain*, which devoted several pages to Murillo, including the locations of many of his masterpieces and reproductions of his work.[14] Thomas Sully, an artist who never visited Spain, for example, found inspiration in Spanish art and themes on visits to London. While in the city in 1837 to paint a full-length portrait of the young Queen Victoria, the painter engaged with publisher and art collector Edward Carey for a painting; his "Register of Pictures" indicates that he painted *The Gypsy Girl* for Carey for a price of three hundred dollars, designing it in England before finishing it in Philadelphia in September 1839 (cat. 12). Two decades later, Sully returned to the theme with his *Gypsy Woman and Child, after Murillo* (1859; Philadelphia Museum of Art), a painting that self-consciously references its Spanish old master source, which Sully copied after an engraving by Simon François Ravenet. In the category of what Sully described as his "fancy pictures," these paintings of artfully ragged peasant children appealed very much to Victorian sentiments and tastes. More importantly, Sully may have been influenced by Thomas Lawrence's *A Gipsy Girl* (1794; Royal Academy of Arts, London), which he would have had a chance to see at the Royal Academy. The tent and campfire in the left middleground of Sully's *Gypsy Girl* lends an aura of authenticity to the scene, one that might have appeared in George Borrow's *The Zincali*, an early and popular account of Spanish Romani people that

enjoyed nine reprints into the twentieth century after its 1841 debut. A chapter titled "English Gypsies" described them as "pitch[ing] their tents in the vicinity of a village or small town by the road side, under the shelter of the hedges and trees."[15]

The Anglo-American-Hispanic connections continued well into the late nineteenth century, largely through the publishing industry and through the efforts of Joseph Pennell and his friendship with James McNeill Whistler. During Whistler's lifetime, R. A. M. Stevenson wrote in his book on Velázquez that "the names of Regnault, Manet, Carolus-Duran, Henner, Whistler, and Sargent, rise to one's lips at every turn in the Prado."[16] Although he had copied paintings believed to be by Velázquez at the Louvre while living in Paris, Whistler honed much of his experience in Spanish art in London. There he engaged with Spanish paintings in public and private collections, collected photographs of Spanish old masters, and fostered painterly rivalries with other artists, including a notable exchange with William Merritt Chase, who specifically sought Whistler out in London because of their mutual interest in the art of Velázquez.[17] Whistler in fact painted *Brown and Gold* (cat. 13) to refute Chase's portrait of him done while in London; as an artistic declaration, Whistler based his pose on Velázquez's portrait of Spanish court actor Pablo de Valladolid (ca.1635; Museo del Prado), a photograph of which he owned. Whistler ultimately aborted every attempt he made to go to Spain and visit the Prado (ostensibly because the culture shock and inability to communicate burdened him), and yet the opportunity to sail the distance all the way to Valparaiso, Chile, where he witnessed the Spanish Bombardment of the South American city in 1866, led to the development of his famous nocturnes (cat. 10).[18]

Whistler's friendship with Pennell and his wife, Elizabeth, provided another opportunity to engage with Spain, albeit from the comfort of his home in England. The Pennells spent July and August of 1895 in Spain, primarily Andalusia, with Joseph returning the following spring to make numerous drawings and sketches for an 1896 London edition of Irving's *The Alhambra* (see cats. 22–25 and 107).[19] Temperamentally suited as friends—Pennell, for example, described Madrid as a "vile hole"—the two artists were active members of the International Society of Painters, Sculptors, and Gravers, where Pennell was a founder

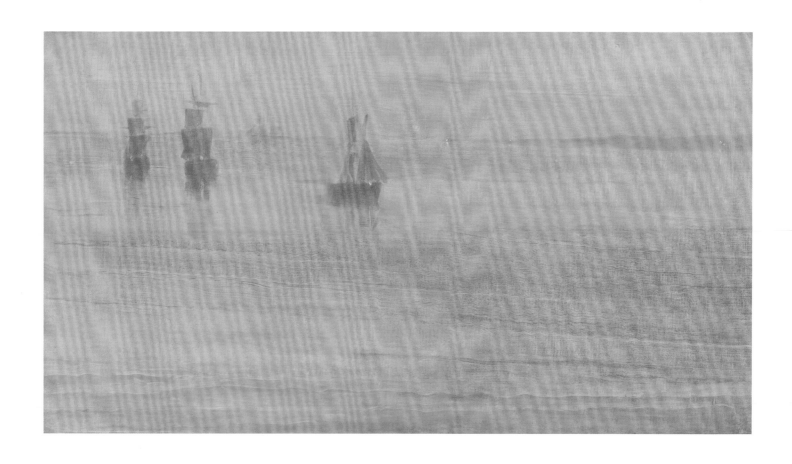

JAMES MCNEILL WHISTLER

AMERICAN, 1834–1903

Nocturne, The Solent

1866 · Oil on canvas · 19¼ × 35½ in. (48.9 × 90.2 cm)

Gilcrease Musuem, Tulsa, Oklahoma, 01.1185

11

GEORGE HENRY HALL
AMERICAN, 1825–1913

La Feria de Jueves
(The Thursday Fair of Seville)

1867 · Oil on canvas · 40⅛ × 32½ in. (102.3 × 82.1 cm)

Museum of Art, Rhode Island School of Design, gift of Mr. Alfred T.
Morris, Sr., 78.145

THOMAS SULLY

AMERICAN, 1783–1872

The Gypsy Girl

1839 · Oil on canvas · 29⅞ × 24⅞ in. (75.88 × 63.8 cm)

Los Angeles County Museum of Art, Gift of Dr. and Mrs. James K.
Weatherly, Houston, Texas, M.82.161

and Whistler served as first president, and where the latter first exhibited his most consciously Velázqueian self-portraits.[20]

Pennell, along with Elizabeth, collected correspondence from Whistler and ultimately wrote an authorized and fawning biography of the artist that also serves as a final and affecting "triangulation of interests" between American, English, and Spanish cultures. As retold in the Pennells' biography of Whistler, and as documented by the artist himself in his correspondence, the first painting Whistler exhibited in London, *At the Piano* (1858–59; Taft Museum, Cincinnati), was acquired by no less than John "Spanish" Phillip, whose paintings were so instrumental in shaping the images of Spain to American and English audiences.[21]

NOTES

1. Louisine W. Havemeyer, *Sixteen to Sixty: Memoirs of a Collector* (New York: Privately printed, 1961), 131–32.

2. For the history and provenance of the painting, see Aureliano de Beruete, *Goya as Portrait Painter*, English ed. (Boston and New York: 1922), 148–49; and Havemeyer, *Sixteen to Sixty*, 153, 156–57. See also correspondence between Joseph Wicht, the painting's seller in Madrid, and Mary Cassatt in the object files of the National Gallery of Art, Washington, DC; for Cassatt and Goya, see M. Elizabeth Boone, "The Paintings Left Behind: Two New Paintings from Mary Cassatt from Seville," *Panorama: Journal of the Association of Historians of American Art* 4, no. 2 (Fall 2018): 1–7.

3. Havemeyer, *Sixteen to Sixty*, 156–57. The story is also repeated and elaborated on in Elizabeth de Gué Trapier, *Goya and His Sitters: A Study of His Style as a Portraitist* (New York: Hispanic Society of America, 1964), 178–79; and in Jonathan Brown and Richard G. Mann, *Spanish Paintings of the Fifteenth through Nineteenth Centuries: The Collections of the National Gallery of Art Systematic Catalogue* (Washington, DC: National Gallery of Art, 1990), 37–41. The painting was reattributed to a member of Goya's workshop in the late 1980s and was believed to have been copied after a drawing of the duke by the artist. See "Report," Object File, Department of European Painting, National Gallery of Art.

4. Rolena Adorno, "Washington Irving's Romantic Hispanism and Its Columbian Legacies," in *Spain in America: The Origins of Hispanism in the United States,* ed. Richard L. Kagan (Urbana: University of Illinois Press, 2002), 49.

5. For additional information on Wilkie and his relationship with Irving, as well as analyses of these paintings, see H. A. D. Miles and David Blayney Brown, *Sir David Wilkie of Scotland (1785–1841)*, exh. cat. (Raleigh: North Carolina Museum of Art, 1987).

6. For an extensive and effective overview of Washington Irving's time in Spain and his resulting literary production, including both English and Spanish editions of his works, see *Washington Irving and the Alhambra: 150th anniversary (1859–2009)*, exh. cat. (Alcobendas: Lerner & TF Editores/Granada: Junta de Andalucía, Patronato de la Alhambra y el Generalife, 2009).

7. For Irving's description, see Washington Irving, *The Tales of the Alhambra* (London: Chatto and Windus, Piccadilly, 1875), 50–51. French writer Théophile Gautier, for example, cited Irving's *Tales* in his own travel account through the Alhambra; see Théophile Gautier, *A Romantic in Spain*, trans. Catherine Alison Phillips (New York, Interlink Books; repr. 2001), 192.

8. Adorno, "Washington Irving's Romantic Hispanism," 51. Other early histories of the United States reinforced the cult of Columbus, such as C. B. Taylor's *A Universal History of the United States*, which devoted its introduction to the navigator; see Taylor, *A Universal History of the United States, Embracing the Whole Period from the Earliest Discoveries down to the Present Time* (New York: Ezra Strong, 1831), 5–12. For more on the idea that Wilkie's Spanish paintings demonstrate a shared history between Britain, Spain, and the United States, see Nicolas Tromans, "The Age of Goya," in *The Discovery of Spain: British Artists and Collectors, Goya to Picasso*, ed. Christopher Baker et al., exh. cat. (Edinburgh: National Galleries of Scotland, 2009), 29–33.

9. For history of the two paintings, as well as biographical information on the artist, see David and Francina Irvin, *Scottish Painters at Home and Abroad: 1700–1900* (London: Faber and Faber, 1975), 333; and Deborah Clarke and Vanessa Remington, *Scottish Artists: From Caledonia to the Continent* (London: Royal Collection Trust, 2015), 118–19.

10. See, for example, Thomas Roscoe, *The Tourist in Spain: Granada. Illustrated from Drawings by David Roberts* (London: Robert Jennings and Company, 1835); and Thomas Roscoe, *The Tourist in Spain and Morocco: Jennings' Landscape Annual for 1838: Spain and Morocco* (London: Robert Jennings and Company, 1838).

11. See Claudia Heide, "The Spanish Picturesque," in

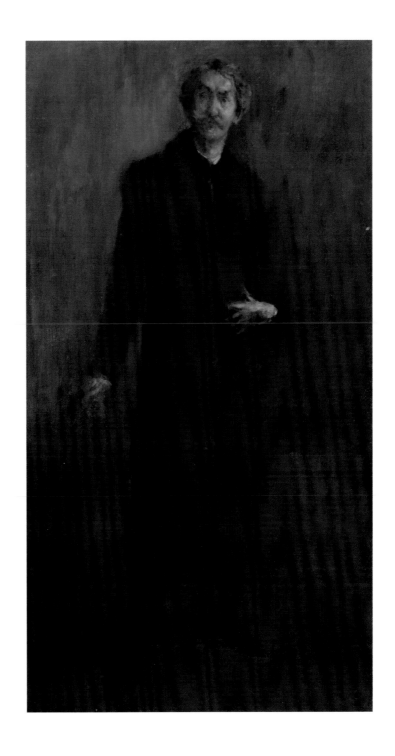

JAMES MCNEILL WHISTLER

AMERICAN, 1834–1903

Brown and Gold

1895–1900 · Oil on canvas · 37½ × 20¼ in. (95.8 cm × 51.5 cm)

The Hunterian Museum and Art Gallery, University of Glasgow,
GLAHA: 46376

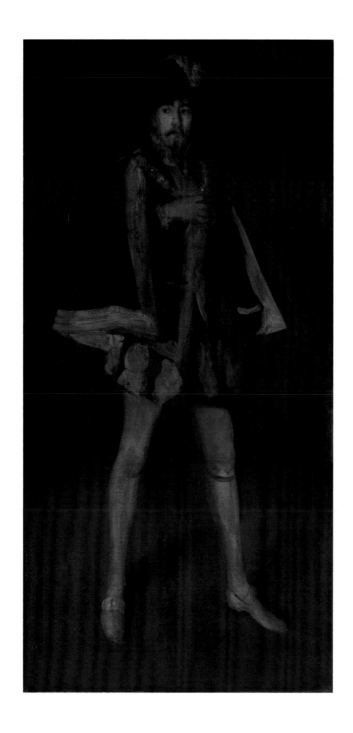

14

JAMES MCNEILL WHISTLER

AMERICAN, 1834–1903

Arrangement in Black, No. 3:
Sir Henry Irving as Philip II of Spain

1876, reworked 1885 · Oil on canvas · 84¾ × 42¾ in. (215.3 × 108.6 cm)

The Metropolitan Museum of Art, Rogers Fund 1910, 10.86

Baker et al., *The Discovery of Spain*, 49.

12. Holly Edwards, *Noble Dreams, Wicked Pleasures: Orientalism in America, 1870–1930*, exh. cat. (Princeton University Press/Williamstown, MA: Clark Art Institute, 2000), 139. For a discussion of Week's use of photography, potentially even his own, see Marianna Shreve Simpson, "Staging the Interior of the Mosque at Cordova," *The Journal of the Walters Art Museum* 70/71 (2012/2013): 109–20.

13. M. Elizabeth Boone, *Vistas de España: American Views of Art and Spain, 1860–1914* (New Haven: Yale University Press, 2007), 39.

14. Many paintings by Murillo were in the Dulwich Picture Gallery by 1811. For a full catalogue and listing, see Xavier Bray, *Murillo at Dulwich Picture Gallery* (London: Philip Wilson Publishers/Dulwich Picture Gallery, 2013); see also William Stirling-Maxwell, *Annals of the Artists of Spain*, vol. 3 (London: John C. Nimmo, 1841).

15. George Burrow, *The Zincali: An Account of the Gypsies of Spain*, 9th ed. (London: John Murray, 1923; repr. *Astounding Stories*, 2015), 11.

16. R. A. M. Stevenson, *The Art of Velasquez* (London: George Bell and Sons, 1895), 14.

17. For more on Whistler's engagement with Spanish art in brief, including his copying of Mazo's *Thirteen Cavaliers* (then thought to be by Diego Velázquez) at the Louvre, his visit to the 1855 Manchester exhibition of Spanish old masters, and his

collecting of photographs after Spanish old masters, see Denys Sutton, *James McNeill Whistler: Paintings, Etchings, Pastels, and Watercolours* (London: Phaidon Press, 1966), 30. For a thorough discussion of Whistler's late portraiture and their self-consciously Velázquezian references, along with his relationship to William Merritt Chase's portrait of him, see Gary Tinterow and Geneviève Lacambre, *Manet/Velázquez: The French Taste for Spanish Painting*, exh. cat. (New York and New Haven: The Metropolitan Museum of Art/Yale University Press, 2003), 523–24, 538–42. Finally, for an examination of Whistler's self-portraiture as a continuation of Velázquez's artistic celebrity, see Sarah Burns, "Old Maverick to Old Master: Whistler in the Public Eye in Turn-of-the-Century America," *The American Art Journal* 22, no. 1 (Spring 1990): 28–49.

18. For Whistler's aborted visit to Spain, see Gordon Fleming, *The Young Whistler, 1834–66* (London: George Allen and Unwin, 1978), 176–77; for more on this and the South American trip's effects on Whistler's artistic output, see Robert H. Getscher, "Whistler's Paintings in Valparaiso: *Carpe Diem*," in *Out of Context: American Artists Abroad, Contributions to the Study of Art and Architecture*, 8th ed. Laura Felleman Fattal and Carol Salus (Westport, CT: Praeger, 2004), 11–22.

19. For accounts of these two trips, see Elizabeth Robins Pennell, *The Life and Letters of Joseph Pennell*, vol. 1 (Boston: Little, Brown, and Company, 1929), 286–89,

306–10. Though his opinions were strong, as Betsy Boone has demonstrated, Pennell's anodyne images for many printed books on Spain turned them from polemics into "an apolitical work of art"; see M. Elizabeth Boone, "Castilian Days: John Hay, Joseph Pennell and the Obfuscation of Politics by Art," *Visual Resources* 31, no. 4 (December 2005): 329–45.

20. See, for example, Richard Dorment and Margaret F. MacDonald, *James McNeill Whistler*, exh. cat. (London and Washington, DC: National Gallery of Art/Tate Gallery, 1995), 283–85.

21. E. R. and J. Pennell, *The Life of James McNeill Whistler in 2 Volumes*, vol. 1 (London: J. B. Lippincott, 1908), 82. This story was confirmed in correspondence from Whistler to another of his biographers, James Anderson Rose; see James McNeill Whistler to James Anderson Rose, November 1878 [?], Library of Congress, Manuscripts Division, Pennell-Whistler Collection, PWC 4/62.

Importing the Picturesque

ILLUSTRATED TRAVEL BOOKS ON SPAIN, 1829–1915

Eugenia Afinoguénova

BEFORE THEY WERE PAINTINGS, SPANISH LANDSCAPES, portraits, and genre scenes were pages in travel books. Over the course of the nineteenth century, guides, descriptions of travels, and epistolary or adventure novels that often doubled as travel books became bestsellers in Euro-American markets. Spain, which in the eighteenth century had been excluded from the traditional educational itineraries, known among upper-class European men as the Grand Tour, had become a preferred destination in the early 1800s, when it acquired a reputation of a Romantic and picturesque land.

There were many reasons why, in the nineteenth century, everyone who could afford it wanted to visit Spain. In 1808–1812, brothers August Wilhelm and Friedrich Schlegel, German philosophers who were fervent promoters and important influencers of the Romantic movement, defined Spain as the natural dwelling of poetry and the Romantic spirit, understood as a union of "religion, a loyal heroism, honor, and love."[1] The inhabitants of the Euro-American world, traumatized by the changes that industrial development was bringing to their social and physical landscapes, were relieved to find a land where the past was still visible and passions still mattered. A country of "peripheral modernity" (to use Beatriz Sarlo's phrase), Spain became the perfect Other toward which one might direct one's quest for roots, authenticity, and traditional lifestyle.[2] Whether raving over its sublime landscape, cautioning against its bandoleros, laughing at its inhabitants, or denouncing its Catholic Church, writers from better-developed nations expressed a mix of thrill

and repulsion in their writing about Spain that made their return home seem pleasant and soothing. Travelers of the age seemed to assume that should they ever need to touch the past again, they would always find it there, unaltered and ready to be consumed.

Another kind of interest in Spain emerged over the course of the Napoleonic conquest and the ensuing Peninsular War, fought by the Spanish and the British in Spanish territory. While Napoleon's armies moved on to conquer other nations, Alexandre de Laborde, who served as the French ambassador in Madrid in 1800–1801 and returned in 1808–1814 to assist the French occupation administration, produced and published two multivolume series dedicated to Spain. The first of these series—the five-volume Descriptive Itinerary through Spain—sought to bring the available knowledge about Spain to a level that would make it an acceptable future territory of the Empire.[3] Besides historical and geographical information largely borrowed from the eighteen-volume Viaje de España by the Spanish Enlightenment historian Antonio Ponz, Laborde's tomes described climate, quality of land, and the most successful crops of every Spanish province.[4] Laborde's second publication, *A Picturesque and Historical Voyage in Spain*, was a four-volume collection of lithographs in folio depicting Spanish monuments with French, Spanish, and English annotations.[5]

For years afterward, these texts, which were almost instantaneously translated into English, and these images, often reproduced in Anglo-American illustrated books on Spain, inspired travelers to contemplate the country

Fig. 6 Alfred Charles Conrade, *The Lion Fountain, Alhambra, Granada*, n.d. Pencil, watercolor, and body color. Private Collection

through the gaze of a putative French occupier long after Napoleon's army had conquered the Peninsula and had subsequently been chased away. Since its first publication in 1845, another authoritative compendium on Spain—the two-volume *Handbook for Travellers in Spain and Readers at Home*—claimed to present an alternative, pro-British, anti-French perspective.[6] Quickly rising to the reputation of the greatest authority on all things Spanish, Richard Ford, the author of this guidebook and a series of abridged books published in London, was probably playing an unacknowledged political role in Spain on behalf of Britain.[7]

In American writings about Spain, politics was also never far removed from prose. Alexander Slidell Mackenzie, a naval officer and a friend of Washington Irving, anonymously published in 1829 the first nineteenth-century travelogue about Spain attributed to an American traveler, *A Year in Spain, by A Young American* (1829). The reason for his trip was never too clear; still, despite the author's professed secret, his text referred to some mysterious "intelligence" received in 1826 or 1827 that made him "anxious to depart, with as little delay as possible, for the South of Spain."[8] Later in the century, John Hay authored another popular travel book, *Castilian Days* (1871), while serving in the United States' diplomatic mission in Madrid

after the dethronement of Queen Isabella II and the proclamation of the First Spanish Republic (1868–1873); in 1903, while Hay was the U.S. Secretary of State, an illustrated and edited version of this book was published.[9]

For foreigners, the pursuit of beauty in Spain was, therefore, hardly a disinterested endeavor. This was a land, not of free fantasy, but rather of calculated fancy. English Romantic-era poet and philosopher Samuel Taylor Coleridge defined fancy as "a mode of Memory emancipated from the order of time and space" yet predicated on a rational operation of "that empirical phenomenon of the will, which we express by the word CHOICE."[10] Since, for citizens of modernizing nations, a trip to Spain was meant to satisfy a demand for a usable past or for terrifying reminders of backwardness, the selective nature of their quests produced an imagery that seldom had anything to do with what Spain could actually offer. Oriental splendor and Christian chivalry merged in these fantasies and spilled over into imagery such as Alfred Charles Conrade's watercolor *The Lion Fountain, Alhambra, Granada* (fig. 6), where the contrast of sun and shade can only partially mitigate the composition's anachronism. Such a visitor, wearing full knightly armor and reminding us of Charles V in Titian's portraits, would never in reality bring his dog to

contemplate the Court of the Lions inside the Alhambra palace at a time when it had been overgrown by grass.

Nostalgia was, however, being transmitted through the most modern forms of media: the press and illustrated travel books, both of which were becoming more and more visually attractive thanks to the improving technology of artistic reproduction. After the 1830s, the market for travel narratives was growing, while the cost of engravings was decreasing. As a result, publishers could make money producing travelogues with an increasing number of illustrations. "Travels sell about the best of anything we get hold of. They don't always go off with a rush, like a novel by a celebrated author, but they sell longer, and in the end, pay better," the New York editor George Putnam would soon acknowledge.[11] It was this—publishers' interest in travel narratives because of the profit they brought in combined with ever-improving reproduction technology—that shaped the image of Spain long before it became a destination for American artists. These factors continued to influence the American perception of the country even after American collectors developed a taste for their compatriots' paintings of Spanish landscapes, monuments, and people, as well as for works by Spanish artists and products by Spanish artisans.

Illustrating the Picturesque

Illustrated travel books in English first came into fashion in Britain, where publisher Robert Jennings started a series in 1830 called the Landscape Annual (renamed in 1835 as Jennings' Landscape Annual) and commissioned writer Thomas Roscoe to write stories under a common title, *The Tourist in. . . .* Importantly, Jennings's was an artistic endeavor, "a work at once novel and attractive, and [. . .] widely differing in point of design and execution from any of a similar class hitherto announced."[12] Between 1830 and 1839, Roscoe produced one volume each dedicated to France and Switzerland, three dedicated to Italy, and four to Spain: *The Tourist in Spain: Granada* (1835), *The Tourist in Spain: Andalusia* (1836), *The Tourist in Spain: Biscay and the Castiles* (1837), and, finally, *The Tourist in Spain and Morocco* (1838).

This was not only the first time a traveler to Spain was defined as a "tourist" but also the first case of a travel book doubling as an artistic album—a "picturesque travel" with the goal, according to the Enlightenment ideas of

William Gilpin, of finding the beauty in nature as if it were an artistic composition.[13] If earlier in the century Laborde's luxurious engravings, which had launched the genre of "picturesque travel" through Spain, featured images separate from descriptions of itineraries, after the Landscape Annual, texts and works of art were forever combined in travelogues about Spain.

Though Roscoe's first three books contained engravings from drawings by David Roberts, one should not think that the artist merely illustrated the text. It was, rather, the author who used the artist's earlier sketches and notes as the source from which to write (see cat. 37). In the preface to the volume *The Tourist in Spain: Andalusia* (1836), Roscoe acknowledged the artist, "who studied carefully on the spot every subject which he has delineated," and stated that, "for much of the information comprised in the Notes descriptive of the plates and wood engravings, the Author is indebted to the personal observation of the same individual."[14] When the last volume, *The Tourist in Spain and Morocco*, was being prepared in 1837–1838, Roberts could not travel to provide images. The preface explained that the outbreak of cholera in Seville placed him behind the sanitary cordon, and he therefore had to ask his friends—including Richard Ford, mentioned earlier—to send sketches for drawings.[15] The text made it seem as if the artist and the writer had been working together all along, but that was not the case. Roberts's sketches dated back to 1832 and 1833, and the "cordon" mentioned in the preface made the artist leave the country in October 1833, four years before the volume was being created. At the time of Roscoe's writing, Roberts was using his own earlier sketches to complete the drawings from which the engravings were made, but he did not author the drawings for the engraving in the 1838 volume, stylistically quite different from his work. There are, furthermore, serious doubts concerning his authorship of some of the drawings from the previous volume.

When sketches, drawings, and engravings became the stuff that travel books were made of, the images of Spain that circulated abroad began to depend not only on the narratives of travelers and tourists but also on a stock of images available for the publishers to reproduce. The American market for travel literature, which was smaller than the British one, soon developed its own dependency on illustrations. The publishing history of Slidell Mackenzie's anonymous memoir, *A Year in Spain*, evidences the shift

toward reproductions of works of art coming from Britain. The 1829 Boston edition of the memoir, which contained only text, was so successful that in 1830 it was expanded to two volumes and published again in the United States and, a year later, in 1831, in Great Britain—edited by Washington Irving.[16] An American edition (it's not clear whether it was the 1829 or 1830 version) somehow landed on the desks of the Spanish authorities, who, having found it "full of lies and gross calumnies against Our Lord the King and His family," banned the books and prohibited the author from re-entering Spain.[17]

Though these two editions had no engravings, visual representations were already such a part of travelogue that the book's prose was reviewed in visual terms, and later editions included illustrations. Reviewing the American edition for the *Quarterly Review*, Washington Irving noted that the author's detailed descriptions had the "fidelity of a Flemish painter," while also possessing "a graphic touch, and a lively coloring."[18] It was only logical that when Irving's version appeared in London, John Murray—the British publisher who at the time was actively expanding in the market of travel literature before commissioning Richard Ford to write the famous guidebook of Spain—had added illustrations from several unacknowledged sources.[19] Some of them reproduced, in a much cheaper form, lithographs from Laborde's *A Picturesque and Historical Voyage in Spain*, while others copied popular etchings of traditional costumes from different parts of Spain, a collection of which Murray must have owned and had used previously to illustrate at least one other book.[20]

In 1836, Slidell Mackenzie's book was expanded to three volumes and published again in New York. This time the American edition also contained illustrations—different from those used by Murray and far less abundant.[21] Two of them were the work of the American engraver Archibald L. Dick from drawings by John Gadsby Chapman. Italy was the closest the artist had ever been to Spain, so his drawings had an eerie quality. Male Spanish laborers appeared dressed in rags and costumes reminiscent of army uniforms (*The Gamblers*, title page of vol. 1), while females appeared wearing mantillas and large hats in circumstances where these would not have been worn in Spain (*The Robbery*, title page of vol. 2). Volume 3—a record of the author's trip to Granada

that was missing from the earlier editions—featured an engraving based on David Roberts's drawing of the Puente Nuevo over the Tajo in Ronda (fig. 7), which appeared earlier in Thomas Roscoe's *The Tourist in Spain: Granada* (1835). This edition ran again in 1847 featuring the same illustrations.

The editorial history of *A Year in Spain* suggests that publishers from the United States found it easier to commission vignettes of genre scenes rather than "picturesque" vistas that required a trip to Spain. Or so it appeared until George Putnam issued in 1851 a revised edition of Washington Irving's *The Alhambra* with seventeen engravings after Felix O.C. Darley.[22] Considered the best illustrator of Irving's text, Darley never traveled to Spain. This did not prevent him, however, from creating images that, in turn, inspired American pictorial landscapes of Spain. Such was the case of Samuel Colman, who, apparently, followed Darley's composition in *The Hill of the Alhambra, Granada* (1865).[23] One of the first American artists to actually visit Spain, Colman nonetheless collected photographs commissioned for both the Spanish and the tourist markets (see cat. 38), and he seemed to rely heavily on other artists' compositions for his own paintings. His *Washing Day, Granada* of 1872 (see cat. 36) is remarkably similar to Roberts's scene of the same subject from nearly four decades earlier. Also following Roberts's example, and somewhat ironically, given its influence, Darley's landscape on the frontispiece of *The Alhambra* (cat. 15), however, was the least characteristic of his illustrations, which otherwise depicted types and genre scenes against a backdrop of Orientalized architectural details.

Throughout the 1800s in the United States, both authors and publishers of travel books on Spain preferred narrative illustrations of Spanish types and, when in need of a landscape or a monument, reproduced engravings from books published abroad. In 1875, Kate Field's *Ten Days in Spain*, which initially appeared as articles in the *New-York Tribune*, featured an unattractive figure on the frontispiece, whom the author called the Brinker. It was, apparently, a Frenchman who had been Field's courier, or escort, through Spain. Inside the book, there was a small portrait of the President of Spain's First Republic, Emilio Castelar (whom Field interviewed in Madrid), alongside that of Don Carlos, who at the time led a civil war against

Castelar. Also included were two glimpses of Spanish scenery (mountains and a street in Toledo) and two scenes of a bullfight, but otherwise these images were overshadowed by the twelve illustrations of the narrator's adventures, making the book seem more like a novel and less like the collection of journalistic dispatches that it actually was (fig. 8). It was not unusual for travel books to double as novels in the United States, especially as novels for young readers, as M. Elizabeth Boone's chapter in this volume demonstrates. Yet while the genre would make narrative illustrations a logical choice, it is remarkable that throughout the 1880s, the images of Spanish landscapes and monuments in these publications would only come secondhand from Europe, from etchings by Gustave Doré or photographs by the French photo studio of Jean Laurent (see, for example, cats. 21, 26, 35, 43, and 62, and Boone's essay in this volume).

Books such as these were not introducing American readers to a Romantic version of the "tourist gaze" that sought self-understanding against the backdrop of picturesque landscapes. Rather, illustrated travel books published in the United States painted Spain as a place of fictionalized, theater-like action that involved strange characters and, importantly, excluded the reader, who was, after all, less likely than any European to embark on a voyage to this faraway land. Just how far the American gaze remained from the European notion of the picturesque becomes clear to anyone who opens the book titled *Well-Worn Roads in Spain, Holland, and Italy. Traveled by a Painter in Search of the Picturesque*, by Francis Hopkinson Smith (1886).[24] Despite the author's professed quest for the picturesque, the short chapters comprising the book narrated only his encounters with local people in the south of Spain. As for beautiful vistas, they were completely lacking in this book, which had small vignettes of objects such as a guitar or architectural details such as an old door handle for its only illustrations.

Gutierrez, Print.

15

FELIX OCTAVIUS CARR DARLEY
AMERICAN, 1822–1888

Frontispiece, The Alhambra

1851 · Lithograph · 8⅝ × 6¹¹⁄₁₆ in. (21.9 × 17 cm) ·
From Washington Irving, *The Alhambra*, rev. ed. New York: G. P. Putnam

Chrysler Museum of Art, Jean Outland Chrysler Library

The Blinker soon returned with a huge piece of bread, and, seated in a stable doorway on my property, I proceeded to munch and munch and munch, while mounted orderlies dashed to

A dinner extraordinary.

and fro, wretched ambulance and baggage wagons passed by, and the dirtiest soldiers I ever beheld — Carlists excepted — stood about in groups, smoking and laughing. All were young, and all looked as though they had as much idea of discipline as a monkey has of the

Fig. 8 Anonymous, *A dinner extraordinary*, from Kate Field, *Ten Days in Spain*. Boston: J. R. Osgood and Company, 1875, p. 227. Widener Library, Harvard Library

Collecting the Picturesque

Toward the end of the nineteenth century, increasing mobility and growing transatlantic markets began to make traveling overseas and importing art and artisanry an essential component of a refined, opulent, "cosmopolitan" American persona.[25] Collecting photographed vistas from places one had traveled became all the rage for those who could afford a camera and a trip. Even those who couldn't afford such things now had access to printed photographic images. As the epitome of this new sensibility, Richard Kagan cites John L. Stoddard's immersive lectures, starting in the 1880s, that featured "light projections of photographs taken during his travels."[26] When published in the 1890s, Stoddard's lectures included quality reproductions of these photographs, some of which were hand-colored.

The Spanish-American War of 1898 may have put an end to America's century-long competition with Spain over the Caribbean, but it did not stop visitors from the victorious nation from touring the lands of its former foe. On the contrary: in the early years of the twentieth century, Americans' interest in Spain, Spanish art, and art dedicated to Spain was steadily growing. In her memoir, art collector Louisine Havemeyer maintained that "after the Spanish War we should have demanded the Prado as an indemnity instead of taking over the Philippines."[27] Boone uncovers the same intermingling of imperialist will and aesthetic interest in the 1903 edition of John Hay's *Castilian Days*, illustrated by Joseph Pennell.[28]

In early twentieth-century travel books, the avoidance of politics by instead paying homage to the beauty of or from a rival country—what we now might have called "art-washing"—took two main forms. First, the illustrations in travel books started catering even more to the habit of "collecting" both Spanish vistas and Spanish artwork. Second, travelogues were now illustrated with views—not genre scenes—from Spain produced by American artists. Both trends in illustrating Spain began before the war of 1898 and lasted through the end of the 1930s, the period that Richard Kagan identifies as the end of the "Spanish Craze." The paradoxical fact that not only sketches but also quality photographs and even prints from the modern medium of stereoscopic imaging were summoned to produce an impression of a land locked in the past finds an explanation in the peculiar interplay

between the real and the imagined that, according to Boone, underpinned American attitudes toward Spain at that time. In illustrated travel books, photography continued the "contradictory task of capturing artistic scenes that naturally exist in countries like Italy or Spain, considered picturesque by American travelers."[29]

It was around this time that American photographs began to replace genre scenes by domestic illustrators and vistas by foreign artists. Some of them were taken by the authors or someone traveling with them. As if amassing photographic views of Spain was not too far removed from collecting Spanish art, travel books authored by prominent art collectors were richly illustrated by such photographs, taken on the spot and perceived as a counterpart of the text. In 1897, Archer Milton Huntington, the future founder of the Hispanic Society of America in New York, authored *A Note-Book in Northern Spain*, which was accompanied by one hundred photographs, "many of which . . . [were] specially taken." Likewise, *Forgotten Shrines of Spain* by Mildred Stapley Byne (1926) came with sixty-seven photographs by her husband, Arthur Byne. At the time, the Bynes were famous for their own collection of Spanish art and artisanry and, even more so, for their assistance to the most prominent American collectors, from Huntington to William Randolph Hearst.[30]

The fact that in turn-of-the-century United States traveling to Spanish monuments, landscapes, and museums had indeed become inseparable from collecting artifacts is clearly evidenced by the travel books of the era, whose illustrations now ranged from photographs and reproductions from Spanish museums to copies of works by Spanish artists that were in American private collections. *The Land of the Castanet: Spanish Sketches*, published in 1896 by Hobart S. Chatfield-Taylor (who in 1892 had been named the Spanish consul at the Chicago Columbian Exposition), featured an anonymous image on the frontispiece that depicted a popular Spanish dance inside the courtyard of an Andalusian house (fig. 9). In a chapter published the same year in *The Cosmopolitan*, this image had been identified as a piece by "Turina."[31] Though its specific location was not given, a very similar piece by the same artist, *The Dance (El baile)*, is in a private collection. Other illustrations in Taylor's publication ranged from etchings of popular characters and costumes to photographs to general views and architectural details of Spanish works

by Velázquez and Francisco Pradilla, a creator of famous historical paintings.

Maud Howe Elliott's 1908 *Sun and Shadow in Spain* brought traveling and art appreciation even closer together with travel writing and art collecting. The book included not only photographs of Velázquez's paintings, Spain's churches and cathedrals, and figures of saints, bullfighters, and Romani people, but also reproductions of three paintings by José Villegas Cordero—a fashionable artist and, at the time, the director of the Prado—in whose house the author and her husband, artist John Elliott, had stayed in Madrid.[32] Two of Villegas's paintings were listed in the book as coming from the collections of the author's two friends, "Mrs. Larz Anderson" and "Miss Dorothy Whitner," while the third, *Death of a Matador*, was identified as being "in the possession of the artist." *Sun and Shadow* also featured an image of dancer, Pastora Imperio, in a triumphant, post-performance pose similar to William Merritt Chase's and John Singer Sargent's portraits of Carmencita [Carmen Dauset Moreno] a decade and a half earlier (fig. 10; see also cats. 16 and 17). A favorite of Spanish painters of the time, Imperio's image was an easily digestible, feminized symbol of Spanishness for American audiences and readers. Since the Andersons joined the author and her husband on this trip to Spain in 1906, it is very likely that this was also the occasion when they purchased a Villegas painting. As to the one not purchased and left "in the possession of the artist," it was, nevertheless, symbolically collected as a photograph in Howe Elliott's book.[33]

Other, more modest publications suggested that their authors also bring back collections, if not of original paintings, at least of postcards and etchings. The popular *Spanish Highways and Byways* by Katharine Lee Bates, published four times between 1900 and 1912, included forty photographic illustrations of landscapes, religious buildings, and figures of saints, alongside reproductions of classical and contemporary Spanish paintings.[34] Among them, one can identify a few images by Hauser y Menet, the photography studio known for its postcards featuring views of Spain and a series of paintings from Spanish art museums. The book also included a reproduction of a recent piece, *Off for the War! (¡A la guerra!)*, by Alberto Pla y Rubio (1895; Museo del Prado), which depicted Spanish soldiers leaving their families to go off to fight in a war; at the time, the painting was at the Museum of Modern Art in

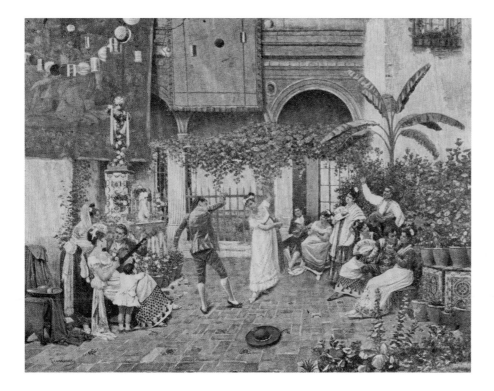

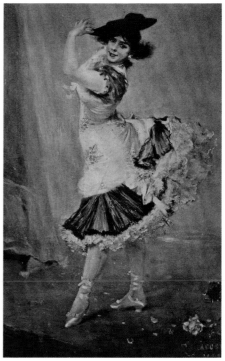

Madrid. Although a search of historical records does not identify any postcard featuring this painting, it was, however, reproduced in 1895 on a *separata* (a separate photo-typed sheet) that came with the magazine *Historia y Arte* and could thus have been circulating in Spain and abroad.[35]

Similarly, *Heroic Spain* (1910) by Elizabeth Boyle O'Reilly featured photos by Underwood & Underwood (a company known for its stereographs), other images without attribution with titles in Spanish, as well as photos of paintings from the Prado, which were available in several photographic series in Spain (fig. 11).[36] Even though most of the photographs were not taken by the authors, their publication suggested that the authors had purchased them and brought them home, thereby bringing Spain closer to the American audience. Thus, the inclusion of Rubio's painting (even though it was finished prior to the war) in Bates's book suggested a connection between a journey through Spain and the American readers' own recent past.

By the early 1900s, travel books about Spain were incorporating drawings of views by American artists, who also collaborated with the illustrated magazines. The popularity of illustrated travel essays had a liberating effect on pictorial representations of Spain, which now circulated uncoupled from specific books, thereby acquiring a life of their own. Such was the case of Walter Hale's

Fig. 9 Anonymous, Frontispiece for Hobart Chatfield-Taylor, *The Land of the Castanet: Spanish Sketches*. Chicago: H. S. Stone & Co., 1896. Widener Library, Harvard Library

Fig. 10 José Villegas Cordero, *Imperio* from Maud Howe Elliott, *Sun and Shadow in Spain*. Boston: Little, Brown, and Company, 1908, p. 408. University of Wisconsin-Madison

drawings for *Familiar Spanish Travels* by William Dean Howells. When the book came out in 1913, the same images were also published as illustrations for a different text, Harrison Rhodes's essay "A Bay of Biscay Watering-place" in *Harper's Magazine* (fig. 12).[37] Since Howells's book referred to a trip completed in 1911, we may assume that he simply borrowed several images from the magazine, of which he was also the editor. Still, we do not know whether Hale received a commission to illustrate the article, the book, or both—or whether he simply happened to draw these views of San Sebastián that later came to the attention of the author and magazine editor.

Howells's book also included several illustrations by Norman Irving Black, whose drawings from the same series were later used to illustrate another book: the 1915 edition of Washington Irving's *The Alhambra*. The selection of the sketches for each book was telling. While in the illustrations for Howells's travelogue Spanish monuments

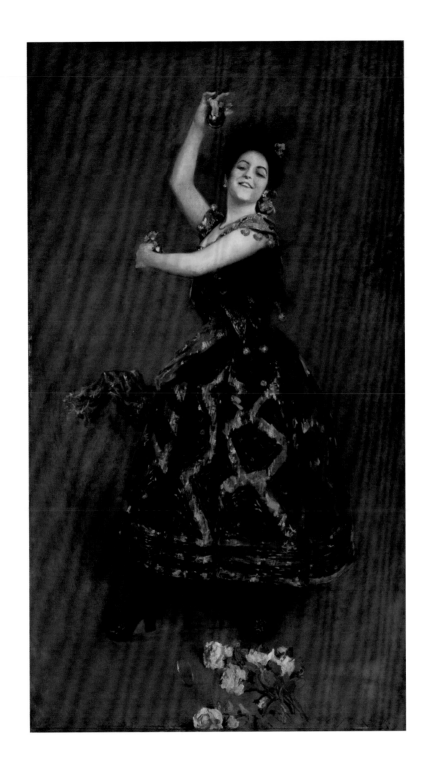

16

WILLIAM MERRITT CHASE
AMERICAN, 1849–1916

Carmencita

1890 · Oil on canvas · 69⅞ × 40⅞ in. (177.5 × 103.8 cm)

The Metropolitan Museum of Art, Gift of Sir William Van Horne,
1906, 06.969

50

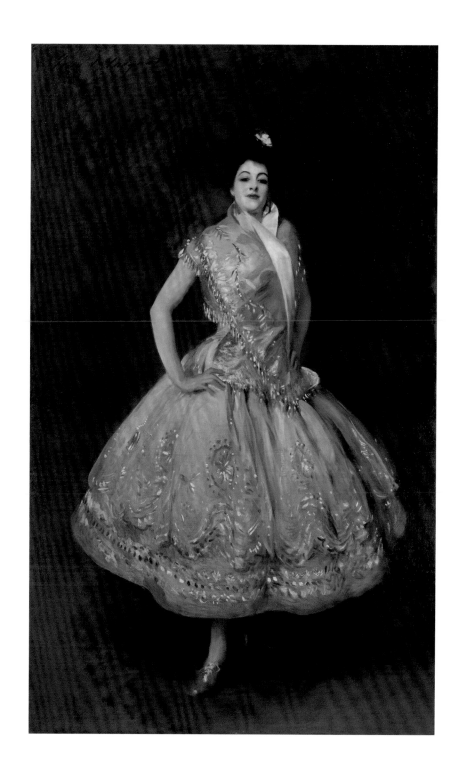

JOHN SINGER SARGENT

AMERICAN, 1856–1925

La Carmencita

1890 · Oil on canvas · 90 × 54¼ in. (228.6 × 134.22 cm)

Musée d'Orsay, Paris, RF746

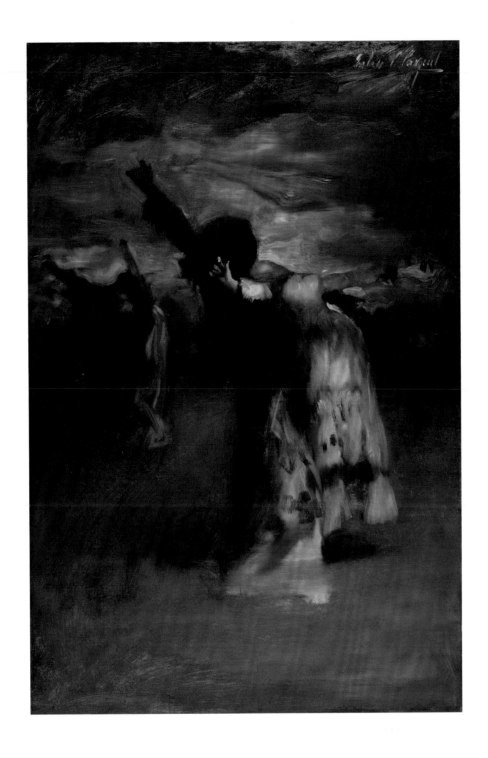

JOHN SINGER SARGENT
AMERICAN, 1856–1925

Study for 'Spanish Dance'

ca. 1879–80 · Oil on canvas · 28½ × 19 in. (72.3 × 48.2 cm)

The Nelson-Atkins Museum of Art, Kansas City, Missouri,
gift of Julia and Humbert Tinsman, F83-49

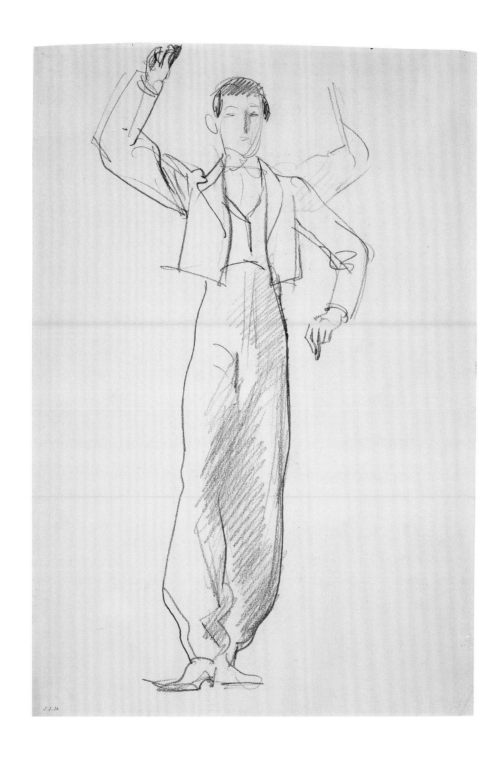

JOHN SINGER SARGENT
AMERICAN, 1856–1925

Untitled (Spanish Dancer)

ca. 1879 · Graphite on paper · 14½ × 10 in. (36.83 × 25.4 cm)

Milwaukee Art Museum, gift of Karen Johnson Boyd in honor of
Russell Bowman, M2002.68

A SPANISH HIDALGO, BY EL GRECO

THE SEA SWEEPS INLAND IN A CIRCLE OF BLUE, TO FORM THE ENTRANCE
TO THE HARBOR, SAN SEBASTIAN

Fig. 11 El Greco, *A Spanish Hidalgo*, frontispiece for Elizabeth Boyle O'Reilly, *Heroic Spain*. New York: Duffield and Company, 1910. From the American Geographical Society Library, University of Wisconsin-Milwaukee Libraries

Fig. 12 Walter Hale, *The Sea Sweeps Inland in a Circle of Blue, to Form the Entrance to the Harbor, San Sebastian*, in W. D. Howells, *Familiar Spanish Travels*. New York; London: Harper & Brothers, 1913. From the University of Wisconsin-Milwaukee Libraries

acted as framing for characters using old means of transportation—horses, donkeys, and mules—the majority of the drawings selected for Washington Irving's stories were views devoid of human presence, suggesting a space outside of time, rather than one locked in the past. Such an approach to illustrating *The Alhambra* had existed since the end of the nineteenth century. In 1896, a new Anglo-American edition came with drawings by Joseph Pennell, who at the time was working in London alongside James Abbott McNeill Whistler (see cats. 10, 13, and 14).[38] Although Pennell's drawings may have had some influence on Irving Black's work, the 1915 edition succeeded in bringing the stories from *The Alhambra* to the twentieth-century reader. Featuring a theater curtain, the cover of the book looked back at decades of imagining Spain as a stage full of exotic characters whom the reader was unlikely ever to meet. Inside, however, there was a map of the Alhambra, inviting the reader to follow the narrator's steps. Meanwhile, the drawings that focused on buildings and views established a connection between Irving's time and the reader's own (figs. 13, 14).

FROM THE NAPOLEONIC WARS UP UNTIL WORLD WAR I, travel books ensured a steady supply of the picturesque to the American audience, and Spain was one of its main sources. With each kind of illustration succeeded by another over the years, lithographed foreign vistas, domestic genre sketches, Spanish paintings, drawings by American artists, and even photography all strived to convey a peculiar form of beauty that did not take the viewers' breath away but rather inspired them to accept the trauma of their own modernizing societies. One should remember, however, that this adjustment through travel necessitated the continuous reproduction of the imagery of the beauty, history, and faith of Spain—a

PALACE OF THE ALHAMBRA

TO THE traveller imbued with a feeling for the historical and poetical, so inseparably intertwined in the annals of romantic Spain, the Alhambra is as much an object of devotion as is the Caaba to all true Moslems. How many legends and traditions, true and fabulous, — how many songs and ballads, Arabian and Spanish, of love and war and chivalry, are associated with this Oriental pile! It was the royal abode of the Moorish kings, where, surrounded with the splendors and refinements of Asiatic luxury, they held dominion over what they vaunted as a terrestrial paradise, and made their last stand for empire in Spain. The royal palace forms but a part of a fortress, the walls of which, studded with towers, stretch irregularly round the whole crest of a hill, a spur of the Sierra Nevada or Snowy Mountains, and overlook the city; externally it is a rude congregation of

[39]

Fig. 13 Map of the Alhambra, Washington Irving, *The Alhambra*. Boston: Ginn & Company, 1915. Widener Library, Harvard Library

Fig. 14 Text and illustrations by Norman Irving Black, Washington Irving, *The Alhambra*. Boston: Ginn & Company, 1915, pp. 37–38. Widener Library, Harvard Library

country whose customs were described as bizarre even as its vistas kept circulating and bringing pleasure to armchair travelers and profit to publishers.

This production and reproduction of carefully calibrated imagery turned into an "import operation" in several meanings of the term: "To bring or carry in from an outside source, especially to bring in (goods or materials) from a foreign country for trade or sale," as well as "To carry or hold the meaning of; signify [. . .] To express or make known, [. . .] To betoken or indicate."[39] Looking for ways to signify and express the strange and unique quality of Spain that would make their books attractive to an American reader, the publishers of the earlier travelogues in the United States imported foreign illustrations of the picturesque and attempted to craft something new, which they identified with theater-like scenes set in vaguely Oriental surroundings. It was, however, the industrial development of the late nineteenth and early twentieth centuries that allowed American travelers to define the Spanish picturesque as a combination of landscape, art, and backwardness. This was a beauty easy to import, since photography could capture the landscapes and money assisted in the importing of art. As for Spain's

backwardness, the country's government, which was now trying its hand at tourism, understood it as one of its major selling points. This image of Spain, persisting until now, was not unrelated to the cosmopolitan Americans' view of the picturesque: it was, after all, Huntington who financed Spain's first tourism development initiatives, championed by his friend the Marquis de la Vega-Inclán, which laid the foundations for Spain's self-identification in the international arena for decades to come.[40]

NOTES

*The author thanks Sally Anna Boyle for her editorial work on this piece.

1. August Wilhelm Schlegel, Lecture XXIX, "Spanish Theater," *A Course of Lectures on Dramatic Art and Literature by August Wilhelm Schlegel*, trans. John Black (London: H. G. Bohn, 1846), 500; see also Friedrich Schlegel, Lectures XI and XII, *Lectures on the History of Literature: Ancient and Modern, from the German of Friedrich Schlegel* (Edinburgh: W. Blackwood, 1818), vol. 2, 78–165.

2. Sarlo coined the term "modernidad periférica" to refer to countries like Argentina. See Beatriz Sarlo, *Una modernidad periférica: Buenos Aires, 1920 y 1930* (Buenos Aires: Nueva Visión, 1988). The classical study about tourism as a quest for authenticity is Dean MacCannell, *The Tourist: A New Theory of the Leisure Class* (New York: Schocken Books, 1976).

3. Alexandre de Laborde, *Itinéraire descriptif de l'Espagne: et tableau* élémentaire *des différentes branches de l'administration et de l'industrie de ce royaume* (París: H. Nicolle & Lenormant, 1808).

4. Antonio Ponz, *Viaje de España, o Cartas en que se da noticia de las cosas más apreciables y dignas de saberse que hay en ella*, 18 vols. (Madrid: Joaquín Ibarra, 1772–1794).

5. Alexandre de Laborde, *Voyage pittoresque et historique en Espagne par Alexandre de Laborde, et une société de gens de lettres et d'artistes de Madrid, dédié à son Altesse Sérénissime le Prince de la Paix* (Paris: P. Didot l'aîné, 1806–1818).

6. Richard Ford, *Handbook for Travellers in Spain and Readers at Home*, 2 vols (London: James Murray and Sons, 1845).

7. The author's personal conversation with Carmelo Medina Casado and José Ruiz Mas, coeditors of *Las cosas de Richard Ford: Estampas varias sobre la vida y obra de un hispanista en la España del siglo XIX* (Jaén: Universidad de Jaén, 2010).

8. [Alexander Slidell Mackenzie], *A Year in Spain, by A Young American*, 1 vol. (Boston: Hilliard, Gray, Little and Wilkins, 1829), 202.

9. M. Elizabeth Boone, "*Castilian Days*: John Hay, Joseph Pennell and the Obfuscation of Politics by Art," *Visual Resources: An International Journal on Images and Their Uses* 21, no. 4 (2005): 329–45.

10. Samuel Taylor Coleridge, *Biographia Literaria* (Oxford: The Clarendon Press, 1907), 173, capitalization in the original.

11. Cited in Pere Gifra-Adroher, *Between History and Romance: Travel Writing on Spain in the Early Nineteenth-Century United States* (Madison: Fairleigh Dickinson University Press, 2000), 35–36.

12. Thomas Roscoe, "To the Reader," *The Tourist in Switzerland and Italy* (London: R. Jennings, 1830), n.p.

13. William Gilpin, *Three Essays: On Picturesque Beauty, On Picturesque Travel and On Sketching Landscape: To Which Is Added a Poem, on Landscape Painting* (London: R. Blamire, 1792), 41–45.

14. "Advertisement," in Thomas Roscoe, *The Tourist in Spain: Andalusia* (London: R. Jennings, 1836), vi. In 1837, Roberts would publish a book of original drawings and watercolors, *Picturesque Sketches in Spain Taken During the Years 1832 & 1833 By David Roberts* (London: Hodgson & Graves, 1837).

15. Thomas Roscoe, "Preface," in *The Tourist in Spain and Morocco* (London: R. Jennings, 1838), v.

16. [Alexander Slidell Mackenzie] *A Year in Spain, by A Young American*, 2nd ed., 2 vols. (New York and Boston: G. & C. H. Carvill and Hilliard, Gray and Co, 1830); [Alexander Slidell Mackenzie] *A Year in Spain, by A Young American*, 2nd ed., 2 vols. (London: Murray, 1831). On Irving's role, see Gifra-Adroher, *Between History and Romance*, 102.

17. [Alexander Slidell Mackenzie] "Royal order excluding the Author from Spain," in *Spain Revisited by the Author of A Year in Spain* (London: Bentley, 1836), 329–330.

18. Washington Irving, "A Year in Spain," *Quarterly Review* 44 (February 1831): 319–322. Also quoted in Gifra-Adroher, *Between History and Romance,* 102.

19. By the end of the 1830s, Murray would become a monopolist for guidebooks for every part of the world.

20. Lady Maria Callcott, *A Short History of Spain* (London: Murray, 1828).

21. [Alexander Slidell Mackenzie] *A Year in Spain, by A Young American*, 2nd ed., 3 vols. (New York: Harper & Brothers, 1836).

22. Washington Irving, *The Alhambra*, illus. F. O. C. Darley (New York: G. P. Putnam, 1851), facs. ed. (Tarrytown, N.Y.: Sleepy Hollow Press, 1982). See also Richard L. Kagan, *The Spanish Craze: America's Fascination with the Hispanic World, 1779–1939* (Lincoln: University of Nebraska Press, 2019), 148.

23. See, for example, Colman's *The Hill of the Alhambra, Granada*, in *American Paintings in the Metropolitan Museum of Art*, vol. II, ed. Kathleen Luhrs (New York: Metropolitan Museum of Art, 1965), 351.

24. Francis Hopkinson Smith, *Well-Worn Roads in Spain, Holland, and Italy. Traveled by a Painter in Search of the Picturesque* (Boston and New York: Houghton, Mifflin and Co., 1886).

25. Inge Reist and José Luis Colomer, eds., *Collecting Spanish Art: Spain's Golden Age and America's Gilded Age* (New York: The Frick Collection, in association with the Centro de Estudios Europa Hispánica and the Center for Spain in America, 2012).

26. Kagan, *The Spanish Craze*, 152–153; see, for example, Charles Augustus Stoddard, *Spanish Cities; with Glimpses of Gibraltar and Tangier* (New York: C. Scribner's Sons,

1892) or the section on Spain in Charles Augustus Stoddard, *Lectures, Paris, la Belle France, Spain* (Chicago and Boston: Geo L. Shuman, 1898).

27. Aline B. Saarinen, *The Proud Possessors* (New York: Random House, 1958), 163. Louisine W. Havemeyer, *Sixteen to Sixty: Memoirs of a Collector* (New York: Privately printed, 1961), 130.

28. John Hay, *Castilian Days* (Boston/New York: Houghton, Mifflin & Co., 1903); see Boone, "*Castilian Days.*" Pennell, who worked with Whistler, was the illustrator of the 1896 edition of Washington Irving's *The Alhambra* (London, New York: Macmillan, 1896).

29. Boone, "*Castilian Days,*" 335.

30. Archer M. Huntington, *A Note-book in Northern Spain* (New York: Putnam, 1898); Mildred Stapley Byne, "Preface," *Forgotten Shrines of Spain* (Philadelphia and London: J. B. Lippincott Cp., 1926), v. About the clientele of the Bynes' Spanish antiquary business, see Kagan, *The Spanish Craze*, 290–294.

31. Hobart S. Chatfield Taylor, *The Land of the Castanet: Spanish Sketches* (Chicago: Herbert S. Stone & Company, 1896); Hobart S. Chatfield Taylor, "The Evolution of the Spaniard," *The Cosmopolitan* XX, no. 3 (July 1896): 238–246. The image is on page 242, identified as "Popular fête in the early XIX century." Joaquín Turina y Areal was the artist from Sevilla and the father of the composer Joaquín Turina.

32. Maud Howe Elliott, *Sun and Shadow in Spain* (Boston: Little, Brown, and Company, 1908). In 1916, Howe Elliott, together with her two sisters, would win a Pulitzer prize for her work on the biography of their mother, the abolitionist Julia Ward Howe.

33. On the Elliotts' connections to art collectors such as the Andersons and Isabella Gardner, see Nancy Whipple Grinnell, *Carrying the Torch: Maud Howe Elliott and the American Renaissance* (Hanover: University Press of North England, 2014), 112.

34. Katharine Lee Bates, *Spanish Highways and Byways* (New York: Macmillan, 1900).

35. *Historia y Arte, Revista mensual ilustrada* I, no. 4 (July 1895): n.p.

36. Elizabeth Boyle O'Reilly, *Heroic Spain* (New York: Duffield and Co., 1910).

37. Harrison Rhodes, "A Bay of Biscay Watering-place," *The Harper's Magazine* 127 (July 1913): 165–176.

38. Washington Irving, *The Alhambra*, ed. Edward K. Robinson, illus. Norman Irving Black (Boston: Ginn & Co., 1915).

39. *The American Heritage Dictionary of the English Language* (New York: Houghton Mifflin Harcourt, 2015).

40. Ana Moreno Garrido, "Come to Spain! America in Spanish Tourism Policy (1911–1954)," *Journal of Tourism History* 9, nos. 2–3 (2017): 193–204.

20

WASHINGTON IRVING

AMERICAN, 1783–1859

Tales of the Alhambra

1832 · Geoffrey Crayon [Washington Irving], 2 vols. London: Henry
Coburn and Richard Bentley

Milwaukee Art Museum Research Center

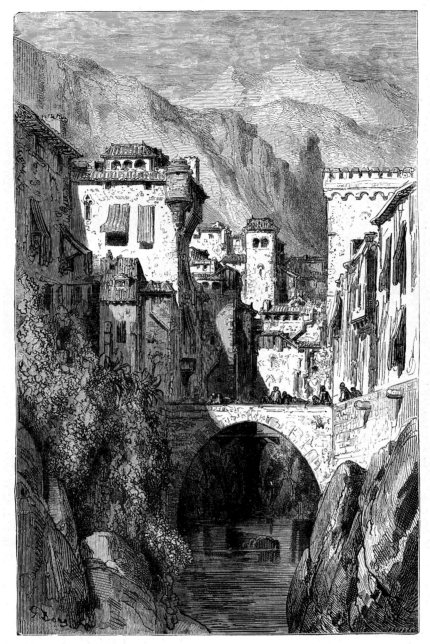

BANKS OF THE DARRO. *To face page 168.*

21

GUSTAVE DORÉ

FRENCH, 1832–1883

Banks of the Darro

1881 · Wood engraving · 13¹⁵⁄₁₆ × 10⅜ in. (35 × 26 cm) ·
From Jean-Charles Davillier's *Spain: Social Life and Customs,*
illustrated by Gustave Doré and translated by J. Thomson.
London: Bickers and Son

22

JOSEPH PENNELL

AMERICAN, 1857–1926

One of the Shabbiest Posadas
in Granada

1894 · Pen and ink on paper · 13 × 17½ in. (33.02 × 44.45 cm) ·
Study for Washington Irving, *The Alhambra*, 1896

Milwaukee Art Museum, gift of The Art Institute of Chicago, M1953.17

23

JOSEPH PENNELL

AMERICAN, 1857–1926

The Generalife, Granada

1894 · Pen and ink on paper · 11⅛ × 17½ in. (28.26 × 44.45 cm) ·
Study for Washington Irving, *The Alhambra*, 1896

Milwaukee Art Museum, gift of The Art Institute of Chicago,
M1953.19

24

JOSEPH PENNELL
AMERICAN, 1857–1926

Alhambra, Interior of the Tower of the Captive

1894 · Pen and ink on paper · 16½ × 9⅝ in. (41.91 × 24.45 cm) ·
Study for Washington Irving, *The Alhambra*, 1896

Milwaukee Art Museum, gift of The Art Institute of Chicago, M1953.20

JOSEPH PENNELL

AMERICAN, 1857–1926

In the Garden of the Generalife

1894 · Pen and ink on paper · 18¾ × 15¾ in. (47.63 × 40.01 cm) ·
Study for Washington Irving, *The Alhambra*, 1896

Milwaukee Art Museum, gift of The Art Institute of Chicago, M1953.18

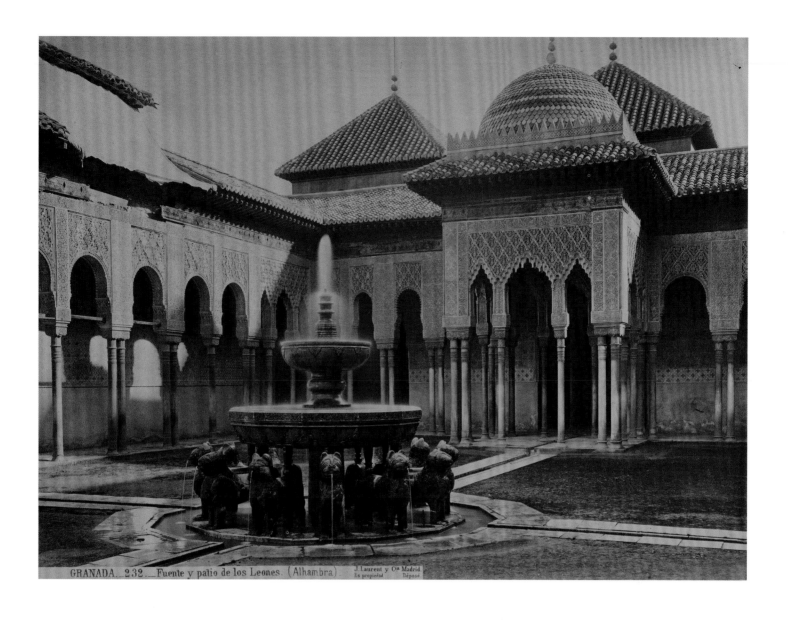

GRANADA. 232. Fuente y patio de los Leones. (Alhambra) J. Laurent y Cⁱᵃ Madrid
Es propiedad Déposé

26

JEAN LAURENT
FRENCH/SPANISH, 1816–1886

Granada—232. Fountain and Court of the Lions (Alhambra)

ca. 1870 · Albumen print from wet collodion negative · 9¾ × 13⅜ in.
(24.8 × 34.0 cm)

Chrysler Museum of Art, Museum purchase, 2018.38.2B

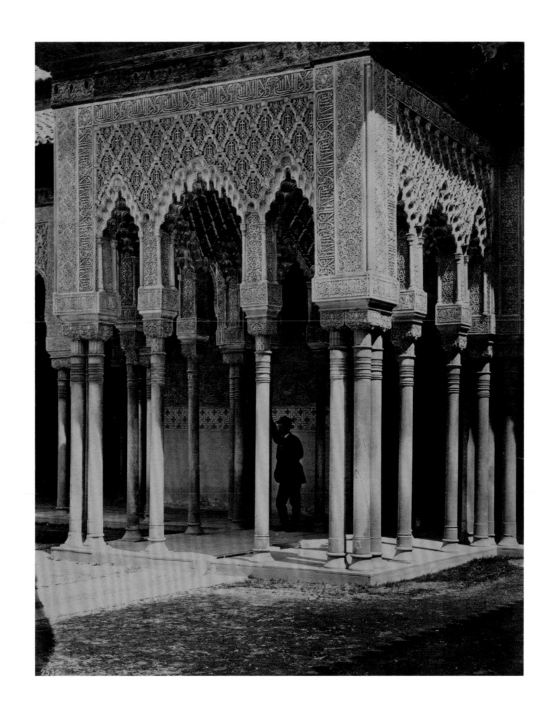

27

FRANCIS FRITH

ENGLISH, 1822–1898

Porch, Hall of Justice, The Alhambra Granada

ca. 1871 · Albumen print · 8 × 6½ in. (20.3 × 16.5 cm)

Chrysler Museum of Art, museum purchase in memory of Alice R.
and Sol B. Frank, 2019.27.1

MARY BRADISH TITCOMB
AMERICAN, 1858–1927

The Alhambra

ca. 1906 · Oil on canvas · 22¼ × 18¼ in. (56.52 × 46.36 cm)

Chrysler Museum of Art, Museum purchase with funds given in
memory of Joan Foy French by her daughters Wendy and
Christina, 2018.25.1

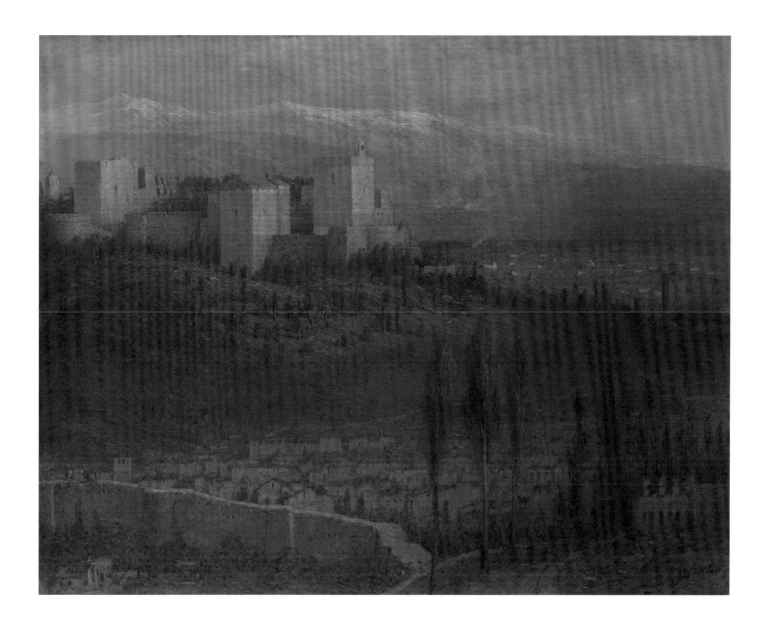

29

JOHN FERGUSON WEIR

AMERICAN, 1841–1926

The Alhambra, Granada, Spain

ca. 1901 · Oil on canvas · 36¼ × 46½ in. (92.1 × 118.1 cm)

The Metropolitan Museum of Art, Gift of David T. Owsley, 1964,
64.119

30

CARRIE HILL

AMERICAN, 1875–1957

View of Segovia

ca. 1925 · Oil on canvas · 36 × 30 in. (91.44 × 76.2 cm)

Birmingham Museum of Art; Promised gift of Dr. Julius E. Linn, Jr.

31

ERNEST LAWSON
AMERICAN, 1873–1939

Segovia

ca. 1916 · Oil on canvas · 20 × 25 in. (50.8 × 63.5 cm)

Minneapolis Institute of Arts, The John R. Van Derlip Fund, 39.54

JOHN SINGER SARGENT

AMERICAN, 1856–1925

Ilex Wood, Majorca

1908 · Oil on canvas · 22½ × 28 in. (57 × 71 cm)

Carmen Thyssen-Bornemisza Collection, on loan at the Museo
Nacional Thyssen-Bornemisza, Madrid

33

CHILDE HASSAM

AMERICAN, 1859–1935

Church Procession, Spain

ca. 1883 · Oil on canvas · 12½ × 17 in. (31.8 × 43.2 cm)

Private Collection

34

SAMUEL COLMAN

AMERICAN, 1832–1920

Gibraltar from the
Neutral Ground

ca. 1863–66 · Oil on canvas · 26⅛ × 36⁹⁄₁₆ in. (66.4 × 92.2 cm)

Wadsworth Atheneum Museum of Art, Hartford, CT, Gallery Fund,
1901.35

72

SEGOVIA.__ 382.__ Vista general del acueducto romano J. Laurent Madrid.

35

JEAN LAURENT

FRENCH/SPANISH, 1816–1886

Segovia—382. General View of the Roman Aqueduct

ca. 1870 · Albumen print on original mount · 9⅞ × 13¾ in. (25.1 × 34.9 cm)

Chrysler Museum of Art, Museum purchase, in memory of Alice R. and
Sol B. Frank, 2019.27.2

"The Most Picturesque Scenes Abound in the Lower Quarters"

AMERICAN ART AND SPANISH LABOR

Brandon Ruud

AS THE ESSAYS IN THIS CATALOGUE DEMONSTRATE, Spain offered nineteenth- and early twentieth-century visitors numerous attractions, from opportunities for study at Madrid's famed academies and museums to the Alhambra's renowned architecture, from the dramatic Sierra Nevada mountains to secluded courtyards. Travel narratives and tourist guides extolled—and occasionally lambasted—these places in both image and word, directing thousands of people to visit and experience them. Sometimes directly, sometimes opaquely, illustrators and writers mostly praised a variety of rural Spanish labor, but at other times ventured into factories, which they nonetheless tinged with folkloric flavor. In almost all cases, to be sure, the literary approach to labor was described in the most picturesque terms, as preindustrial and romantic, the antithesis of factories and mass production in the rest of western Europe and the United States— the very things, in fact, that many tourists came to Spain to escape. That artists and writers viewed Spanish working classes as charming and colorful is perhaps best attested by the Spanish travelogue written by Jean-Charles Davillier and illustrated by Gustave Doré, first published in 1876, one of the more expansive editions of its kind, which comprised a journey across the entirety of the country:

> The most picturesque scenes abound in the lower quarters of Madrid. First come the *barberillos* [*sic*; barbers], who shave their patrons in the open air. Then a *jarrero* [jar vendor] passes, laden with a number of earthen jars, beneath which he almost

disappears. Further the *carboneros* (colliers) weigh sacks of coke on a sort of steelyard, using them as a counterpoise by leaning on a long pole which raises the weighing apparatus clear of the ground.[1]

As the account attests, labor in Spain was something to be observed and enjoyed by the outsider, no matter how difficult or grueling, as a "picturesque" spectacle outside the debased factory system of the United States. While many of these writers may have intended their words and images to serve as catalysts for handcrafting or a celebration of tradition, they unintentionally, in the words of one scholar, constructed Spain "as a living relic of an earlier stage of cultural evolution, naturalizing—and thus perpetuating— the mechanizing impulses of American industrialism."[2]

Picturesque and Pastoral

In an 1896 travelogue through Seville written for the *Cosmopolitan,* Hobart Chatfield-Taylor, a biographer and novelist and the Honorary Consul of Spain in Chicago, surveyed on a carriage ride through the countryside the various forms of labor that one was bound to see and retold them to armchair tourists in rosy and romantic fashion:

> Women are washing in the streams, strings of donkeys come and go, their little backs bending under the weight of panniers and pottery; meek horses amble by bearing a man astride and a woman sidewise; goats, pigs, gipsy-girls dancing by the wayside, soldiers, beggars, a drunkard sleeping in

Fig. 15 David Roberts, *Old Buildings on the Darro, Granada*, 1834. Oil on panel. Victoria and Albert Museum, Given by John Sheepshanks, 1857, FA.175[O]

the sun, and beyond it all, to complete the picture, lie the green, rolling fields tufted with brown olive trees, the silvery river, and graceful Seville outlined against the blue sky, with her *giralda* and her fifty church towers, her lanky chimneys, and her glinting walls of white.[3]

Chatfield-Taylor's idealistic depiction of the rural working class serves as a near catalogue of the most popular subjects and themes that American artists employed when visually describing Spanish labor. Indeed, his brief line on laundresses has its visual analogue in a painting from another Andalusian city (albeit 150 miles eastward), Samuel Colman's *Washing Day, Granada* (cat. 36). Colman was one of the earliest artists from the United States to journey away from the mainstream European capitals and spend extensive time traveling through Spain. By 1862, he had begun sending his Spanish-themed paintings to the United States for exhibition at the National Academy of Design and the Boston Athenaeum Gallery, where they were warmly received.[4] In an 1864 review of one of his first paintings of Granada to be exhibited in the United States, in fact, the critic waxed rhapsodic about the canvas,

acknowledging Colman as "our most picturesque landscape painter, whose greatest successes have been in painting the splendors of a time and country not his own."[5] Colman returned briefly to the United States after the close of the Civil War, but by 1871 he was back in Europe, revisiting Madrid and Seville and then venturing into northern Africa.[6]

In *Washing Day, Granada*, Colman focused on one of the most picturesque and frequently depicted scenes in Spain: Granada's medieval district along the Darro River, framed by ancient architecture; the scene was a favorite with foreign artists from David Roberts to John Frederick Lewis (cats. 7 and 8). Although his multiple residencies in Spain lent his compositions an aura of authenticity, like many artists from the United States who traveled and painted there, Colman both owned and relied on images and travelogues for some of his compositions; he collected photographs by Charles Clifford, particularly those commissioned for Queen Isabella II's royal tour of Andalusia in 1862, and *Washing Day, Granada* shows a great resemblance to David Roberts's *Old Buildings on the Darro, Granada* (fig. 15).[7] To many tourists and their guidebooks, the Darro represented a fluid division between the

36

SAMUEL COLMAN

AMERICAN, 1832–1920

Washing Day, Granada

ca. 1872 · Oil on canvas tacked over panel · 30 × 40 in. (76.2 × 101.6 cm)

Private Collection

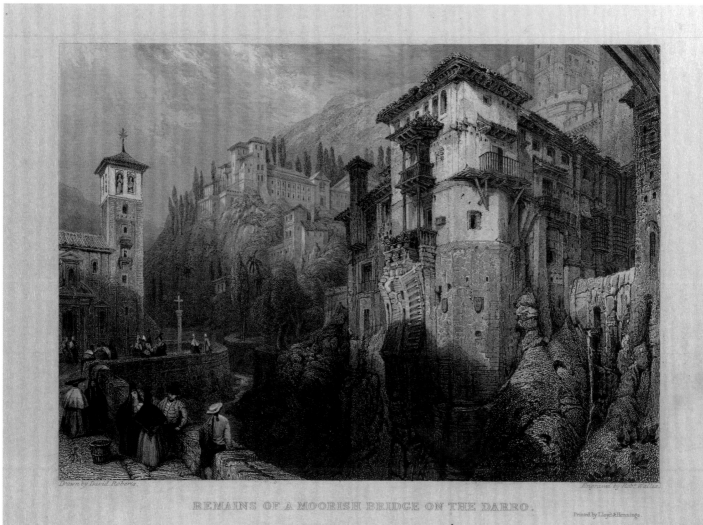

REMAINS OF A MOORISH BRIDGE ON THE DARRO.

London. Published Oct 28 1834 by Robert Jennings & Cº 62, Cheapside.

37

DAVID ROBERTS

SCOTTISH, 1796–1864

Remains of a Moorish Bridge on the Darro

1835 · Wood engraving · 9½ × 12½ in. (24.13 × 31.75 cm) ·
From Thomas Roscoe, *The Tourist in Spain. Granada.*
London: Robert Jennings and Company

Chrysler Museum of Art, Jean Outland Chrysler Library

38

CHARLES CLIFFORD

ENGLISH, 1821–1863

Untitled [Cathedral, Torre del Oro and Guadalquivir River, Seville]

1862 · Albumen silver print · 11⅝ × 15½ in. (29.5 × 39.4 cm)

The J. Paul Getty Museum, Los Angeles, 85.XM.367.2

Generalife on the right bank and the Albaicín, the historic Islamic district, on the left. Many tourist guides referred to people wading along the banks of the Darro, largely in search of the minute particles of gold that washed down the river.[8] With his brush, Colman translated such romantic scenes from a bygone era into one with contemporary yet quotidian associations: groups of women washing laundry along the banks of the river and then hanging them out to dry on nearby buildings. The picturesque nature of such scenes made them popular with American artists, particularly as they related to foreign cultures, and the "other," from African Americans and newly arrived urban immigrants on U.S. soil to French and Dutch peasants in Europe.[9]

If women "washing in streams" provided one visual representation of labor from Chatfield-Taylor's account, then the "strings of donkeys" that "come and go, their little backs bending under the weight of panniers and pottery" supplied another extremely popular subject, one that Robert Frederick Blum in particular milked to great advantage. Blum sailed for Europe in June of 1882, joining a party of artists that included William Merritt Chase, James Carroll Beckwith, Arthur Quartley, and Frederick Vinton, among others. Although the party split up after arriving in Paris, and only Blum, Chase, and Vinton traveled on together to Madrid, all these artists shared a passion for Spanish art and culture. The group held an honorary birthday party for Mariano Fortuny and painted a program in the ship captain's quarters in a "Fortunyesque style"; Beckwith himself was instrumental in promoting Hispanism in the United States, organizing and attending the performances given in New York by Carmen Dauset Moreno (also known as Carmencita).[10] The *Century Magazine* documented the trip in an article that included at least one illustration by each of the artists, including Blum's menu design for the Fortuny dinner.[11] Blum and Vinton spent several days in Madrid, where they visited the Museo del Prado and copied the works of Diego Velázquez and Jusepe de Ribera. Chase, who had spent much of the previous summer copying there, devoted most of his time to the outskirts of the city, making studies and painting outdoors. Blum and Vinton then left for Toledo, where Blum stayed for several weeks, and Vinton returned to Madrid.[12]

The journey outside the Spanish capital provided all three artists with the opportunity to paint directly from nature and introduced them to subjects not found in urban Madrid. This was Chase's second visit to the country. While he spent his first summer primarily in Madrid, painting at the Prado and creating drawings that were ultimately illustrated in George Parsons Lathrop's book, *Spanish Vistas* (cat. 67; see also Boone's and Piper's essays in this volume), this second visit found him traveling further afield and exploring new subjects: a series of bright landscapes of the environs of Madrid and Toledo that emphasized the country's preindustrial reputation but also, perhaps ironically, revealed changes to its culture and landscape. In both *Sunny Spain* (cat. 39) and *Outskirts of Madrid* (cat. 40), Chase emphasized the heat of the Spanish sun, the parched earth, and, to varying degrees, the architecture. In *Sunny Spain*, the more finished quality of which has led some scholars to suggest that it was completed in the artist's studio back in the United States, the commercial and ecclesiastic mix uncomfortably. The large crucifix on the side of the building at right (varyingly identified as the Convent of San Pablo or San Juan de la Penitencia) surveys the entire scene, looking down on the mercantile café advertising *vinos* above its entrance and, at left, the distant *cigarrales*, leisure estates situated at the south edge of the Tagus River outside Toledo.[13] Literally and figuratively caught in the middle is the muleteer at center, standing behind his animal and perhaps the denizen of the modest worker's cottage extending outward from the church.

Perhaps a more literal and sardonic view of the tension between the commercial and the industrial, the pastoral and traditional, is Chase's *Outskirts of Madrid*. A more suburban view identified as the southwestern edge of the capital, done either as Chase left with Blum and Vinton for Toledo or on his return to the city, this painting is rougher and more loosely handled than *Sunny Spain*; that, along with the inscription "August 1882," suggests that it was done on-site. The foreground conveys the seeming stability—in American eyes—of traditional Spain: a parched, barren earth where two women carry *cántaros* (jugs), one walking toward the city, the other at left, shielding her eyes and entering the picture plane; facing the viewer at left is a "scrawny Murilloesque urchin" handling a *cántaro* of his own; and entering the picture along the dusty path is a man riding the ubiquitous mule. Bursting in on this bucolic scene of the Spanish past is the ever-expanding city of Madrid, whose population (as Betsy

39

WILLIAM MERRITT CHASE
AMERICAN, 1849–1916

Sunny Spain

1882 · Oil on canvas · 19½ × 29 in. (49.5 × 73.7 cm)

Collection of Lois and Arthur Stainman

WILLIAM MERRITT CHASE
AMERICAN, 1849–1916

Outskirts of Madrid

1882 · Oil on canvas · 32 × 45¾ in. (81.3 × 116.2 cm)

Yale University Art Gallery, Gift of Duncan Phillips, B.A. 1908,
1939.265

Fig. 16 Robert Frederick Blum, *My Watercarrier*, n.d. Pen and ink on paper. Cincinnati Art Museum, Gift of Norbert Heermann, 1925.586

Boone has noted) doubled with new inhabitants, many of them laborers, between 1850 and the turn of the century, the same period when many artists from the United States visited.[14] The tension between the two systems is reinforced by the background smokestack at near center, which is framed between two church towers. Once again the industrial is squeezed between the religious, and yet portrayed as far off and seemingly distant.[15]

Similarly, in his travels outside of Madrid, and particularly in the time he spent in Toledo, Blum emphasized Spain's reputation for traditional, preindustrial labor rather than concentrate on the city's dramatic setting and medieval architecture. He produced multiple drawings and sketches while in Toledo, as well as finished paintings and studies that would act as models for later canvases completed back in his studio in the United States. According to his own accounts, Blum created a sensation by setting up his easel and painting the streets of Toledo. In a letter to Chase, Blum added a sketch he titled "My Spanish Admirers," showing the artist painting at an easel, crowded by a group of dazzled children.[16] Donkeys and *aguadors* (water carriers), however, were a favored theme for Blum, and he devoted many of his drawings and sketches to it (fig. 16). In *Toledo Water-Carrier* (cat. 41), he created an anecdotal, narrative genre scene of labor. To be sure, donkeys and water carriers have been a staple of the American imagination of Spain since Washington Irving first published his *Tales of the Alhambra* in 1832, in which he wrote whimsically of the phenomenon:

> The streets rang with his cheerful voice as he trudged after his donkey, singing forth the usual summer note that resounds through the Spanish town: "—Quien quiere agua—agua mas fria que la nieve?"—"Who wants water—water colder than snow? Who wants water from the well of the Alhambra, cold as ice and clear as crystal?" When he served a customer with a sparkling glass, it was always with a pleasant word that caused a smile; and if, perchance, it was a comely dame or dimpling damsel, it was always with a sly leer and a compliment to her beauty that was irresistible.[17]

Here, an *aguador* with *cántaro*-laden beasts of burden pauses on his delivery route, stopping outside the Casa

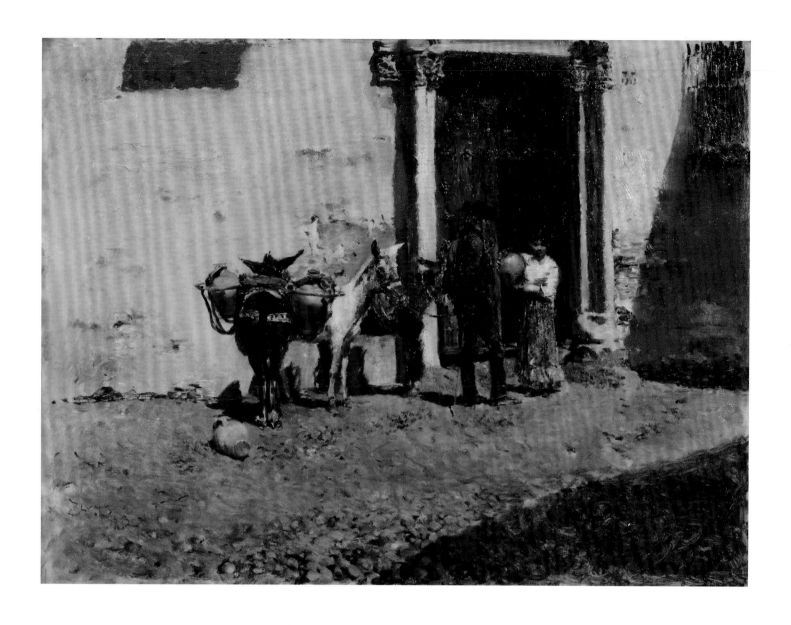

ROBERT FREDERICK BLUM

AMERICAN, 1857–1903

Toledo Water-Carrier

1882 · Oil on panel · 11¾ × 15¾ in. (29.85 × 40 cm)

Baker/Pisano Collection

Figueroa on the calle de Santa Isabel to chat with a young woman who has just received her water supply. Blum's painted version of the scene gives visual description to Irving's written one, though while the water carrier turns and directly addresses the "comely dame," she turns away from him, gazing openly at the viewer. Is the scene one of a possible flirtation, a typical feature of such interactions in American genre paintings of the time?[18] Is she conscious of being watched and thus turns her attention away from the water carrier, catching your gaze instead? Faced with such American narrative scenes where labor is domestic and routine—and thus not part of the incorporated labor system—audiences and critics subjected female workers to sexual comments, describing such scenes in both romantic and sentimental, as well as ribald and vulgar, terms: a "flirtation" or a "saucy" story, for example.[19] In these written accounts, perhaps not surprisingly, most writers emphasized the woman's sexuality over that of the man's, using terms like "coquettish lass" or "coquettish-looking maiden" to describe the woman in the scene.[20] This reaction underscores the vulnerability for laboring women—whether domestic or industrial. Like many painters, Blum claimed a relationship with the worker, thus one that seemed to give license for more intimate depictions. In a letter to Chase, written after the former had departed for the Netherlands, Blum remarked: "I have fallen in with a water carrier & consequently shall stay here another week."[21] These episodes also suggest how the intersections of class, gender, and race influenced the way artists addressed the depiction of labor.

In Blum's *Toledo Water-Carrier*, the wall and the tall doorway operate as a barrier between public and private areas. Doorways and portals proved decisive spaces, ones in which the private and the public blurred; interior settings, Spanish courtyards in particular, provided American and European artists alike with numerous opportunities for picturesque narrative interpretations. Blum's *Spanish Courtyard*, one of the paintings that the artist executed back in the United States based on his Spanish studies, offers another example of domestic labor peppered with anecdote (cat. 42). As Bruce Weber has noted, *Spanish Courtyard* recalls similar paintings of such enclosures by Mariano Fortuny: people engaged in conversation sitting in a brightly lit garden courtyard, barely "pictorial elements and little more" amid the wealth of architectural

detail and a profusion of plants.[22] In Blum's painting, a group of women seated around a courtyard fountain busily attend to their sewing, while a man dressed in black leans forward on his chair, assertively addressing the object of his affections as she demurely concentrates on her task.

This division between private and public space also invaded scenes of (private) domesticity and (public) labor, and it extends to John Singer Sargent's *Moorish Courtyard* (cat. 44). A near obsession with nineteenth-century travelogues and tourists, the Casa del Chapiz appeared in several guides; even the immensely popular (and terse) Baedecker guide of 1898 described the house in classist terms: "a mansion erected in the 16th cent. in the Mudéjar style for two wealthy Moriscoes. It possesses two separate patios, and is now occupied by several poor families."[23] Tourist photographs and travel guides reinforced this view of the house, often featuring a lone figure seated or standing amid the ramshackle northern patio (the favored view of artists and writers) or among the implied byproducts of domestic labor: laundry hanging on lines or over balcony rails; caged poultry; and upturned ollas and braziers (cat. 43; figs. 17 and 18).[24] Sargent took this description one step further in his *Moorish Courtyard*, adding a pair of donkeys to the mix of braziers and cages. In spite of his loose approach to the painting, Sargent still managed to capture a wealth of detail, from the cobblestone pavement to the mihrab that serves as the background focal point. In a scrapbook he compiled between around 1874 and 1880, a period that coincides with his first significant trip to Spain as an artist in 1879–80, Sargent included several reproductions of paintings by Spanish old masters, along with tourist photographs of the Alhambra and other Islamic architectural details. He may have relied on these images, in addition to his own sketches and drawings, when creating paintings such as *Moorish Courtyard*.[25]

Mechanized yet Saucy

If *aguadors* and donkeys provided artists and tourists alike with scenes of picturesque, preindustrial labor in Toledo, just outside the metropolis of Madrid, Seville's tobacco factory offered visitors a vision of romantic mechanization—handcrafted production on a mass scale. Described as the most commonly visited site in Spain, the

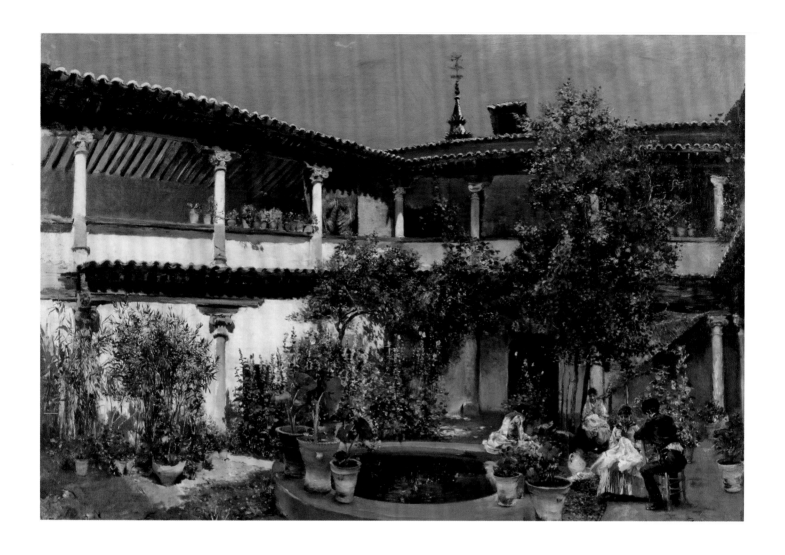

42

ROBERT FREDERICK BLUM

AMERICAN, 1857–1903

Spanish Courtyard

1883 · Oil on canvas · 29⁵⁄₁₆ × 40³⁄₈ in. (74.5 × 102.6 cm)

Cincinnati Art Museum, Gift of Joni Herschede and Museum
Purchase with funds from the Fanny Bryce Lehmer Endowment,
2002.104

GRANADA.__2191.__Patio de una casa morisca en el Albaycin. J. Laurent y Cⁱᵉ Madrid Es propiedad. Déposé

43

JEAN LAURENT

FRENCH/SPANISH, 1816–1886

Granada—2191. Patio of a
Moorish House in the Albaicín

ca. 1863 · Albumen print · 19⁵⁄₁₆ × 15³⁄₈ in. (49 × 39 cm)

Victoria and Albert Museum, E.2966-1995

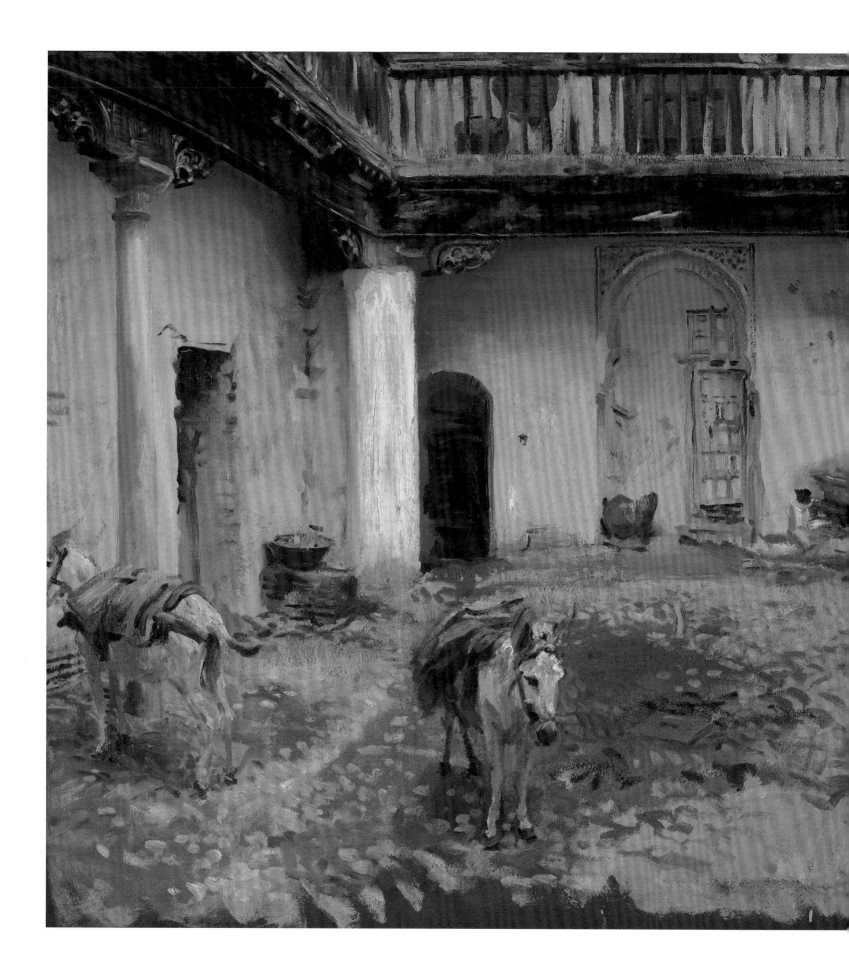

JOHN SINGER SARGENT

AMERICAN, 1856–1925

Moorish Courtyard

1913 · Oil on canvas · 28 × 36 in. (71.1 × 91.4 cm)

Myron Kunin Collection of American Art, Minneapolis, MN

Fig. 17 Treviño and Arroyo, *Casa del Chápiz*, 1910. Photograph, old positive. Museo Sorolla, nº inv. 83693

Fig. 18 Austin Whittlesey, *Granada–Casa del Chapiz*, from Bertram Grosvenor Goodhue, *The Minor Ecclesiastical, Domestic, and Garden Architecture of Southern Spain*. New York: Architectural Book Publishing Co., P. Wenzel and M. Krakow, 1917, p. 73. From the University of Wisconsin-Milwaukee Libraries

Real Fábrica de Tabacos de Sevilla was a staple of travel writers throughout the nineteenth century and even into the early twentieth. A seemingly infinite series of guidebooks and periodicals included the tobacco factory among the "must-stops" in their travelogues, and many writers were overwhelmed by the experience. One portrayed the transition from the "fairy scene" of Seville's Alcazar to the workfloor of the tobacco factory as "like nothing on this planet. Put your hand into a pitcher of hot water and quickly plunge it into another of cold, and the change will not be a whit more strange than to pass from the beautiful Alcazar to the presence of five thousand young girls, all in one room."[26] Even early on in the history of tourist narratives of Spain, novelist and poet Théophile Gautier, writing on his 1840 journey through the country, made a point of stopping to see the factory; but, like many a writer after him, he emphasized the largely female workforce in chauvinistic and even prurient terms:

> We were taken to the work-rooms where the leaves are rolled into cigars. As soon as we were taken in the room, we were assailed by a hurricane of noise: they were all talking, singing, and quarreling at the same time. I have never heard such an uproar. They were for the most part young, and some of them were very pretty. The extreme negligence of their dress enabled one to appreciate their charms in full liberty.[27]

The tobacco factory and the city of Seville also gave artists and writers license to make specific comparisons with its most famous Spanish painter, Bartolomé Esteban Murillo, and draw general parallels between his famous ragged street urchins and tobacco workers and laborers.

In the 1890 issue of *Mataura Ensign*, a regional New Zealand periodical (a sure sign of the tobacco industry's nearly global repute), one writer described the tobacco factory as "one of the sights of Seville which no tourist misses." After gaining permission to enter, the tourist is accompanied by a matron, "not in order to prevent girls from flirting with them (nothing could do that), but to see that no tobacco or bundle of cigarettes may disappear." In fact, the anonymous author—presumably male—spends considerable time on the gender and the perceived blatant sexuality of the factory workers:

> These girls are more frank than subtle in their flirtations. There is not one in the crowd who will not be immediately conscious of a man's gaze fixed upon her, nor will she be the first to turn her eyes away. Some will wink, and even throw a kiss from a distant corner at the rich *Inglese* (all foreigners are supposed to be wealthy Englishmen).[28]

The writer further suggests that the results of these women's aggressive sexuality are displayed along the factory walls: "passages are lined with cradles, and the poor young girl mothers to whom they belong implore us with eyes and hands for a penny for the Murillos of the future lying in them." The writer's reference to the great Spanish baroque painter would not have been lost on the cultivated audience, who would have appreciated the connection between Murillo's famous beggars and street urchins in reference to the workers' own panhandling.

As these episodes suggest, the sexuality of the female workers was a main feature of the travel writer's concern and of the tourist's gaze and one that needed constant reiteration. Gendered, sexualized comparisons to the famous protagonist of Georges Bizet's 1875 opera, *Carmen*, were, in fact, a common and oft-repeated trope in written descriptions of Spain's cigar and cigarette industry. In an 1885 article for the *Catholic World*, the anonymous writer spent several pages describing Sevillian industries, from the cannon and copper foundries to a large porcelain manufactory run by an Englishman. The author, however, devoted much of his attention to the "great government tobacco-factory, close by the cathedral, where no fewer than five thousand females are employed."[29] He described in detail the "enormous barrack" with its "whitewashed halls, divided into colonnades" and "guarded by soldiers," but he made it clear from the outset that the real "sight is the workwomen," referring to them as "spirited hoydens," "saucy cigarreras," and "Carmens."[30] Bizet's popular character provided an almost universal touchstone for brazen female sexuality, just as Pierre Beaumarchais's and Gioachino Rossini's Sevillian barber Figaro provided a common male paradigm of intrepidness, as well as other comedic Spanish archetypes (cat. 45). By the end of the nineteenth century, even illustrated travel pictorials used these popular operas as shorthand for descriptions of Spanish characters and types.[31]

But even before the debut of Bizet's opera, the *cigarrera* was an object of fascination and sexualization. An 1860 article from the *Merchants' Magazine and Commercial Review* lamented, in effect, the disappearance of the Orientalist fantasy of womanhood, which was part and parcel of the touristic appeal of the Andalusian province:

> They form a pleasant gipsey [*sic*] encampment to look at as you take them in a *coup d'oeil* from one end of the hall, with their red and yellow head-cloths, strange colored turbans and impromptu coquettish draperies twisted and bound round their coarse, full-blooded faces. We see no more the old mantilla that the ancient *cigarrera* wore, and which was an eastern sort of disguise, such as the Scripture women had, and as such you still see in the half Moorish town of "Tarifa." It was crossed over the face and bosom, and was a provoking, enticing, love-making sort of disguise, that left only the signal making eyes and candid forehead visible.[32]

Similarly, Chatfield-Taylor's extensive story on Seville paid scant attention to the industry, mentioning only in passing and toward the end of the article the "huge tobacco factory, where five-thousand ugly, dirty women, vaunted as beautiful, roll cigars and cigarettes, and nurse their sickly babies" (fig. 19).[33]

American painter Walter Gay's 1895 atmospheric composition *Cigarette Girls, Seville* (cat. 46, and detail pg. 74) is both the visual confirmation of the architecture and refutation of the gendered descriptions, equal parts invented fantasy and pictorial record. Gay, an expatriate living in Paris and most noted for his paintings of opulent

45

JOSÉ JIMÉNEZ ARANDA
SPANISH, 1837–1903

Figaro's Shop

1875 · Oil on wood panel · 17 $\frac{5}{16}$ × 22 $\frac{5}{8}$ in. (44 × 57.4 cm)

The Walters Art Museum, Baltimore, Maryland, 37.4

Fig. 19 Gustave Doré, *Cigarerras at Work in the Fabrica de Tabacos of Seville*, from Jean-Charles Davillier, *Spain: Social Life and Customs*. London: Bickers and Son, 1881, p. 250. From the American Geographical Society Library, University of Wisconsin-Milwaukee Libraries

French interiors, visited Spain in the spring of 1878, and then in 1894 and 1895 produced two large-scale versions of Seville's Royal Tobacco Factory (fig. 20).[34] In the painting at Colby College, the artist depicts the vast, arched, and cavernous factory where mostly young women work at row after row of tables—receding into the distance—rolling cigarettes. In both versions, Gay endowed the paintings with picturesque qualities: light floods the canvases, pouring through arched windows and along colonnades. While several women work, others stop to chat, share letters, recline in boredom, or gaze upon their sleeping children, cozily cradled at their feet.

Contemporary accounts of the factory building match Gay's painterly reportage: "The interior consists of long, whitewashed halls, divided into colonnades by rows of pillars, from which spring vaulted ceilings."[35] As Lou Charnon-Deutch has noted, however, nineteenth-century tobacco factory workers would hardly have identified with or recognized the activity in Gay's interpretations.[36] The vibrant reds and rosy pinks that dot the Colby painting lend a striking touch, and the red rose behind the ear of the foreground figure encourages associations with the doomed, seductive heroine of Bizet's opera—and

thus all Spanish women generally.[37] In addition, a group of women at far right disrobe, an unlikely activity in the openness of the workroom, especially one open to (male) tourists, furthering the canvas's aura of sexual suggestiveness and providing an antidote to the modestly covered, shawl-clad women in the foreground. Perhaps most importantly, the painting evokes a serene, preindustrial working environment, one in which employees are bathed in light and air, leisurely rolling cigarettes by hand and taking breaks or relaxing as it suited their moods. Gay's visual description—and the attention showered on the Sevillian cigarette factory by artists, diplomats, travel writers, and tourists—neatly defines the ways in which labor for non-whites, women, and children was addressed in the postindustrial era: as a preindustrial spectacle and a potential peril for the morally undeveloped or irresponsible. Indeed, as the twenty years' worth of descriptions of the Sevillian tobacco factory demonstrate, female shop workers were almost always discussed in sexual terms, whether as flirtatious fortune hunters, sexually active "Carmens," or even, in one instance, "dirty" and "ugly."

Fig. 20 Walter Gay, *Las Cigarerras*, 1894. Oil on canvas. Goya Museum, Castres, France, Musée d'Orsay, RF 892

Conclusion

Nineteenth- and early twentieth-century depictions of Spanish labor embodied aims that were multiple, complex, and sometimes contradictory. Even as artists, critics, and reformers imagined labor as a potential peril to the working class in the United States, they presented it as a visible, narrative spectacle to middle- and upper-class tourists in Spain. On the one hand, paintings and travelogues conveyed and encouraged the values of entrepreneurism, hard work, and innovation; on the other hand, they provided cautionary lessons and parables about the vulnerability of working women—if not the very real mental or physical risks posed by most factory work at the turn of the century. Perceived as intuitive and spiritual, without cheapness or degradation, Spanish craft reminded privileged viewers of what labor could be, anaesthetizing them to the brutal realities of work in the factory or on the street. Further, while artists may have intended their images to serve as catalysts for a national celebration of Spanish labor, they unintentionally, in the words of one scholar, constructed "a living relic of an earlier stage of cultural evolution, naturalizing—and thus perpetuating— the mechanizing impulses of American industrialism."[38] In that regard, text and image often collided: travel literature magnified the perils for women workers, who were constantly being observed and scrutinized; at the same time, these paintings diverted viewers' attention from not only the topics of America's own immigration, industrialization, and urbanization, pacifying them through rosy-cheeked "Carmens" and *jugerros*, whose smiling countenances comforted observers in the galleries and assured them that the political and social order was indeed secure.[39]

46

WALTER GAY

AMERICAN, 1856–1937

Cigarette Girls, Seville

1895 · Oil on canvas · 50⅛ × 67⅜ in. (127.3 × 171.1 cm)

Colby College Museum of Art, Waterville, ME, Gift of
Mr. and Mrs. Bronson Griscom, 1968.008

NOTES

1. Jean-Charles Davillier, *Spain: Social Life and Customs*, trans. J. Thomson, illus. Gustave Doré (London: Bickers and Son, 1881), 414.

2. Emily Dana Shapiro, "Machine Crafted: The Image of the Artisan in American Genre Painting, 1877–1908," (Ph.D. diss., Stanford University, 2003), 99.

3. H. C. Chatfield-Taylor, "Seville, The Fair," *The Cosmopolitan: A Monthly Illustrated Magazine* 21, no. 1 (May 1896): 8–9.

4. For lists and records of some of these exhibitions, see Boston Atheneaum, *Catalogue of the Thirty-Ninth Exhibition of Paintings and Statuary at the Athenaeum Gallery* (Boston: Fred Rogers Printer, 1863), 314; *The Torre del Vino*; Boston Atheneaum, *Catalogue of the Forty-First Exhibition of Paintings and Statuary at the Athenaeum Gallery* (Boston: Fred Rogers Printer, 1865), 318; *Gate of Viberambla*. See also Maria Naylor, ed., *The National Academy of Design Exhibition Record: 1861–1900, In Two Volumes* (New York: Kennedy Galleries, Inc., 1973): 177–79.

5. "Art: Exhibition of the National Academy of Design," *The Round Table: A Saturday Review of Politics, Finance, Literature, Society and Art* 1, no. 21 (May 7, 1864): 326.

6. For contemporary sources on Colman, see G. W. Sheldon, *American Painters* (New York: D. Appleton and Company, 1881): 72–76. For a more recent, thorough review, see Wayne Craven, "Samuel Colman (1832–1920): Rediscovered Painter of Far-Away

Places," *The American Art Journal* 8, no. 1 (May 1976): 16–37.

7. Colman traveled through Europe and North Africa for nearly four years beginning in 1871, although it is unknown if Granada was on his itinerary; regardless, the painting is clearly a studio production. See Craven, "Samuel Colman," 27. Colman collected photographs during his journeys through Spain, including two by Charles Clifford that are now housed at the Getty: *The Albaicin Viewed form the Alhambra* and Untitled [Cathedral, Torre del Oro and Guadalquivir River]. Colman donated these to the National Academy of Design, who subsequently deaccessioned them in the 1980s. Although known today as *Washing Day, Granada*, it is likely the painting exhibited in 1872 as *On the River Darro, Granada*. See *Catalogue of Messrs. Samuel Colman and Geo. H. Hall's Entire Collection of Paintings & Watercolors*, exh. cat. (New York: Somerville Art Gallery, 1872), cat. no. 52.

8. See, for example, Albert F. Calvert, *Granada: Present and Bygone* (London: J. M. Dent and Company; New York: E. P. Dutton and Company, 1908), 219.

9. In her groundbreaking work on American genre painting, Elizabeth Johns effectively described this tendency by artists to classify, remarking particularly that "women, too, of all social classes both black and white, were an 'other.' Like black men, they enjoyed neither

economic nor social power." See Johns, *American Genre Painting: The Politics of Everyday Life* (New Haven: Yale University Press, 1991), 11, 19–20.

10. For a more complete description of the shipboard activities and the art created, see Bruce Weber, "Robert Frederick Blum (1857–1903) and His Milieu" (PhD diss., The City University of New York, 1985), 170–74; for Beckwith's experience and interactions with Carmencita, as well as Sargent's painting of her, see Jo Labanyi, "The American Connection: Sargent and Sorolla," in *The Spanish Night: Flamenco, Avant-Garde and Popular Culture 1865–1936*, ed. Ángel González et al., exh. cat. (Madrid: Museo Nacional Centro de Arte Reina Sofía, 2008), 98–99.

11. Clarence C. Buel, "Log of an Ocean Studio," *The Century* 27 (January 1884): 356–371.

12. Different scholars have published different itineraries for the trio of artists. Bruce Weber, for example, wrote that after three weeks in Madrid, the group traveled together to Toledo, with Chase quickly returning to Madrid alone and Blum and Vinton staying on together. See Weber, "Robert Frederick Blum," 177–78; in her more recent treatment, Betsy Boone suggests that while Chase was "busy painting landscapes," Blum and Vinton stayed in Madrid, copying at the Prado. See Boone, *Vistas de España* (New Haven: Yale University Press, 2007), 158. The Prado's copyist

register confirms this latter point: records for July and August 1882 show that Vinton and Blum were in the galleries on July 5; Vinton returned on July 8; and then again on August 22. See *Registro de copistas correspondiente a los años 1873 a 1881*, Archives, Museo Nacional del Prado, and *Registro de copistas correspondiente a los años 1882 a 1886*, Archives, Museo Nacional del Prado, though Blum's last name is possibly listed as "Cuni." The registers are also listed in Boone, *Vistas de España*, Appendix B, 214–19.

13. The possible identification of the building was provided by José Pedro Muñoz Herrera in communications with Besty Boone, who recognized the background *cigarrales*. See Boone, *Vistas de España*, 154, 246n44.

14. Boone, *Vistas de España*, 154.

15. For additional paintings that Chase completed during this sojourn between Madrid and Toledo, as well as additional interpretation on these two, see Ronald G. Pisano, *William Merritt Chase, Landscapes in Oil: Complete Catalogue of Known and Documented Work by William Merritt Chase (1849–1916)*, vol. 3 (New Haven: Yale University Press, 2009), 17–19, cats. L.22 and L.29.

16. Robert Frederick Blum to William Merritt Chase, *My Spanish Admirers* (Letter Fragment), August 21, [1882], pen and black ink, Cincinnati Art Museum, Museum Purchase, Folsom Fund, 1916.194.

17. Washington Irving, *Tales of the Alhambra* (London: Chatto and Windus, 1875), 156.

18. Many of these comments were directed at the works of mid-nineteenth-century and Civil War–era artists and their depictions of interaction between men and women; see, for example, Barry Gray, "John Rogers, The Sculptor," *New York Times*, November 25, 1862, Scrapbook, vol. 3, John Rogers Collection, New-York Historical Society.

19. For "saucy" and "flirtation," see *Springfield Republican* (March 1862), Scrapbook, vol. 3, Rogers Collection, New-York Historical Society; see also, most recently, Kirk Savage, "John Rogers, the Civil War, and 'the Subtle Question of the Hour,'" in *John Rogers: American Stories*, ed. Kimberly Orcutt, exh. cat. (New-York Historical Society, 2011), 65.

20. For "coquettish lass," see *Boston Post*, May 24, 1862, and for "coquettish-looking maiden," see *New York Times*, April 1862.

21. Robert Frederick Blum to William Merritt Chase, Toledo, August 28 [1882], Cincinnati Art Museum, Gift of Norbert Heermann. Blum had a habit in his personal correspondence of claiming possession over Spanish people and workers, describing them as "My Admirers" or "My Water Carrier," thus furthering the hierarchical nature of American tourism and Spanish labor. See also Robert Frederick Blum, *My Spanish Admirers* (Letter Fragment), August 21

[1882], pen and black ink, Cincinnati Art Museum, Museum Purchase, Folsom Fund, 1916.194, and Blum, *My Watercarrier*, pen and ink, Cincinnati Art Museum, Gift of Norbert Heermann, 1925.586.

22. Weber, "Robert Frederick Blum," 179–80.

23. Karl Baedecker, *Spain and Portugal: Handbook for Travelers* (Leipzig and London: Karl Baedecker/Dulau and Company, 1898), 343.

24. Austin Whittlesey, with a preface by Bertram Grosvenor Goodhue, *The Minor Ecclesiastical, Domestic, and Garden Architecture of Southern Spain* (New York: Architectural Book Publishing Co., P. Wenzel and M. Krakow, 1917), 72–75.

25. John Singer Sargent, Scrapbook, ca. 1874–80, Metropolitan Museum of Art, 50.130.154; see, for example, page 5 verso and page 53 verso for photographs of paintings by Fortuny; page 20 (inserted), pages 21 recto and verso, page 22 verso, page 23 (inserted), and page 24 recto for the Alhambra; page 34 verso, page 47 verso, page 48 recto and verso, page 49 verso, page 50 recto and verso, page 51 recto, page 52 recto and verso, and page 53 recto for photographs of paintings by Spanish old masters, primarily Velázquez and Goya; page 54 verso, page 55 recto for select photographs of Madrid and Toledo; and pages 57 and 58 recto for Islamic architectural and ornamental detail. Perhaps not surprisingly, the album also contains photographs

of labor, including beasts of burden and *jarreros*.

26. "Great Tobacco Factory of Spain," *Flag of Our Union* 22, no. 22 (June 1, 1867): 340.

27. Ibid.

28. "Seville's Cigarette Girls," *Mataura Ensign* 1, no. 977 (May 9, 1890): 2.

29. "Delectable Seville," *The Catholic World: A Monthly Magazine of General Literature and Science* 41, no. 246 (September 1885): 729.

30. Ibid.

31. In a particularly notable example, an author described *chulos* and *banderilleros* in a bullfight as "costumed exactly like Figaro, in the 'Barber's' opera." See Charles Dudley Warner, *The Bull-Fight* 28, no. 1 (November 1883): 11. This article contained illustrations by Robert Blum.

32. "Cigar-Making in Seville," *The Merchants' Magazine and Commercial Review* 42, no. 5 (May 1, 1860): 638.

33. Chatfield-Taylor, "Seville, The Fair," 8–9.

34. Gay is documented in the Prado's copyist registers from April and May 1878; Sarah Parrish has discussed that Gay visited Andalusia and Seville to paint the tobacco factories prior to executing his first composition in 1894. A smaller and more painterly study of the subject titled *Cigarrières* by Gay recently sold at auction in 2018. See *Registro de copistas correspondiente a los años 1873 a 1881*, Archives, Museo Nacional del Prado; Sarah Parrish et al., *Art at*

Colby: Celebrating the Fiftieth Anniversary of the Colby College Museum of Art (Waterville, ME: Colby College Museum of Art, 2009), 172; and *Christie's Online*, Tuesday, November 20, 2018, Lot 00173, American Art Online.

35. "Delectable Seville," 729.

36. Lou Charnon-Deutsch, *Fictions of the Feminine in the Nineteenth-Century Spanish Press* (University Park: Pennsylvania State University Press, 2002), 283, n7.

37. For this interpretation, see Parrish, *Art at Colby*, 172.

38. Shapiro, "Machine Crafted," 99.

39. See, for example, David Lubin, *Picturing a Nation: Art and Social Change in Nineteenth-Century America* (New Haven: Yale University Press, 1994), 205–12.

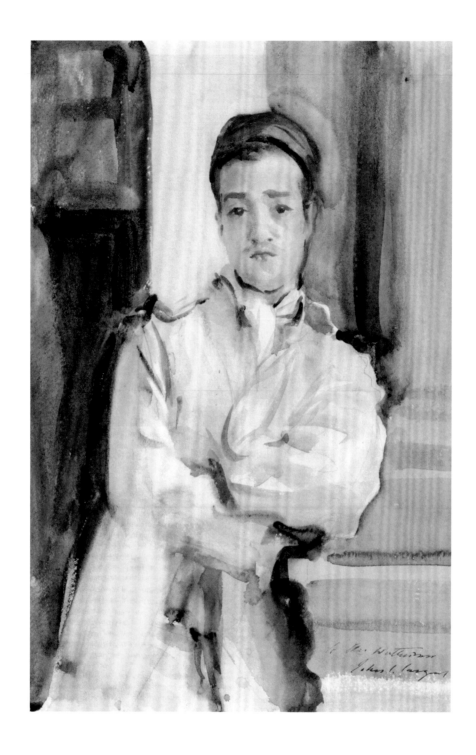

JOHN SINGER SARGENT

AMERICAN, 1856–1925

Spanish Convalescent

ca. 1903 · Watercolor and pencil on paper · 18 × 12 in. (45.7 × 30.5 cm)

Collection of Macon and Joan Brock

JOHN SINGER SARGENT
AMERICAN, 1856–1925

Ramalho Ortigão

1903 · Graphite on paper · 15⅛ × 9⅞ in. (38.42 × 25.08 cm)

Milwaukee Art Museum, gift of Candy and Bruce Pindyck in honor
of her mother Beth Wolan Rogovin, M1990.117

JOHN SINGER SARGENT
AMERICAN, 1856–1925

Spanish Window

1908 · Watercolor on paper · 13¾ × 10 in. (35 × 25.4 cm)

Collection of the Columbus Museum, Georgia; Gift of Dr. and
Mrs. Louis Hazouri, G.1980.50

CHILDE HASSAM
AMERICAN, 1859–1935

Plaza de la Merced, Ronda

1910 · Oil on panel · 25½ × 20½ in. (64.6 × 52 cm)

Carmen Thyssen-Bornemisza Collection, on loan at the Museo
Nacional Thyssen-Bornemisza, Madrid, CTB.1996.22

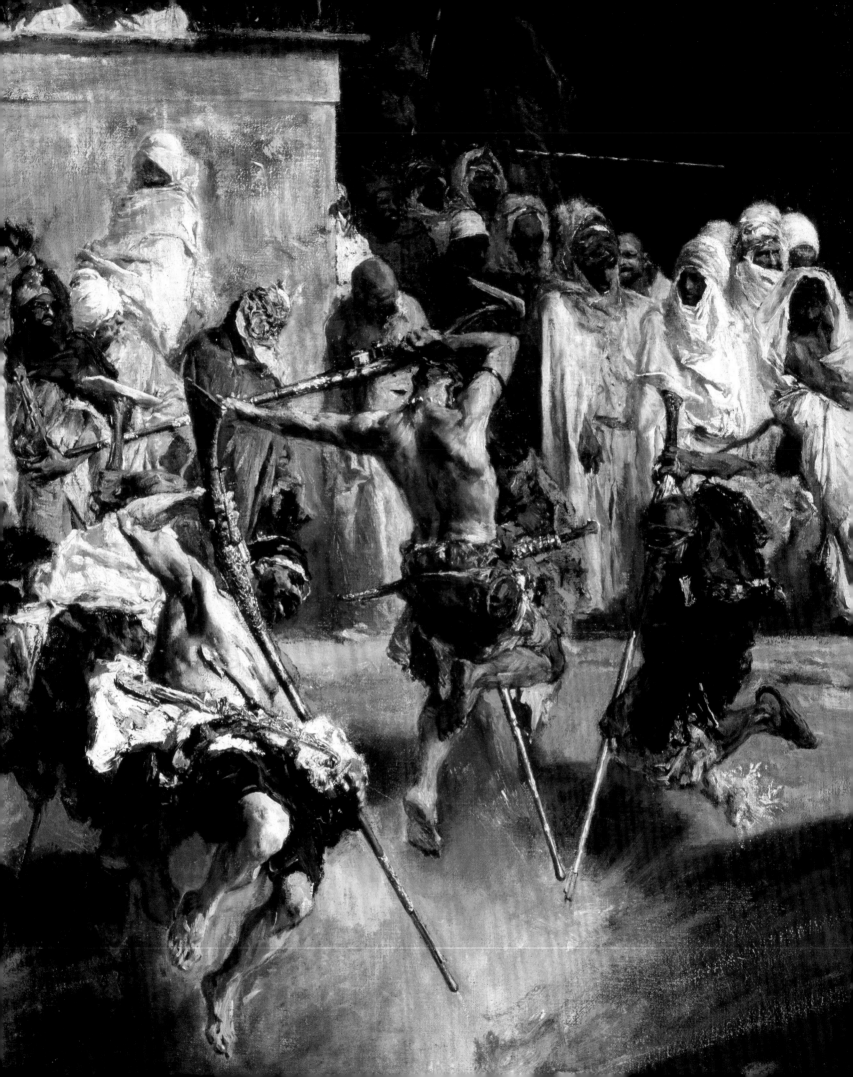

Mariano Fortuny and Americans in Spain

Francesc Quílez Corella

DURING THE NINETEENTH CENTURY, THE IBERIAN Peninsula, which until that moment had been largely neglected by tourists, became a point of intense interest among European and American travelers. No doubt, this historic period gave rise to the general interest in traveling beyond the traditional tourist routes.[1]

Visitors viewed Spain with cultural prejudices and with natural reservations and precautions. In general, the journey was perceived as an adventure that would yield uncertain results, as it required venturing forth into unfamiliar and inhospitable terrain. Many guidebooks warned of the dangers that awaited travelers who dared to go beyond the Despeñaperros mountain gorge, the natural border of Spain's inner plateau. This was the region that, according to old romantic legends, was home to outlaws inclined to commit acts of banditry. Nonetheless, more than a few reckless adventurers were undaunted and bravely followed this fearsome itinerary. Many of them, and especially artists, reinterpreted Spanish *costumbrismo*, or genre painting, and shaped many of the stereotypes that live on to this day.[2]

American painters were not immune to this phenomenon. Following the example and experiences of their European counterparts—particularly the French—they chose to focus on customs, scenes, and styles in tune with established themes that had already awakened the interest of many painter-travelers who visited Spain in that era.[3] Without abandoning the principle of narrative realism, artists prioritized poetic truth over authenticity. In a way, the themes they represented did not speak to a realist tradition so much as give rise to a kind of hybrid language that combined a realist or picturesque underlayer with an aesthetic that questioned the Baroque pictorial school on which so many of these same artists had based their work.

With good reason, the journey to Spain included an obligatory visit to the Prado Museum, in whose picture galleries artists could discover the works of the most renowned and canonical painters in the history of Spanish art. This discovery led them to carry out residencies at the museum in order to copy paintings by some of its most hallowed artists, including Diego Velázquez, Jusepe de Ribera, and Bartolomé Esteban Murillo.[4]

Within this framework, it is interesting to note that in the 1860s and, in particular, between 1867–68, the painter Mariano Fortuny—who years later emerged as one of the foremost figures in the international art scene—also chose to use the Prado as a training space.[5] There he made copies of some of the aforementioned artists, including Ribera (fig. 21) and Francisco de Goya, who was then viewed as a perhaps derivative link in the chain of great masters in the Spanish School.

In a great deal of his work, Fortuny chose to incorporate concealed allusions to these Spanish masters, as was the case of *The Spanish Wedding* (fig. 22). In this painting, Fortuny sought to amend the genre tradition, practicing a sort of Goyaesque revisionism that he achieved with a seasoned *préciosité* nonetheless imbued with a keen virtuosity. Such paintings have been pejoratively referred to as *tableautines de cascones* ("little pictures of men in greatcoats"), to which the artist was always committed

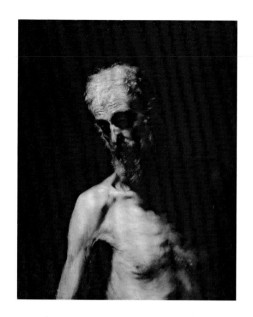

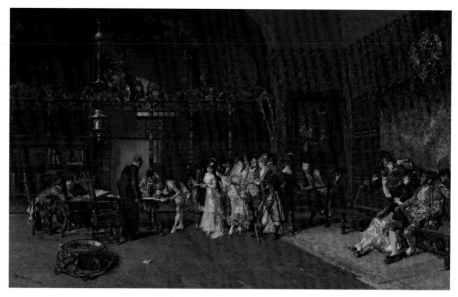

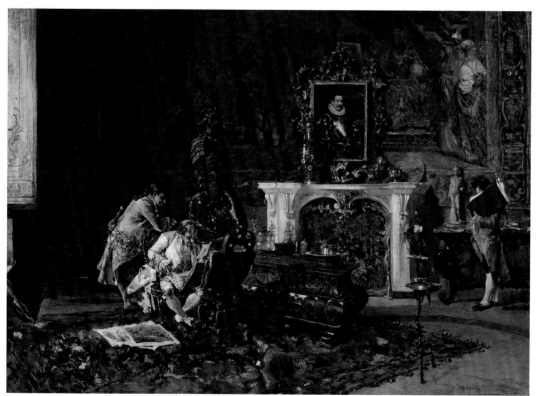

Fig. 21 Mariano Fortuny, *Saint Andrew* (Copy after Ribera), ca. 1867. Oil on canvas. Museo Nacional del Prado, Madrid, P008178

Fig. 22 Mariano Fortuny, *The Spanish Wedding*, 1870. Oil on wood. Museu Nacional d'Art de Catalunya, 010698-000

Fig. 23 Mariano Fortuny, *Antiquaries*, ca. 1863–65. Oil on canvas. Museum of Fine Arts, Boston. S. A. Denio Collection–Sylvanus Adams Denio Fund and General Income, 24.17

Fig. 24 Mariano Fortuny, Study for the painting, *Lunch in an Old Convent in the Alhambra,* 1871. Ink on paper. Museu Nacional d'Art de Catalunya, 008725-D0R

and which satisfied his European and American clientele's tastes and aesthetic appetites. Indeed, after its debut in May 1870 in the gallery of art dealer Adolphe Goupil (1806–1893) in Paris's Place de l'Opéra, *The Spanish Wedding* contributed to Fortuny's social, financial, and critical recognition. It also helped establish his preeminent place among American artists and collectors, to which the presence of some of his most celebrated works in the United States attests (fig. 23).[6] This relationship between Fortuny and the American market existed throughout his life, thanks to the maneuverings of Goupil, who facilitated the exchange on both sides of the Atlantic.

One example of this important phenomenon is on display in *A Stop on the Road* (1872; private collection),[7] also known as *Lunch in an Old Convent in the Alhambra,* from the period during which Fortuny lived in Granada, from 1870 to 1872 (fig. 24).[8] *Lunch,* like many of the paintings that Fortuny executed during his two-year residence in Granada, appealed to American collectors, perhaps for their perceived exotic or historical qualities, and linked to travel guides and romantic narratives like Washington Irving's *Tales of the Alhambra.* Known until now only through reproductions and a sketch that Fortuny made in a letter, the first record of the acquisition of *Lunch in an Old Convent* is in the registration book from the Goupil gallery, which is now at the Getty Research Institute in Los Angeles. On May 1, 1881, the work was acquired by William Hood Stewart (1820–1897), a Philadelphia sugar baron who invested a significant share of his profits in building a vast art collection, which included many important European paintings.[9] In addition to his hometown of Philadelphia, Stewart spent much of his life in Paris, where he established friendships with several artists, including Fortuny, which would explain why the magnate acquired so many of the Spanish artist's works.[10]

In 1898, few months after Stewart's death, his extensive collection was auctioned off at the American Art Galleries in New York, and *Lunch in an Old Convent* was acquired by George Jay Gould I (1864–1923) who, after the death of his father, had inherited the family's railroad fortune.[11] He was also the owner of a large art collection, kept at his house in New York, which included works from most major European schools, including some pieces by Fortuny.[12] In that same year, however, Gould decided to sell the Fortuny to another New Yorker, Gustav Bruce Berckmans

(1859–1902), director of Tiffany & Company and chief purchaser of their precious stones. The painting's new owner was unable to enjoy his acquisition for long, as he died unexpectedly in 1902 in London's Savoy Hotel after contracting typhoid fever. The work was inherited by his son, Bruce Berckmans Jr. (1901–1968), who was one year old when his father died and who grew up to work in trade and finance.[13]

It is more than a little unusual for an artist to move far from the media spotlight toward the periphery of the art world when, only months prior to his 1870 relocation to the Andalusian city, he achieved tremendous success in what was then the capital of European culture. Although we do not know the true motives behind Fortuny's decision, through a close reading of his correspondence we can nevertheless glimpse a firm desire for a change of scenery. He had chosen a city that would enable him to withdraw from all those constraints that, in his judgment, might hinder a truly creative renewal process. In some letters, we also sense a feeling of weariness and dissatisfaction with the requirement that he constantly tend to the commercial demands of the art market.[14]

Far from the suffocating pressure which had obliged him to work on themes and motifs that did not satisfy him, Fortuny's time in Granada was one of the most productive in his short artistic career (fig. 25). Although this is not widely discussed, it was also one of his most innovative phases, as he was able to delve into new aspects of artistic practice, whereas before he had formerly been limited to sketching.[15] Perhaps during this period, he showed a greater fondness for cultivating a fresh approach to Orientalism, one that was be far more powerful and theatrical.

Well into the nineteenth century, the city of Granada was famous as a destination for those touring Spain, later becoming an obligatory stop on the Orientalist tour that many painters in the era took, and which often ended in the Moroccan city of Tangier.[16] This is perhaps most obvious in the career and paintings of Edwin Lord Weeks (cat. 61), who made a pilgrimage to Fortuny's Granada studio during a trip through Spain and who, throughout the 1870s, made multiple trips to Morocco, Algeria, Egypt, Lebanon, Palestine, and Syria.[17]

Fortuny, who had direct artistic experience with North African subjects early in his career, most notably in the municipal commission for his *Arab Fantasia* (cat. 51),

Fig. 25 Mariano Fortuny, *Granada Landscape*, ca. 1871. Oil on canvas. Museu Nacional d'Art de Catalunya, 010701-000

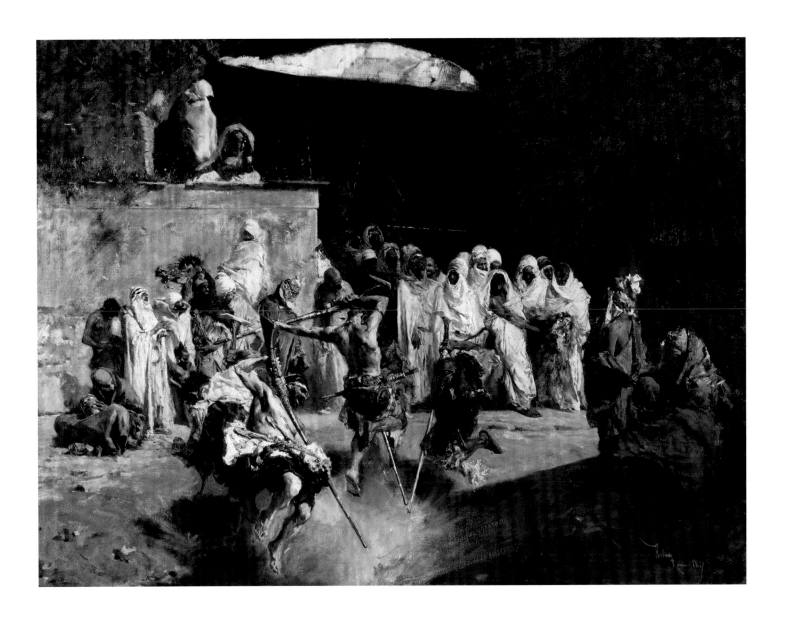

MARIANO FORTUNY

SPANISH, 1838–1874

Arab Fantasia

1867 · Oil on canvas · 20½ × 26⅜ in. (52 × 67 cm)

The Walters Art Museum, Baltimore, Maryland, 37.191

MARIANO FORTUNY

SPANISH, 1838–1874

The Slaughter of the Abencerrajes

1870 · Oil on canvas · 29 × 26¾ in. (73.5 × 93.5 cm)

Museu Nacional d'Art de Catalunya, purchased 1949,
Inv. No. 044189-000

Fig. 26 Mariano Fortuny, *Tribunal of the Alhambra*, 1871. Oil on canvas. Fundación Gala-Salvador Dalí

Fig. 27 Mariano Fortuny, *Old Town Hall of Granada*, 1873. Oil on panel. Museo de Bellas Artes de Granada

made the most of Granada's scenery, including the Alhambra, which became the best of all possible subjects (fig. 26). It is also worth observing that many of his paintings of Granada, including *The Slaughter of the Abencerrajes* (cat. 52) were created in the halls of the Alhambra and had relevance to legendary stories popular not only with European but American audiences as well.

One need not go further than the works present at this exhibition to confirm the importance of Granada's landscape to many American painters. Within this creative context, there was an abundance of representation of the spaces that formed part of the city's rich heritage and tradition. Beyond the logical interest in the Alhambra, there were also other focal points, such as the renowned Casa del Chapiz, which piqued the imagination of many artists, including John Singer Sargent (see cat. 44). Fortuny

also painted the Casa del Chapiz, as well as the market by the old city Council House, part of the traditional tour of Granada's most characteristic and iconic spaces (fig. 27).[18] These sites inevitably unfolded into a tourist route that also included the Sacromonte district, the historic home to Romani families, who lived in precarious conditions in caves burrowed into the rocky hillside.

This period of Fortuny's career in Granada also led to a repertoire that included a large number of dancers, in isolated scenes or as part of the entire composition; in these paintings, the subjects seemingly take part in improvised musical gatherings. These same themes can be seen in Fortuny's representation of picturesque types, including the emphasis he gave to the Romani and their customs.[19] It is not unusual that his selection of subjects would include these types of portraits, as he viewed Romani as exotic characters owing to their singularity and unconventionality. This led to his deployment of certain cultural stereotypes and archetypes, including, most frequently, the rendering of dance, which accentuated the local folkloric iconography (fig. 28). The superficial foreignness of these subjects is part of what gave Fortuny such instant and lasting appeal to both American artists who visited Spain and the collectors who acquired his work at auctions and galleries in the United States.

Fig. 28 Mariano Fortuny, *Gypsy Dancing in a Garden in Granada*, ca. 1872. Oil on canvas. Private Collection

NOTES

1. F. Calvo Serraller, "Los viajeros románticos franceses y el mito de España," *Imagen romántica de España*, exh. cat., vol. 1 (Madrid: Ministerio de Cultura 1981), 21–61; and, by the same author, *La imagen romántica de España. Arte y arquitectura del siglo XIX* (Madrid: Alianza, 1995).

2. S. L. Stratton, *Spain, Espagne, Spanien: Foreign Artists Discover Spain 1800–1900*, exh. cat. (New York: Equitable Gallery, 1993); *Les peintres français et l'Espagne. De Delacroix à Manet, Castres,* exh. cat. (Castres: Musée Goya, 1997);

and M. S. Lundström, *Travelling in a Palimpsest: Finnish Nineteenth-Century Painters' Encounters with Spanish Art and Culture* (Helsinki: Academia Scientiarum Fennica, 2008).

3. C. M. Osborne, "Yankee Painters at the Prado," in *Spain, Espagne, Spanien*, ed. Stratton, no. 2, 58–77.

4. C. M. Osborne, "Yankee Painters," no. 2. The copyist registers for the Prado Museum, for example, contain a large number of references to the work executed by the painter John Singer

Sargent from October 17 to November 29, 1879. During this period, he made copies of *Las Meninas*, *Las Hilanderas*, *The Jester Calabacillas*, the *Equestrian Portrait of Prince Baltasar Carlos,* and *Aesop*, all by Velázquez, and of José de Ribera's painting of Christ. See *Manet, Velázquez. La manière espagnole au XIXème siècle*, exh. cat. (Paris: Réunion des musées nationaux, 2002).

5. M. Doñate, C. Mendoza, and F. M. Quílez Corella, *Fortuny: 1838–1874*, exh. cat. (Barcelona: Museu Nacional d'Art de Catalunya, 2003);

and J. Barón, ed., *Fortuny: 1838–1874*, exh. cat. (Madrid: Brizzolis, 2017).

6. Fortuny's canonization in the United States is attested to by the extensive published references that appeared early in the twentieth century. See, for example, *Masters in Art: A Series of Illustrated Monographs,* vol. 10 (Boston: Bates and Guild Co., 1909), 43–84; and Doñate, "Fortuny en las colecciones del siglo XIX," in *Fortuny*, Doñate, Mendoza, and Quílez Corella, no. 5, 407–15.

7. Mireia Berenguer and I have begun the process of locating some of Fortuny's works whose whereabouts are unknown; this research will be published shortly. The first breakthrough in this effort was our successful location of this painting, which is in a private collection in the United States. Despite the importance of the work, we did not have a color photo of it until now. The first reproduction is from 1875, in *Oeuvres choisies de Fortuny reproduites en photographies* (Goupil et Cie, éditeurs, 1875), and the latest is from 1933, in *Fortuny, 1838–1874: avec cinquante-deux reproductions y compris deux portraits de l'artiste* (Bologna: Giuseppe Maylender, 1933), no. 26. Fortuny's letter, dated February 28, 1871, was sent from Granada to his friend Goyena; it is part of the Fortuny Collection in the Museu Nacional d'Art de Catalunya's Cabinet of Drawings and Prints (8725 DOR). For more on Fortuny's time in Granada, see C. Mendoza, "De Granada a Portici: un nuevo lenguaje artístico," in *Fortuny*, Doñate, Mendoza, Quílez Corella, no. 5, 47–61; see also F.M. Quílez Corella, "Grenade, une étape de l'itinéraire orientaliste de Benjamin-Constant. Le contexte culturel du voyage en Espagne et l'ascendant de Mariano Fortuny," in *Benjamin-Constant. Merveilles et mirages de l'Orientalisme*, ed. N. Bondil, exh. cat. (Toulouse, 2014), 117–58; and F. M. Quílez Corella, ed., *Tiempo de ensoñación. Andalucía en el imaginario de Fortuny*, exh. cat. (Barcelona, 2016).

8. Mendoza, "De Granada a Portici: un nuevo lenguaje artístico," in *Fortuny,* Doñate, Mendoza, and Quílez Corella, no. 5, 47–61; Quílez Corella, "Grenade, une étape de l'itinéraire orientaliste de Benjamin-Constant. Le contexte culturel du voyage en Espagne et l'ascendant de Mariano Fortuny," in *Benjamin-Constant*, ed. Bondil, exh. cat. (Toulouse: Hazan, 2014), 117–158; and Quílez Corella, ed., *Tiempo de ensoñación*, no. 7.

9. Goupil & Cie Stock Books no. 5, 1870–1872, 125. http://archives.getty.edu:30008/getty_images/digitalresources/goupil/goupil.htm, No. 5444, bearing the title *Un alto en el camino del convento*, had been acquired by Goupil from Fortuny for 10,000 francs, and the dealer sold it to Stewart for 20,000 francs. Three days later, on May 4, Stewart acquired the painting *Un arcabucero* for 10,000 francs. Many works from Stewart's collection are now also in many other museums, including the Walters Art Museum in Baltimore.

10. Stewart owned various important works by Fortuny, including *The Court of the Alhambra*; the first of three versions of *The Print Collector*; *The Choice of a Model*; *Arab Praying; Masquerade; A Street in Tangier; Miss Del Castillo on her Deathbed; Gypsy Caves; The Pigs;* and *The Slaughterhouse of Portici*. W. R. Johnston, "W. H. Stewart, The American Patron of Mariano Fortuny," *Gazette des Beaux-Arts* (March 1971): 183–88.

11. *Catalogue de luxe of the Modern Masterpieces gathered by the late connoisseur William H. Stewart* (New York, 1898). Gould paid $6,900 for the painting, which is documented in a letter that Bruce Berckmans Jr. sent on February 11, 1965, to the Parke-Bernet Gallery in New York (private files).

12. N. J. Lakewood, "American Collections XXI: The Collection of George J. Gould," *The Collector and Art Critic* 2 (April 15, 1900): 200–201. In the 1890s, Gould bought new works by Fortuny: the painting *Arab Guard* for 41,600 francs (Goupil Book no. 14, Stock no. 21981, p. 22, row 1); and, in 1899, the watercolor *The Mazarine Library* for $10,000 (Knoedler Book no. 4, Stock no. 8742, p. 245, row 6).

13. The painting was described in abundant detail in *Masters in Art*, no. 6, 81.

14. In November 1870, he wrote to his friend, the painter Martín Rico (1833–1908): "I have come here, because there are painters [. . .] and one can be entirely independent." M. Rico, *Recuerdos de mi vida* (Madrid, 1906), 74.

15. F. M. Quílez Corella, "Balance de un tiempo feliz," in *Tiempo de ensoñación*, ed. Quílez Corella, no. 7, 23–31.

16. J. À Carbonell, *Josep Tapiró. Pintor de Tànger*, exh. cat. (Barcelona: Museu Nacional d'Art de Catalunya, 2014); and, by the same author, "La Alhambra y la nostalgia del oriente desaparecido en la obra de Fortuny y sus colegas franceses," in *Tiempo de ensoñación*, ed. Quílez Corella, no. 7, 199–205.

17. See, for example, "In the Footsteps of Fortuny and Regnault," *Century Magazine* 23, no. 1 (November 1881): 30; and Marianna Shreve Simpson, "Staging the 'Interior of the Mosque at Cordova' by Edwin Lord Weeks," *The Journal of the Walters Art Museum* 70/71 (2012/2013): 109–20.

18. Fortuny's two sketches of the Casa del Chapiz are housed in the Drawings and Prints Collections at the Museu Nacional d'Art de Catalunya (MNAC 123441 D y 105775 DOA).

19. S. Fanjul, "El sueño de Al-Andalus," *La quimera de Al-Andalus* (Madrid: Siglo XXI de España Editores, S.A., 2004), 194–215; V.I. Stoichita, *L'image de l'autre: noirs, juifs, musulmans et "gitanes" dans l'art occidental des Temps Modernes, 1435–1789* (Paris, 2014); and C.M. y Torres Herrera, *Palabras pintadas, escenas descritas. Granada vista por los artistas extranjeros* (Granada, 2016).

53

JOAQUÍN SOROLLA Y BASTIDA

SPANISH, 1863–1923

Street in Granada

ca. 1909 · Oil on canvas · 41⅜ × 28⅜ in. (105 × 72 cm)

Museo Sorolla, n° inv. 00856

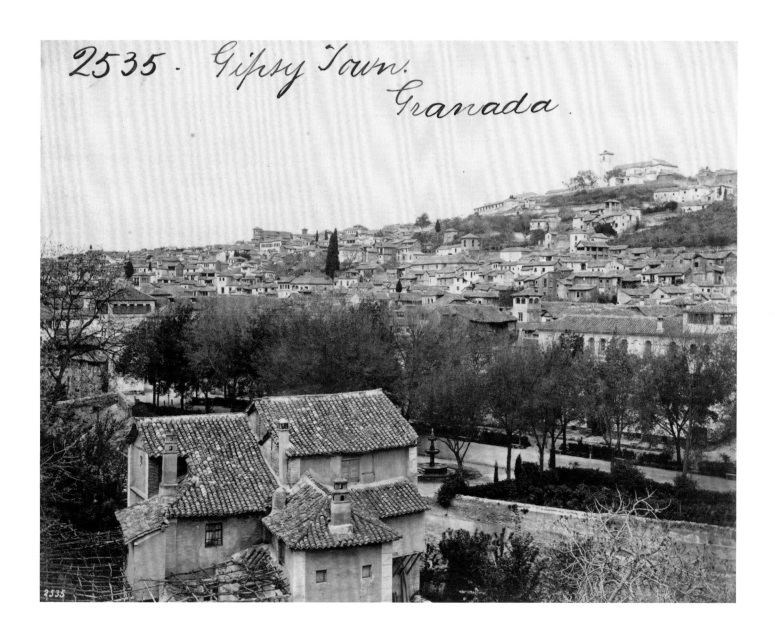

54

FRANCIS FRITH

ENGLISH, 1822–1898

Gipsy Town. Granada

ca. 1871 · Whole-plate albumen print from wet collodion glass
negative · 6½ × 8 in. (16.51 × 20.32 cm)

Victoria and Albert Museum, acquired from F. Firth and Company,
1954, E.208:1528-1994

JOAQUÍN SOROLLA Y BASTIDA

SPANISH, 1863–1923

Hall of the Ambassadors, Alhambra, Granada

1909 · Oil on canvas · 41 × 32 in. (104.1 × 81.3 cm)

The J. Paul Getty Museum, Los Angeles, 79.PA.154

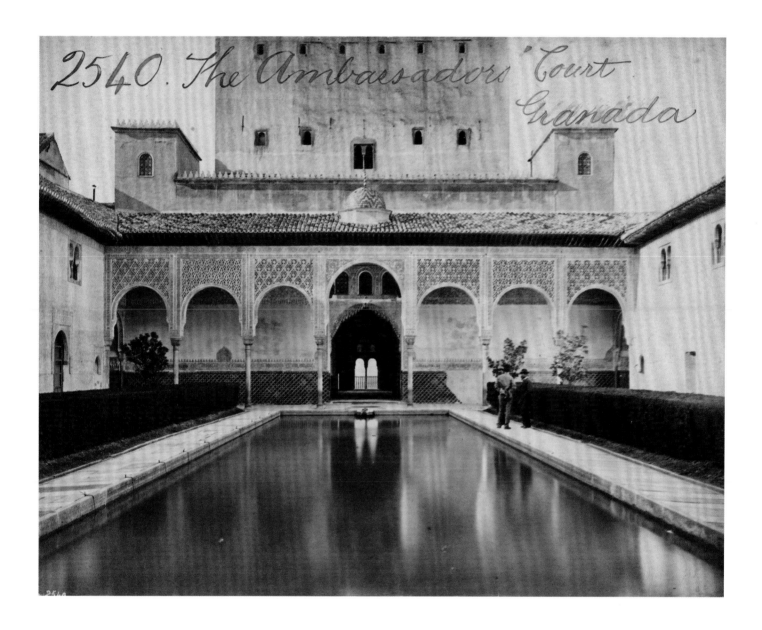

56

FRANCIS FRITH

ENGLISH, 1822–1898

The Ambassadors' Court.
Granada

ca. 1871 · Whole-plate albumen print from wet collodion glass
negative · 6½ × 8 in. (16.51 × 20.32 cm)

Victoria and Albert Museum, acquired from F. Firth and Company,
1954, E.208:1533-1994

57

RAFAEL SEÑAN (SEÑAN Y GONZALEZ)

SPANISH, ACTIVE CA. 1900

Granada, Alhambra,
Door of Justice

ca. 1895 · Albumen print · 10⅜ × 8 in. (26.4 × 20.3 cm)

Sheldon Museum of Art, University of Nebraska–Lincoln, Anna R.
and Frank M. Hall Charitable Trust, H–2279.1978

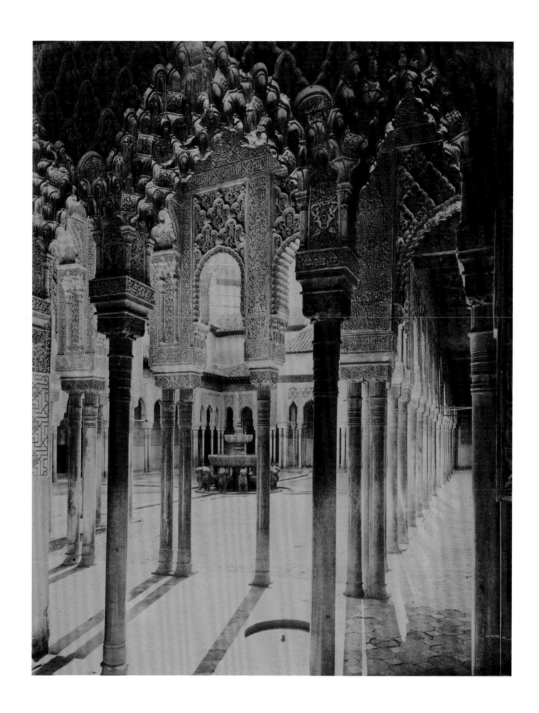

58

CAMINO

SPANISH, DIED 1888

Granada, Courtyard of the Lions (Alhambra)

ca. 1880 · Albumen print from wet collodion negative · 10 × 7¹⁵⁄₁₆ in.
(25.5 × 20.2 cm)

Chrysler Museum of Art, Museum purchase, 2018.38.1

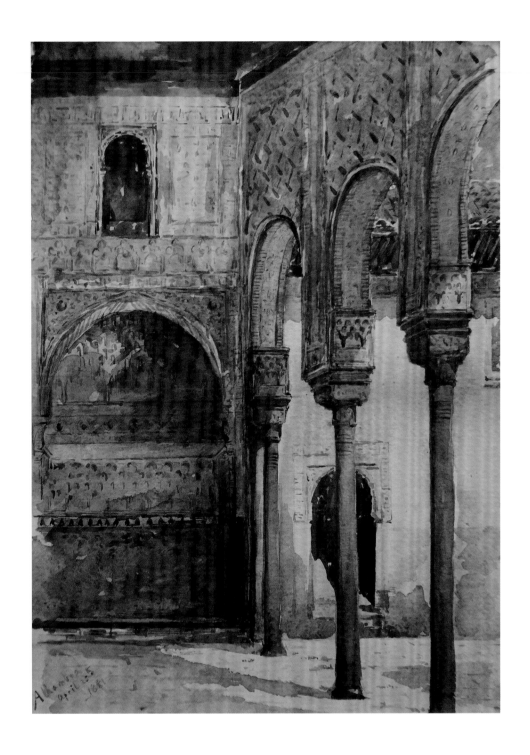

ELIZABETH BOOTT

AMERICAN, 1846–1888

The Alhambra

1881 · Watercolor on paper · 14 × 10 in. (35.6 × 27.94 cm)

Catherine and Louis Pietronuto

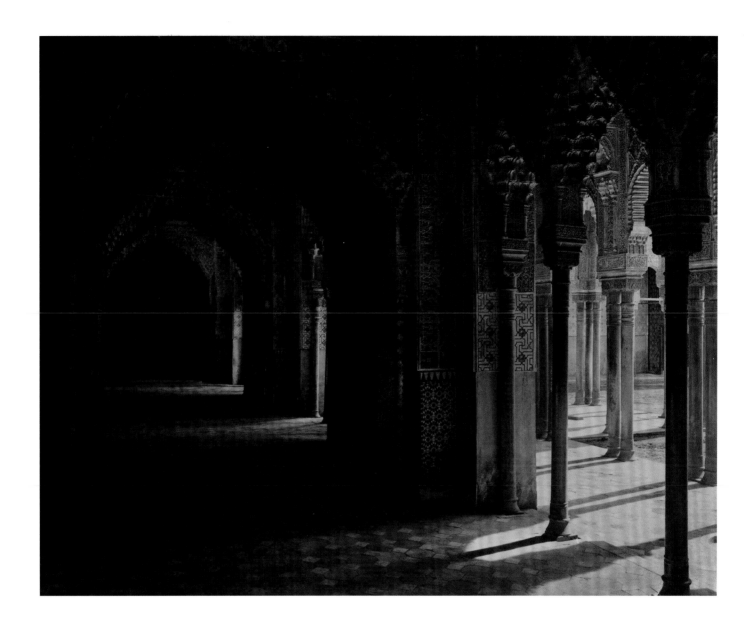

60

ADOLPHE BRAUN

FRENCH, 1811–1877

Alhambra at Granada,
Hall of Justice

ca. 1880 · Vintage carbon print · 15⅛ × 18⅝ in. (38.4 × 47.3 cm)

Chrysler Museum of Art, Museum purchase, 2019.4

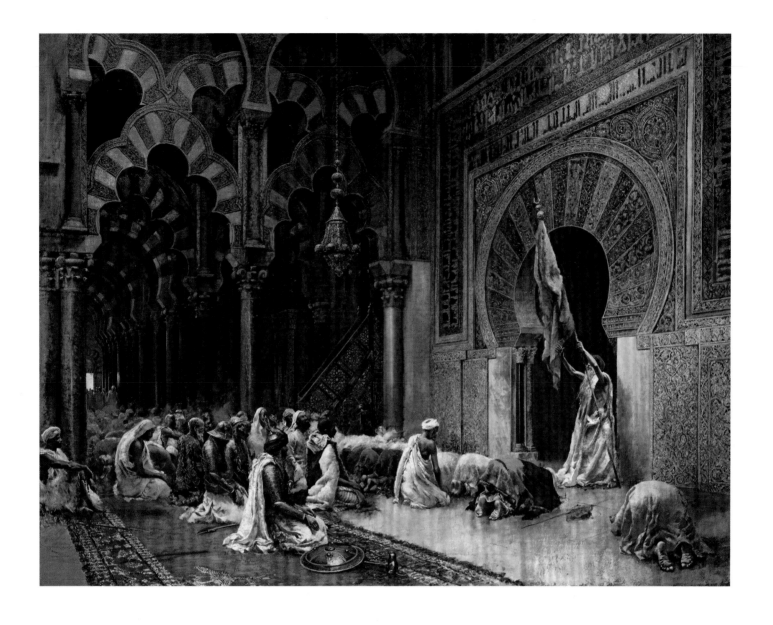

61

EDWIN LORD WEEKS
AMERICAN, 1849–1903

Interior of a Mosque at Cordova

ca. 1880 · Oil on canvas · 56⅛ × 72⅝ in. (142.56 × 184.47 cm)

The Walters Art Museum, Baltimore, Maryland, 37.169

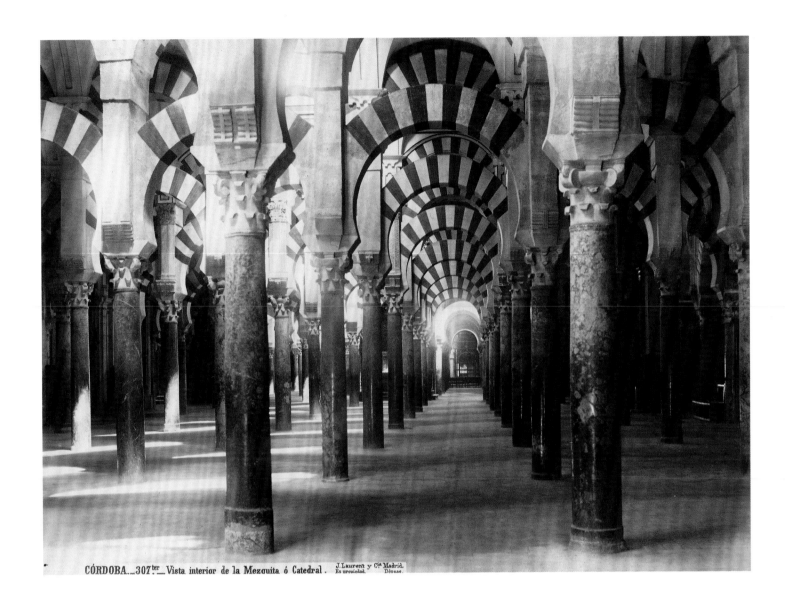

CÓRDOBA.—307.ᵗᵉʳ. Vista interior de la Mezouita ó Catedral . J.Laurent y Cⁱᵃ Madrid. Es uroniedad. Déucae.

62

JEAN LAURENT

FRENCH/SPANISH, 1816–1886

Córdoba—307. Interior View of the Mosque or Cathedral, Córdoba

1875 · Albumen print · 9⅞ × 13⁷⁄₁₆ in. (25.1 × 34.1 cm)

The J. Paul Getty Museum, Los Angeles, 84.XA.761.26.2

63

WILLIAM MERRITT CHASE

AMERICAN, 1849–1916

The Moorish Warrior

ca. 1878 · Oil on canvas · 59³⁄₁₆ × 94⁷⁄₁₆ in. (150.4 × 239.9 cm)

Brooklyn Museum, Gift of John R.H. Blum and Healy Purchase
Fund B, 69.43

64

JOAQUÍN SOROLLA Y BASTIDA

SPANISH, 1863–1923

Court of the Dances, Alcázar, Seville

1910 · Oil on canvas · 37½ × 25 in. (95.3 × 63.5 cm)

The J. Paul Getty Museum, Los Angeles, 79.PA.151

Learning about Spain

CHILDREN, TRAVEL BOOKS, AND FICTIONS OF THE FOREIGN

M. Elizabeth Boone

"It seems to me," assented Saint, "that a visit to Europe before one had studied history would be a great mistake."

—*Three Vassar Girls Abroad*

SPAIN IS A COMPLEX COUNTRY, WITH GALICIANS, Basques, and Catalans in the north, Castilians in the center, and Andalusians in the south. It is a country with four primary languages, only one of which—Castilian—is intelligible to those who speak what is generally known as Spanish.[1] A nation with multiple languages, it is also a Catholic country that has been marked by other religions —particularly Judaism and Islam—over the course of two thousand years. The ancient Castilian city of Toledo, a short distance southwest of Madrid, provides a case in point: it is a city of layered and intertwined histories, comprising the lives of Romans, Jews, Visigoths, Muslims, and Catholics. As such, during the nineteenth century in particular, it proved a rich source for artists, illustrators, and photographers catering to the tourist trade (see cats. 65, 66, 68, and 69 for example).

For those travelers who visit a foreign country such as Spain, reading in advance seems to increase the educational value of a journey, making the visit more meaningful. Travel books guide travelers in their journey, tell them what to look for, and explain the history of the people and places they will encounter. They help make sense of complexity. The authors and artists who write and illustrate such books tell readers what they will see, and the degree to which a traveler recognizes these images often determines both the value of the guide and the success of the journey. This essay explores a series of illustrated travel books published in the 1880s—by Elizabeth Champney, George Lathrop, Susan Hale, and William Parker Bodfish—in order to suggest that what readers see when they travel might first and foremost be what they have been taught to see in advance.[2] By focusing on Toledo and its portrayal in late nineteenth-century travel books, the means by which visual and textual messages about Spain were communicated will become clear. How children and young adults in the United States learned about Spain—and what they thought they knew about the city of Toledo—began with these books.

Elizabeth Champney and the *Three Vassar Girls Abroad*

It may come as no surprise that two of these four authors were women, as children were seen in the nineteenth century as a natural audience for female writers. Elizabeth Williams Champney was indeed a mother, and "Lizzie," as she sometimes signed her work, received considerable acclaim for her travel books aimed at young adults. Champney (1850–1922) and her artist husband, James Wells Champney, collaborated on many projects during their thirty years of marriage.[3] It was during their extended honeymoon in 1875 that the Champneys first visited the Basque Pyrenees and began their involvement with Spain. Several articles resulted from this trip, as well as one of the few essays written by J. Wells Champney, titled "Among the Carlists" and published in *Appletons'*

Journal, and a story by Lizzie W. Champney for *The Galaxy*, called "Father Tolo's Umbrella."[4] When choosing topics, the Champneys were a typical Victorian couple; the male member of the partnership dealt with the real world of war and politics, while his wife created imaginary tales of love and marriage. Returning to the United States to divide their time between Deerfield, Massachusetts, and the city of New York, they established their reputations as writer and artist. They traveled abroad with their two children whenever possible and made a complete loop through the Iberian Peninsula during the summer of 1880. It is on this second journey that most of Elizabeth Champney's writings about Spain are based.

The *Three Vassar Girls* books, which were written for young women between twelve and sixteen years of age, cemented Champney's popular success as an author. Each book features a different trio of college girls, who expand their knowledge of the world through travel in Europe and America. Designed as an introduction to the people, art, literature, and history of these diverse continents, the books explore such themes as the strength of family ties, the constancy of female friendship, the importance of good works and acts of philanthropy, and the triumph of education over bigotry toward other cultures. The first book in the series, published in 1878, places the girls on the German Rhine, while *Three Vassar Girls Abroad*, from 1882, which includes chapters set in Madrid, Toledo, Córdoba, Seville, and Granada, details the travels of Cecilia Boylston (nicknamed Saint), Maud van Vechten, and Barbara Atchison through France and Spain. The subtitle of the volume, *Rambles of Three College Girls on a Vacation Trip through France and Spain for Amusement and Instruction,* juxtaposes education with pleasure, and Saint makes her observation about the value of studying history after visiting the French châteaux, one of which had been lovingly restored by Spanish historical painter Ignacio León y Escosura. "How much more we enjoy these things from seeing them after we have completed the course in history," her friend Barbara had noted. "I can well imagine that to one who knew nothing of the events at the time," she added, "a visit to this old town would be a bore."[5] The chapter on Toledo in *Three Vassar Girls Abroad* describes the city as a magical place, first glimpsed at night flooded by the light of a silver moon.[6]

that of St. Juan de los Reyes. It was built by Ferdinand and Isabella, to commemorate the conquest of Granada, and the exterior walls are hung with a fringe of chains and manacles, said to have been taken from the limbs of Christian captives rescued from the land of the Moor. Isabella subsequently gave the church and convent attached, to her favorite, Cardinal Ximenes. The cloister, in the most florid style of Gothic architecture, is one of the most beautiful in Spain. A garden which resembles a hot-house gone wild, is walled in by galleries of

Fig. 29 James Wells Champney, *Interior Court at Toledo*, from Elizabeth W. Champney, *Three Vassar Girls Abroad*. Boston: Estes and Lauriat, 1882, p. 112. Private Collection

Many of the illustrations for the *Three Vassar Girls* books were provided by the author's husband, who often signed his work "Champ" in order to distinguish himself from his distant cousin, the painter Benjamin Champney. Additional images, by "other distinguished artists," fill in the gaps, and the Toledo chapter includes Gustave Doré's *Interior of the Cathedral, Toledo*, an image used again the following year in Susan Hale's *A Family Flight Through Spain*. Doré was one of the most famous artists to depict Spain; his illustrations originally accompanied a series of articles written during the 1860s by Baron Jean-Charles Davillier for the French periodical *Le Tour du Monde*,

A STREET IN TOLEDO.

65

JAMES WELLS CHAMPNEY
AMERICAN, 1843–1903

A Street in Toledo

1882 · Wood engraving · 8¼ × 6½ in. (20.95 × 16.51 cm) ·
From Elizabeth W. Champney, *Three Vassar Girls Abroad*.
Boston: Estes and Lauriat

Private Collection

which had been translated and republished in deluxe book format for English-speaking readers in 1876.[7] Champney's drawings appeared in multiple volumes as well. *A Street in Toledo* (cat. 65), for example, was used again in 1889 for Fred Ober's *Knockabout Club in Spain*.[8] The drawing, which cannot be linked to any specific site in the city of Toledo, depicts a mounted caballero who stops to admire a pretty young girl on a balcony.

Champney's drawing of an *Interior Court at Toledo* is more identifiably Toledan, and many visitors to the city remarked upon the use of household patios for both the stabling of animals and social interaction (fig. 29). For her part, Elizabeth Champney declared that Toledo "was not a gay city, certainly, nor a particularly neat one, with its stable-yard invariably occupying the interior court, which was often the reception-room and dining-room as well, of the house." In keeping with this rather droll observation, her husband's illustration depicts a small child tentatively offering a treat to a somnolent donkey. It is not unusual to find these images—whether by Doré or by Champney—used and reused in travel books produced about Spain. Repetition encourages recognition; it also leads to preference. In the words of psychologist James Cutting, who has studied what he calls the "mere exposure" effect, "we tend to like things we have seen before, indeed we tend to value them more."[9] Readers who saw these images repeated over time internalized their romantic conceptions of Spain, perceiving them as both accurate and appealing.

In *Three Vassar Girls Abroad*, Elizabeth Champney referred to Toledo as a center for magic and alchemy, a theme she picked up again in another story, "The Romance of Two Cameras," published eight years later.[10] Both Champneys were enthusiastic about photography, and the painter sometimes took his own photographs for use in the creation of original compositions. Champney centered this story on two fictional protagonists, Eleanor Thurston and Thomas Winter, who were traveling through Spain independently of one another. Eleanor enjoys taking photographs with her camera, which metaphorically functions as a symbol of advanced US technology (and in opposition to slow industrial development in Spain). The chemical process by which an image appears from what seems to be nothing can easily look, to those who have never seen it before, like magic. Thomas, a professional photographer and writer of magazine articles, first sees

and, without her knowledge, photographs the beguiling young lady in the cloister of Toledo's San Juan de los Reyes. The resulting narrative, which mixes art, science, magic, and photographs, ends in New York, but, as Elizabeth Champney explained, "it was in the old Spanish town of Toledo that Eleanor's matter-of-fact detective camera first played her false and led her into the byways of romance."[11]

Sections of "The Romance of Two Cameras" reappear in Champney's final contribution to the literature of Toledo, *Witch Winnie in Spain*, published in 1898. Champney had begun the *Witch Winnie* series a decade earlier, using the books to introduce her readers to three female art students, Winnie De Witt, Tib Smith, and Milly Roseveldt. As in the *Three Vassar Girls Abroad*, love and marriage are primary themes, but serious discussions of art, history, and even politics also make their way into the stories. The girls make a special visit to the Prado to see the work of Diego Velázquez. "We have only a short time to remain in Madrid," says Winnie, "but I can think of no better way of improving it than by making a copy of one of those heads of Velasquez."[12] In keeping with its focus on art, this book is illustrated with works by old masters and new ones, among them Velázquez, Mariano Fortuny, and Martín Rico (fig. 30). Rico's picturesque paintings of heavily-loaded donkeys and the streets of Toledo inspired many subsequent views in the late nineteenth century.[13]

The outbreak of the Spanish-American War serves as a backdrop for *Witch Winnie in Spain*, and Tib's parents, who have become separated from the girls, are trying to rejoin them. Meanwhile, a Spaniard follows the trio as they travel through the peninsula, convinced that the innocent young women are spies for the Cuban cause. Photography again plays a role in the story, with the man stealing the girls' negatives in order to prevent them, he believes, from passing information to their rebel allies. The girls' attitude is revealed in a telling scene that again occurs in the courtyard of San Juan de los Reyes, as Tib reads from Sir Arthur Helps's *Spanish Conquest in America*, a book first published in 1855 with the extended subtitle *and its relation to the history of slavery and to the government of colonies*. "No race of men has at any time been wholly composed of brutes, and it is but justice to the history of the Spaniards in Cuba that we study for a moment with Tib and Milly the character of this remarkable man [Bartolomé de las Casas]," wrote Champney, addressing her readers.[14] Presenting this cleric known

PERMISSION OF THE AMERICAN ART ASSOCIATION.

PLAZA, TOLEDO.— BY RICO.

Fig. 30 Martín Rico, *Plaza Toledo—by Rico*, from Elizabeth W. Champney, *Witch Winnie in Spain*. New York: Dodd, Mead and Company, 1898, p. 151. Private Collection

for defending the rights of Indigenous Americans as a singular exemplar of mercy over avarice, the point of Champney's backhanded compliment becomes clear: the Spanish people, she might as well have written, were not all bad. Although the collaboration between the girls and Cuban independence fighters was clearly imagined, the sympathies of all concerned—Champney, her fictional young art students, and her readers—lay with Cuba . . . and the United States. These books, along with those written by her contemporaries George Lathrop and Susan Hale, actively promoted US interests at the same time as they introduced young readers to Spain.

George Lathrop's *Spanish Vistas*

Author George Parsons Lathrop (1851–1898) traveled to Spain with artist Charles Stanley Reinhart (1844–1896) at the behest of the New York publishing firm Harper & Brothers during the summer of 1881, one year after the Champneys.[15] Their collaboration was published first as a series of five articles in *Harper's New Monthly Magazine* in 1882, and all five articles, with minor revisions, were republished as *Spanish Vistas*, an elegantly illustrated book, the following year.[16] Lathrop and Reinhart traveled throughout the peninsula, and their itinerary deliberately incorporated the most well-known and picturesque

cities of Spain. Author and artist had an amicable relationship; Lathrop affectionately christened his collaborator "Velazquez," which he altered to "Velveteen" upon protest from the modest artist, and Reinhart depicted his literary companion in several sketches produced for the text. The portly gentleman who peers intently at an old column —an illuminated initial "I" that begins the chapter on Toledo, titled "The Lost City"—is Lathrop, basket of food, spyglass, and bedroll neatly tied to the saddle of his sleepy burro (fig. 31).

Reinhart included Lathrop again, as well as his own self-portrait, in other illustrations, among them *A Group of Mendicants*, which depicts the beret-wearing artist revealing his empty pockets to an eager crowd of beggars while his companion sits in the background scribbling notes in his journal. The images in *Spanish Vistas* bring the text to life, from *The Narrow Way*, which depicts the hollowed-out walls allowing donkeys with their broad baskets to pass through the narrow streets, to the *Toledo Priest*, with his "bloated body and brutish face."[17] The inclusion of author and artist among the people and monuments of the city provides the reader with the vicarious feeling of actually being there, walking the same streets and seeing the same sites as are described in the text. Readers embarking on a journey of their own could

readily compare their own experiences with those presented by Lathrop and Reinhart, who had traveled there before them.

Toledo, as Lathrop's title for this chapter suggests, was a city that had lost its relevance in the contemporary world. The journey from Madrid to Toledo metaphorically signaled a voyage to the past, a place dominated by the imagination and fantasy. The shift from modernity to decadence had begun at Spain's frontier, remarked Lathrop, but "it was not until we reached Toledo that we really passed into a kind of forgotten existence."[18] The city, he continued, "has been a favorite with the novelists. The Plaza de Zocodover was the haunt of that typical rogue Lazarillo de Tormes; and Cervantes, oddly as it happens, connects the scene of *La Ilustre Fregona* with a shattered castle across the river, which by a coincidence has had its original name of San Servando corrupted into San Cervantes."[19] Following in the footsteps of Washington Irving (see cats. 15, 20, 107, and 108, for example), travel writers often mixed legends into their books about Spain; Lathrop followed suit, including one story in his chapter on Toledo about a lovesick Jewess whose tears made the water in her well bitter and another about a fierce family rivalry that led to a miraculous rescue near the Church of San Justo. Fiction, as well as fact, was used to teach readers about Spain.

Masking the fiction that infused nineteenth-century travel writing, and arguing for the veracity of Lathrop's *Spanish Vistas*, were several engraved photographs by Jean Laurent (for other examples of Laurent's photographs, see cats. 26, 35, 43, and 62). Popularly perceived as being more truthful than drawings, Laurent's photographs depict such architectural details as the cloister of San Juan de los Reyes, Seville's cathedral, and the Alhambra. In addition to these photographs, a *Spanish Peasant* by artist William Merritt Chase was also included in *Spanish Vistas* (cat. 67). Lathrop and Reinhart probably called on Chase, who was copying Velázquez's paintings in the Prado, when they passed through Madrid during the summer of 1881 (for more on this, see Piper's essay in this volume). This artist too made occasional use of photographs by Laurent for his own compositions.[20]

Spanish Vistas contains plenty of fiction, both in text and image. Lathrop stayed in Toledo's popular Fonda del Lino and described the view from the roof of this charming inn on the calle Santa Justa, just off the main square,

as including the main spire of the Cathedral, which is topographically impossible.[21] This digression provided the author with a convenient segue to his consideration of the ecclesiastical edifice. Similarly, in Reinhart's illustration *Men and Boys Slumber Out-of-Doors Even in the Hot Sun*, the artist included a fragment of the sepulcher of the Infante don Fernando Pérez inside the Capilla de Bélen at the Convent of the Comendadoras de Santiago, an interior rather than exterior monument, in the background of his composition (fig. 32). Disparate views of the city were sometimes combined in *Spanish Vistas* to provide a convenient segue, enhance the narrative, or reinforce a particular idea about Spain and the Spanish people. Readers rarely noticed such slippage in fact.

The complete text to which this illustration refers brings one of Lathrop's most negative characterizations of Toledo into focus: "Numbers of the inhabitants are always standing or leaning around drowsily, like animals who have been hired to personate [*sic*] men, and are getting tired of the job. . . . Men and boys slumber out-of-doors even in the hot sun, like dogs; after sitting meditatively against a wall for a while, one of them will tumble over on his nose—as if he were a statue undermined by time—and remain in motionless repose where he happens to strike."[22] Reinhart may not have even visited the chapel he drew behind this image; desirous of a recumbent statue with which to embroider Lathrop's words, he may simply have copied the sculptural fragment from a photograph picked up along the way. Animals and children appear throughout this text, bestialized and infantilized versions of the actual residents of Toledo.

In retrospect, these negative impressions of the city softened as the veil of memory descended over the scene. "Even now in remembrance," Lathrop recalled, "the blots on Toledo fade."[23] As author and artist made their way out of the city, they came upon a funerary procession of children conveying a bier with the body of a small child. "As the little rabble disappeared through the Puerta del Cambron, with their long candles dimly flaming, and the solemn childish face in their midst," Lathrop wrote, "it seemed to me that I beheld in allegory the departure from Toledo of that spirit of youth whose absence leaves it so old and worn."[24] Such was Lathrop's culminating metaphor for Toledo; it was dead, like Spain, and incapable of consequence in the future.

The following text appears within the illustration:

THE LOST CITY.

I.

T was of Spain's past and present that we
were speaking, and "What," I asked, "have we
given her in return for her discovery of our
New World?"

"The sleeping-car and the
street tramway," answered
Velveteen, with justifiable
pride.

He was right; for
we had seen the first
on the railroad, and
the second skimming
the streets of Madrid.
Still, the reward did
not appear great, meas-
ured by the much
that Spain's vent-
ures in the West-
ern hemisphere had
cost her, and by the com-
parative desolation of her present.
The devoted labors of Irving and Prescott,
which Spaniards warmly appreciate, are more
in the nature of an adequate return.

"It strikes me, also," I ventured to add, "that we are rendering
a service in kind. She discovered us, and now we are discovering her."

If one reflects how some of the once great and powerful places of
the Peninsula, such as Toledo and Cordova, have sunk out of sight
and perished to the modern world, this fancy applies with some truth
to every sympathetic explorer of them. It had been all very well to

Fig. 31 George Parsons
Lathrop, *Spanish Vistas*. New
York: Harper & Brothers,
1883, p. 34. Private Collection

Susan Hale's *A Family Flight through Spain*

Susan Hale (1833–1910), author of *A Family Flight through Spain*, was born in Boston, the last of Nathan and Sarah Preston Everett Hale's eight children.[25] She was well educated, like Elizabeth Champney, and eleven years younger than her brother Edward Everett Hale, who also wrote about Spain.[26] Hale made her first trip abroad in 1867 with her older sister Lucretia to visit another brother, Charles, then Consul General of the United States in Egypt. Aside from Spain, which she visited in 1882 and again with painter John Humphreys Johnston and his sister Fanny in 1887, Hale also traveled through the rest of Europe, Mexico, California, and Jamaica during the 1880s and 90s. She recorded these journeys in a series of travel books for children, often written in collaboration with her brother Edward. *A Family Flight through Spain*, the only book in the series authored solely by Susan, was based on their trip from May to June 1882 in the company of Edward's daughter, artist Ellen Day Hale, and a family friend, Mary Marquand.

The series of *Family Flight* books revolves around the travels of the Horner family, Mr. and Mrs. Horner, their four children, and their nanny, Miss Lejeune. Only Mr. Horner, Bessie, Tommy, and Miss Lejeune make the trip to Spain, but upon arrival in Madrid the group encounters several British children traveling alone with their governess to meet their father in Gibraltar. Two of these children—Hubert and Fanny Vaughan—join the Horner clan for the visit to Toledo. The group arrives in the ancient city eager to view the sites and quickly settles in at a pension run by the elderly Figueroa sisters, located at calle Santa Isabel, number 16.

Hale deftly combined passages of geographic and historical information with lighthearted descriptions of the children's reactions to the city. Playful dialogue between the various family members rounds out their characters. Bessie is a history buff, and she keeps her brother entertained with suspenseful stories about Roderick, "the last of the Goths." Her constant references to this historical personage eventually lead to an impatient question from young Hubert, their friend from England:

> "Who is Roderick the Goth?" demanded Hubert;
> "you keep referring to him."

"He was the last of the Goths, so called," said Miss Lejeune, "but we use his name because he was a famous one, and we have the Goths upon our minds, because during their rule in Spain, Toledo was their chief place; and while we are here, we expect to see the traces of their buildings and ways of doing things."

"I do not know anything about history," said Hubert with a tone partly scornful and partly meek, if such a combination can be possible.

"Well, you see, you are in Spain because you have to be," said Tommy; "but as we are here for fun, we want to get all the fun we can out of a country, by knowing all we can about it."[27]

Tommy's response reinforces the notion that advance study will lead to a more enjoyable journey. It also positions Tommy above his less educated companion.

Susan Hale had read *Spanish Vistas* before writing *A Family Flight through Spain*, and like Lathrop only one year earlier, she paid particular attention to the domestic life of the city.[28] Bessie and Fanny lean out their bedroom window to watch the supper preparations in the patio below. The girls are particularly intrigued by the elderly sisters' use of a cord to open the front door from the floor above, eliminating the need to descend the stairs. The huge interior patio was also equipped with a gigantic awning that could be opened or closed with pulleys to shade the courtyard from the blazing sun or admit the cool evening air. Venturing out with a guide, the family climbs the steep, winding streets of the city, passes through the Puerta del Sol, and explores the elaborate architectural details of San Juan de los Reyes. As an amateur artist, Miss Lejeune notes with appreciation Toledo's ample opportunities for sketching.

Hale's brother Edward expressed his hope in a letter to his wife that the publishers of *A Family Flight* might use some of Susan's drawings as illustrations for her book, but none appear to have been used in the finished text. He complained about the other travel books he read and thought his sister's work would reveal "some elements which most books of travel lack."[29] Instead, *A Family Flight through Spain* includes illustrations by the same cadre of artists found in books by other authors: the Frenchman Gustave Doré; the Hungarian Alexander

more than the usual Latin disregard for public decency, the streets and houses are allowed to become pestilential, and drainage is unknown. Enervating luxury of that sort did well enough for the Romans and Moors, but is literally below the level of Castilian ideas. In the midst of the most sublime emotion aroused by the associations or grim beauty of Toledo, you are sure to be stopped short by some intolerable odor.

"MEN AND BOYS SLUMBER OUT-OF-DOORS EVEN IN THE HOT SUN."

The primate city was endowed with enough of color and quaintness almost to compensate for this. We never tired of the graceful women walking the streets vestured in garments of barbaric tint and endlessly varied ornamentation, nor of the men in short breeches split at the bottom, who seemed to have splashed pots of vari-colored paint at hap-hazard over their clothes, and insisted upon balancing on their heads broad-

Fig. 32 Charles Stanley Reinhart, *Men and Boys Slumber Out-of-Doors Even in the Hot Sun*, from George Parsons Lathrop, *Spanish Vistas*. New York: Harper & Brothers, 1883, p. 37. Private Collection

Wagner, whose illustrations were originally published in Theodor Simons's *Spanien* (Berlin, 1880); and the New England illustrator William Parker Bodfish, who published his own book the very same year. The practice of recycling illustrations from text to text promoted a one-dimensional view of Spain. With the same or only slightly altered images repeatedly presented to the reading public, the vast majority of whom never actually visited the country, romantic views of Spain were slow to change.

Through Spain on Donkey-Back with William Parker Bodfish

William Parker Bodfish, the last of these four authors and one of the most inventive illustrators to travel to Spain, is virtually unknown today.[30] Active between approximately 1880 and 1896, Bodfish may have had roots in Massachusetts, where a well-known family of that name, including several members named William Parker Bodfish, lived on Martha's Vineyard in the late nineteenth century.[31] Aside from producing the illustrations and text for *Through Spain on Donkey-Back*, several of which were also reproduced in Susan Hale's *A Family Flight through Spain* of the same year, Bodfish also provided illustrations for a book about colonial life in Vermont by Luthera Whitney called *Old-Time Days and Ways* (1883); a children's book by Amanda B. Harris called *Queer People* (1886); Mary E. Wilkins's *Sunshine for All: Stories and Poems* (1895); and Sophia Miriam Swett's *The Ponkaty Branch Road: And Other Stories for Young People* (1896).

Through Spain on Donkey-Back was published in book format for the Christmas season, with children as its intended audience (fig. 33).[32] Completely ignoring Spain's capital city, Bodfish focused instead on old cities like Toledo and traditional, rather than modern, pastimes. He introduced Spanish holiday customs into his text, including youngsters with noisy *zambombas* (a type of drum), girls roasting chestnuts, and the lively turkey market on the main plaza of Toledo. The doorway of Santa Isabel de los Reyes, located in a completely different part of the city, is visible in the background of this last drawing. Bodfish often enlivened his illustrations with domesticated animals, paying especial attention to the ubiquitous Spanish burro, obediently carrying any number of heavy items on its back. The donkey, who supposedly transported Bodfish through Spain, is never named, but

he is featured at both the beginning and the end of the text, humorously punching his way through the skin of a tambourine. The text for *Through Spain on Donkey-Back* faithfully follows the illustrations; the artist probably traveled through Spain during the winter of 1882 and composed his accompanying narrative after returning to the United States.

Bodfish portrayed in his drawings a wide variety of individuals engaged in private enterprise, among them beggars pleading for alms before the iron gates of a mansion, fruit and vegetable vendors selling their produce in the streets, farmers bringing hay to market with the aid of a string of donkeys, a merchant carrying wine-skins, and water peddlers transporting the precious liquid to the homes of their customers. Toledo's water system, which fascinated visitors to the city (see Blum's *Toledo Water-Carrier*, cat. 41, for example), required the use of either donkeys or wheelbarrows; upon arrival at a private residence, the water vendor transferred enough water from his jars to supply the household for the day (fig. 34, bottom left and bottom right). Some patios, including the one depicted in Bodfish's drawing *The Patio of a Fonda*, had old Moorish wells, which during the wet season provided supplementary water for domestic use (fig. 34, center). The focus on scenes of manual labor offered viewers a welcome opportunity to envision an earlier time in history, a period free from the anonymity and regimented nature of modern industrialized life in the United States (for more on this, see Ruud's essay in this volume).

Bodfish's interest in the domestic life of his Toledan hosts, like that of other travelers who visited the city in the early 1880s, resulted in a detailed description of the rooming house at number 16, calle Santa Isabel. He depicted a serving girl pouring water from one jar to another in a sunny patio decorated with potted plants and a marble tiled floor. Above her, to the right, is the elaborate shading system that Susan Hale described in *A Family Flight through Spain*. *The Interior of a Dwelling*, the vignette placed above the patio scene, provides an interior view of a room in the Figueroa *fonda* (fig. 34, top left). A single woman sits with her cat in a sparsely furnished chamber, warming herself by the coals of a charcoal brazier. To her side is a small round tea table, behind is an empty chair placed in a window alcove, and to the right of the image is a partly open portiere. The floor appears to be constructed

Fig. 33 Title page from William Parker Bodfish, *Through Spain on Donkey-Back*. Boston: D. Lothrop & Co., 1883, title page. Private Collection

Fig. 34 *The Patio of a Fonda*, from William Parker Bodfish, *Through Spain on Donkey-Back*. Boston: D. Lothrop & Co., 1883, unpaginated. Private Collection

of roughly hewn boards, while massive wooden doors separate the room from the window alcove behind, and a crucifix ornaments the wall. These images reiterate the simple yet picturesque nature of life in a quaint old Spanish city.

Learning about Spain, Learning about the World

Scholars, in the words of Cara Byrne, are deeply aware that "all children's literature is inherently political as the genre imagines a child reader and the lessons or belief systems that s/he should hold."[33] Travel writing is likewise political, for travel books, according to literary critic Mary Louise Pratt, create a sense of curiosity, excitement, familiarity, and ownership with respect to distant parts of the world.[34] The visual images that accompany these texts, too often accepted as transparently objective, are likewise making political arguments about the subject at hand. Travel books create expectation in the mind of the traveler, and their images, employing a variety of techniques to promote themselves as unbiased and real, are as deceptive as they are persuasive. It is not uncommon to find the same illustrations in multiple sources, photographs included as a means of asserting the veracity of a text, and images that conform to previously accepted ideas. Often based on individual sketches sutured together into impossible if appealing compositions, these images derive as much from earlier ones as from actual observation. Like children's literature in general, travel books set up an unequal relationship between the creators—author and artist—and the reader. Readers need to challenge this inequitable situation. For what was done in children's travel literature from the nineteenth century is also done in travel literature written for children and adults today.

THE INTERIOR of a DWELLING

THE WAY A ROOM IS HEATED IN WINTER BY A CHARCOAL BRAZIER

TOLEDO: LA FONDA DE LAS DOS HERMANAS.

THE PATIO of a FONDA

WATER JARS,

SWEEPING

IN THE WATER CELLAR

NECESSITIES of LIFE

NOTES

This essay is dedicated to the memory of José Pedro (Josepe) Muñoz Herrera (1959-2015), who shared his deep knowledge of Toledo while first looking at these books with me.

1. Castilian (Spanish), Galician, Basque, and Catalan comprise the four primary languages spoken in Spain.

2. Timothy Mitchell makes this point in "The World as Exhibition," *Comparative Studies in Society and History* 31, no. 2 (April 1989): 234-36.

3. Biographical information may be found in *James Wells Champney, 1843-1903* (Deerfield, MA: Hilson Gallery, Deerfield Academy, 1965); Wendy Alexander, "Elizabeth Williams Champney: A Biographical History," unpublished manuscript, 1974, and Brooke Hunter, "The Champneys and Their Presence in Deerfield," unpublished manuscript, 1994, both in the James Wells Champney Papers, the Pocumtuck Valley Memorial Association Library, Deerfield, Massachusetts; and Judy James Bellamy Bullington, "The Artist-as-Traveler and Expanding Horizons of American Cosmopolitanism in the Gilded Age" (PhD diss, Indiana University, 1997).

4. J. Wells Champney, "Among the Carlists," *Appletons' Journal* 15 (May 27, 1876): 673-76 and (June 3, 1876): 705-707; Lizzie W. Champney, "Father Tolo's Umbrella," *The Galaxy* 22 (July 1876): 61-66.

5. Elizabeth W. Champney, *Three Vassar Girls Abroad: Rambles of Three College Girls on a Vacation Trip through France and Spain for Amusement and Instruction* (Boston: Estes and Lauriat, 1882), 74-77. For a further display of Champney's deep interest in contemporary painters from Spain, see "In the Footsteps of Fortuny and Regnault," *Century Magazine* 23 (November 1881): 15-34.

6. Champney, *Three Vassar Girls Abroad*, 108.

7. The series of articles appeared in *Le Tour du Monde* between 1872 and 1873. Doré had made his first visit to Spain in 1855 in the company of Théophile Gautier, author of *Voyage en Espagne*, another early guidebook to Spain. Doré's second trip, with Davillier in 1861 and 1862, allowed him to amplify his repertoire of Spanish imagery.

8. Fred Ober, *The Knockabout Club in Spain* (Boston: Estes and Lauriat, 1889).

9. James Cutting, "Mere Exposure, Reproduction, and the Impressionist Canon," in *Partisan Canons*, ed. Anna Brzyski (Durham, NC: Duke University Press, 2007), 81-82.

10. Elizabeth W. Champney, "The Romance of Two Cameras," *Century Magazine* 40 (May 1890): 117-24.

11. Champney, "The Romance of Two Cameras," 117.

12. Elizabeth W. Champney, *Witch Winnie in Spain* (New York: Dodd, Mead and Company, 1898), 87.

13. Rico's *Plaza, Toledo* was in the collection of William H. Stewart, a US collector who lived in Paris. See *Catalogue De Luxe of the Modern Masterpieces Gathered by the Late Connoisseur William H. Stewart* (New York: American Art Association 1898), no. 120.

14. Champney, *Witch Winnie in Spain*, 145.

15. For biographical information on Lathrop, see "George Parsons Lathrop," in *The National Cyclopaedia of American Biography* (New York: James T. White, 1899), vol. 9, 193-94; "George Parsons Lathrop," in *Dictionary of American Biography*, ed. Dumas Malone (New York: Charles Scribner's Sons, 1943), vol. 11, 15-16; for biographical information on Reinhart, see "Charles Stanley Reinhart," in *Dictionary of American Biography*, ed. Dumas Malone (New York: Charles Scribner's Sons, 1935), vol. 8, 490-91.

16. Lathrop's book was serialized in *Harper's New Monthly Magazine* 64 (April 1882): 640-62; 64 (May 1882): 801-20; 65 (July 1882): 205-22; 65 (August 1882): 371-92; 65 (September 1882): 346-66. See also "The Spanish Peninsula in Travel [A Review of Lathrop's *Spanish Vistas*]," *The Atlantic Monthly* 52 (September 1883): 408-11.

17. George Parsons Lathrop, *Spanish Vistas* (New York: Harper & Brothers, 1883), 36, 53-54.

18. Lathrop, *Spanish Vistas*, 35.

19. Lathrop, *Spanish Vistas*, 39.

20. See M. Elizabeth Boone, *"Vistas de España": American Views of Art and Life in Spain, 1860-1914* (New Haven: Yale University Press, 2007), 170-71.

21. Lathrop, *Spanish Vistas*, 52.

22. Lathrop, *Spanish Vistas*, 66.

23. Lathrop, *Spanish Vistas*, 68.

24. Lathrop, *Spanish Vistas*, 69.

25. Biographical information may be found in "Susan Hale," in James Grant Wilson and John Fiske, eds., *Appletons' Cyclopaedia of American Biography* (rev. ed., New York, D. Appleton and Company, 1900), vol. 3, 33; Caroline P. Atkinson, ed., *Letters of Susan Hale* (Boston: Marshall Jones Company, 1919).

26. Edward E. Hale, *Seven Spanish Cities and the Way to Them* (Boston: Roberts Brothers, 1883). Hale wrote a second book about Spain in collaboration with his sister Susan; see Edward Everett Hale and Susan Hale, *The Story of Spain* (New York: G. P. Putnam's Sons, 1886).

27. Susan Hale, *A Family Flight Through Spain* (Boston: D. Lothrop & Company, 1883), 100.

28. Hale included a detailed floor plan of the rooming house in an unpublished letter about her visit to Toledo. See Susan Hale, letter to her sister Lucretia, June 20, 1882. Hale Family Papers, Sophia Smith Collection, Smith College Libraries, Northampton, Massachusetts.

29. Edward E. Hale, Jr., *The Life and Letters of Edward Everett Hale* (Boston: Little,

Brown, and Company, 1917), vol. 2, 301. The one exception may be a drawing titled "A Placid Family," which depicts a family group comfortably ensconced in a railway carriage. See Hale, *A Family Flight*, 15.

30. For limited biographical information, see Peggy and Harold Samuels, *The Illustrated Biographical Encyclopedia of Artists of the American West* (Garden City, NY: Doubleday & Company, 1976), 52.

31. According to records maintained by the Martha's Vineyard Museum, a person named William Parker Bodfish was born November 16, 1864, to a father with this same name. See Historical Records of Tisbury, Dukes County, Massachusetts, http://history.vineyard.net/.

32. William Parker Bodfish, *Through Spain on Donkey-Back* (Boston: D. Lothrop & Co., 1883). Bodfish's book was also serialized in *Wide Awake: An Illustrated Magazine for Young People* 16 (April 1883): 337–40; 16 (May 1883): 441–45; 17 (June 1883): 59–62; 17 (July 1883): 125–27; 17 (August 1883): 189–91; 17 (September 1883): 237–40. See also "Through France in Sabots," *Wide Awake: An Illustrated Magazine for Young People* 18 (December 1883): 47–50; 18 (February 1884): 175–77; 18 (April 1884): 306; 19 (June 1884): 31–33; 19 (September 1884): 225–27.

33. Cara Rose Byrne, "Illustrating the Smallest Black Bodies: The Creation of Childhood in African American Children's Literature, 1836–2015" (PhD diss., Case Western Reserve University, 2016), 22.

34. Mary Louise Pratt, *Imperial Eyes: Travel Writing and Transculturation* (2nd ed., London: Routledge, 2007), 3.

66

JAMES CRAIG ANNAN

SCOTTISH, 1864-1946

A Carpenter's Shop—Toledo, from Camera Work, No. 45

January 1914 · Photogravure · 8¼ × 11¾ in. (21 × 29.8 cm)

Chrysler Museum of Art, Museum purchase, 89.143.3

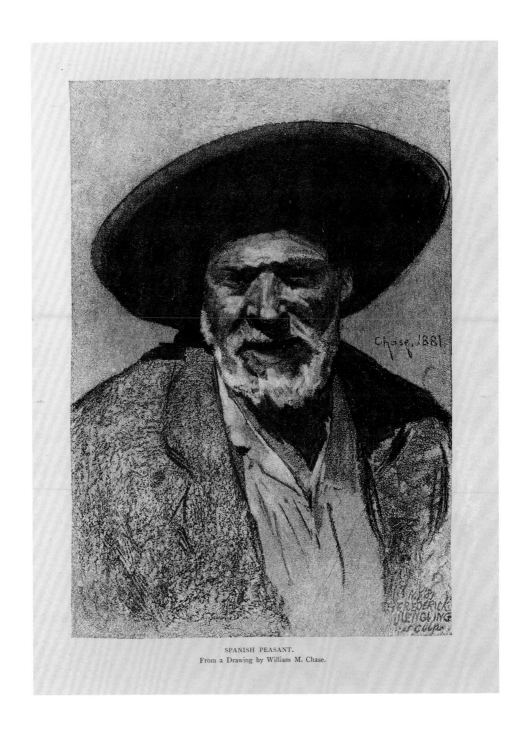

SPANISH PEASANT.
From a Drawing by William M. Chase.

67

FREDERICK JUENGLING
AMERICAN, BORN GERMANY, 1846–1889
AFTER WILLIAM MERRITT CHASE
AMERICAN, 1849–1916

Spanish Peasant

1883 · Wood engraving · 9 × 6⁹⁄₁₆ in. (22.86 × 16.67 cm) ·
From George Parsons Lathrop, *Spanish Vistas*. New York: Harper & Brothers

Private Collection

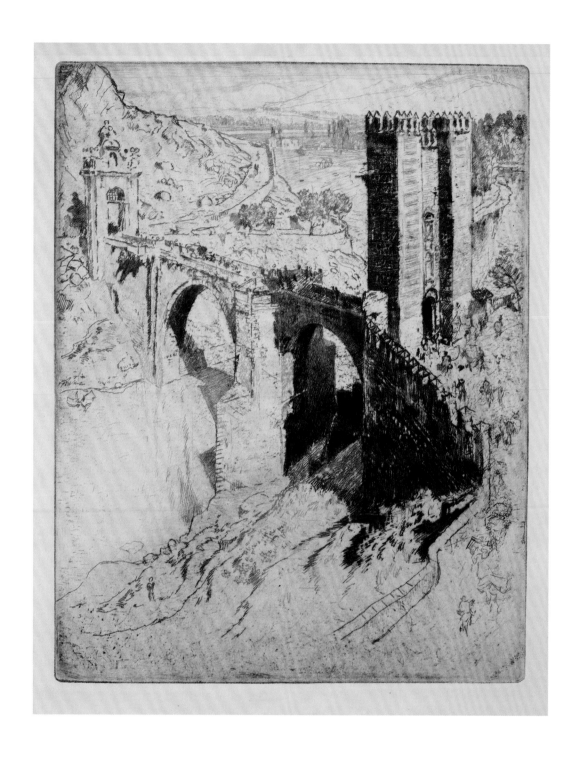

68

JOSEPH PENNELL
AMERICAN, 1857–1926

Bridge of Alcántara, Toledo

1904 · Etching mounted on board · 15¹¹⁄₁₆ × 11¾ in. (39.8 × 29.8 cm)

Milwaukee Art Museum, gift of Mr. and Mrs. Walter J. Goldsmith,
M1981.208

69

CHARLES CLIFFORD

ENGLISH, 1821–1863

Puerta del Sol, Toldeo

ca. 1860 · Albumen print · 16¼ × 12¹⁄₁₆ in. (41.3 × 30.6 cm)

Chrysler Museum of Art, gift of Charles Isaacs and Carol Nigro,
97.40.3

"Not to Be Confounded with the Mere Act of Copying"

AMERICANS IN SPAIN AND OLD MASTERS IN THE UNITED STATES DURING THE LATE NINETEENTH CENTURY

Corey Piper

IN THE FALL OF 1874, THE RECENTLY FORMED MUSEUM OF Fine Arts, Boston, mounted a grand exhibition of the collection of the Duke of Montpensier, Prince of the House of Orléans, on loan from the Duke's residence in Seville and installed in the Boston Athenaeum. The exhibition presented one of the largest and most distinguished groups of Spanish old master paintings ever seen together in the United States, featuring canvases by Velázquez, Murillo, Ribera, Zurbarán, and other painters of Spain's Golden Age. Altogether, the venture proved a great success in attracting large crowds of visitors and acclaim for both the celebrated old masters and the magnanimous Duke.[1] One reviewer, however, challenged the didactic value of the enterprise, casting doubts on whether firsthand experience with Spanish old masters contributed anything substantial to the public's aesthetic education. In the pages of the journal *Old and New*, the painter and critic William James Stillman pondered, "It is a question raised anew by the coming of the Spanish pictures, and not so readily settled as might be supposed, whether the art of past epochs is really an aid to *popular* art-education, and, consequently, whether galleries of old masters are of any use in other than *technical* development—the training of artists, and not the formation of tastes."[2] The multitudes of American artists and likeminded travelers who journeyed vast distances to experience Spain's storied collections would seem to offer an affirmative answer to Stillman's query, that the study of the country's old masters could indeed shape tastes broadly and profoundly in other aesthetic realms.

During the final decades of the nineteenth century, a steady stream of paintings traversed the Atlantic from Spain to the United States, composed of works by Spanish old masters and American painters. While the enthusiasm for Spain's old masters among Gilded Age collectors and the broader art public has been well documented in recent art historical studies, the reception for American artists' work produced in and around their time in Spain been less extensively detailed.[3] Rather than forming two separate histories, the reception of Spanish painting in the United States and that of American painters' Spanish works were thoroughly intertwined. The paintings American artists created out of their experiences in Spain were indeed frequently exhibited and commented upon back in the United States, but they entered into an art world in which a multitude of genres, styles, and schools competed for the public's attention. Focusing on a select group of American painters among the many who traveled to Spain, this essay examines the ways in which old master precedents frequently overlaid responses to Americans' Spanish-themed paintings, and it charts the ways in which American artists both embraced and pushed back against such associations. Copies after old masters played an essential role in framing the public's expectations, by building awareness of stylistic tenets of Spanish painting and by aligning the copyists' own original works with those of the most famous old masters. Artists further exploited such associations in their original compositions, using works based on their time in Spain as a forum for experimentation and bold new directions in their own painting, as Spanish old masters

were frequently held up as harbingers of modern values in the painting of directness, realism, and painterly bravado.

For most American painters who traveled to Spain, the opportunity to study the collection of Spanish old masters at Madrid's Prado Museum ranked among the country's principal attractions. Until late in the nineteenth century, only scattered examples of Spanish old master painting could be found in American collections, such as that assembled by the Philadelphia-born collector Thomas Jefferson Bryan, a collection that was placed on view at the New-York Historical Society in 1867. The collection included several canvases then thought to be by Bartolomé Esteban Murillo and a portrait of *Queen Mariana,* at the time credited to Diego Velázquez and now attributed to his son-in-law Juan Bautista Martínez del Mazo (cat. 70). The Prado, with its staggering concentration of masterworks from the Spanish Royal Collections, offered an exhaustive catalogue of Spanish old master painting that left many American painters overwhelmed (see, for example, cats. 75 and 76). After seeing the museum for the first time, Thomas Eakins famously exclaimed, "I have seen big painting here," while William Merritt Chase proclaimed, "Velazquez is the greatest painter that ever lived."[4] Upon her first arrival in Madrid, Mary Cassatt reported to her friend Emily Sartain that she was reeling from the paintings she had encountered on the walls of Madrid's museums, and was diligently studying photographs of famous paintings in order to prepare herself for the next stop on her journey in Seville.[5]

Cassatt first registered as a copyist at the Prado on October 5, 1872, and though she was the only American artist recorded that year, she encountered several fellow artists from France who were copying in the museum at the same time.[6] Copying after old masters was a well-established part of the curriculum in Europe's fine art academies, and young painters were especially drawn to the museum's collections for their didactic value. John Singer Sargent and Thomas Eakins both embarked on journeys to study Spanish painting under encouragement from their teachers, Carolus-Duran and Léon Bonnat, two Frenchmen who were themselves ardent devotees of the work of Velázquez. Chase made numerous studies after old masters in German collections during his studies at the Academy of Fine Arts in Munich, including a copy after Velázquez's *Self-Portrait* at Munich's Pinakothek,

before his first visit to Spain in 1881, which included a dedicated campaign of copying at the Prado. While copying was traditionally rooted in academic practice, it was equally pursued by independent-minded painters. Prior to his first visit to Spain, Édouard Manet spent time copying one of the Louvre's most famous Spanish masterpieces, then thought to be by Velázquez, known as *The Gathering of Gentleman* or *The Little Cavaliers*, which was also reportedly copied by James McNeill Whistler (cat. 71).[7]

Although some copies functioned merely as student lessons, never seeing the light of day, others circulated broadly in a variety of contexts, from public exhibitions to the walls of artists' studios. Far removed from their original museum setting, such copies offered the opportunity to understand the style and manner of the old master original, but also to appreciate the skill, technique, and creative facility of the copyist.[8] In the fall of 1882, Chase exhibited a group of copies created in the Prado the previous summer at the Art Students League monthly exhibition, including his copy after Velázquez's *Aesop* and six other paintings after the artist (cat. 72). In choosing the progressive Art Students League to show such canvases, Chase clearly intended the works as a showcase of his artistic allegiances as well as his own painterly acumen. At least one reviewer enthusiastically received the work this way, declaring, "Nothing exhibits more forcibly Mr. Chase's versatility, and that faculty of being able to throw himself into the conditions which influence other men in their work. This demands a certain imaginative power, and is not to be confounded with the mere act of copying."[9]

In November 1883, the Metropolitan Museum of Art presented *The Loan Exhibition of Copies of Old Masters,* which assembled a group of nearly two hundred copies after paintings by Rembrandt, Titian, Velázquez, and other celebrated old masters held in European collections. The exhibition was organized by the American artist John W. Mansfield and largely drew upon the copy work of other American painters, with a few canvases supplied by European artists. Velázquez was the second most popular old master on the walls of the exhibition, represented by twenty-two copies, which were joined by a few scattered copies after Murillo and Jusepe de Ribera.[10] The assemblage of famous masterpieces from throughout Europe transported visitors on a whirlwind tour of its famous collections including the National Gallery in London, the

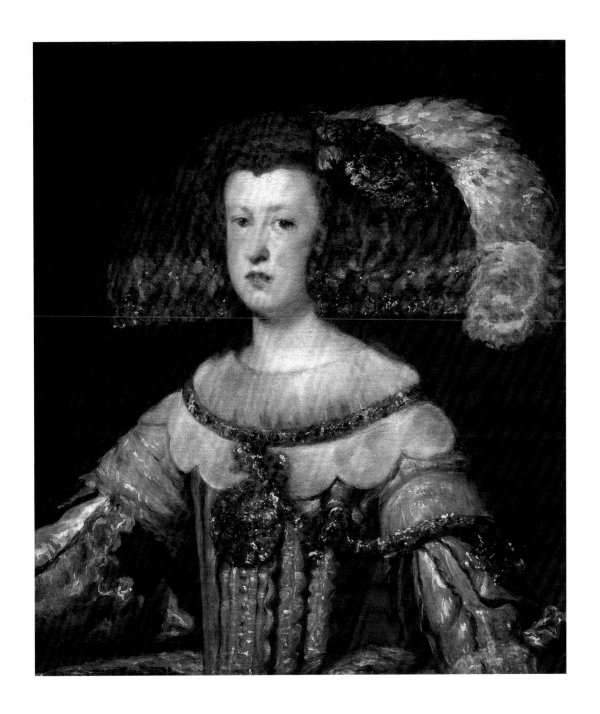

70

ATTRIBUTED TO JUAN BAUTISTA MARTÍNEZ DEL MAZO

SPANISH, 1591–1652

Queen Mariana

ca. 1652–53 · Oil on canvas · 27 × 23½ in. (68.58 × 59.69 cm)

New-York Historical Society, gift of Thomas Jefferson Bryan, 1867.209

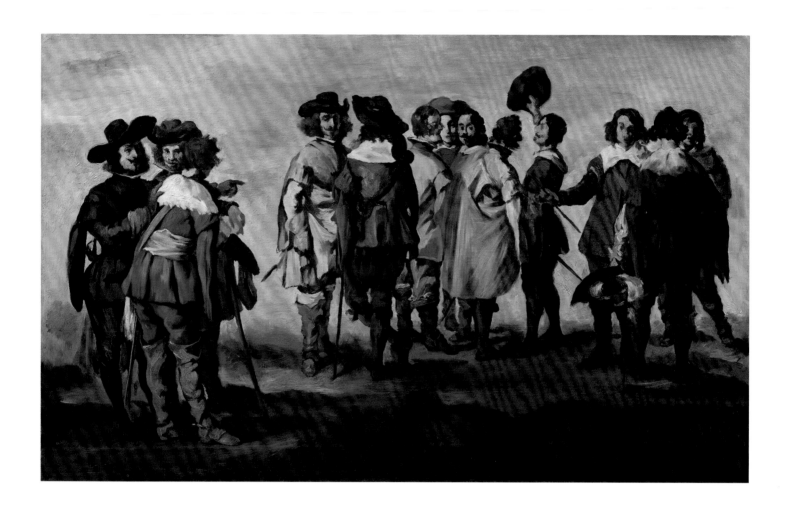

71

ÉDOUARD MANET

FRENCH, 1832–1883

The Little Cavaliers

ca. 1860 · Oil on canvas · 18 × 29¾ in. (45.7 × 75.6 cm)

Chrysler Museum of Art, gift of Walter P. Chrysler, Jr., 71.679

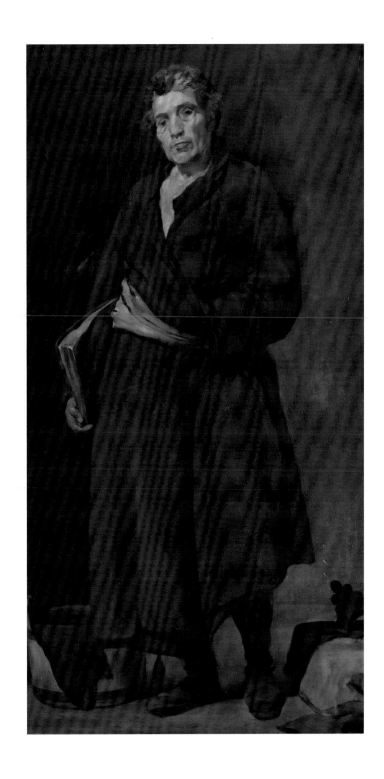

WILLIAM MERRITT CHASE
AMERICAN, 1849–1916

Copy of Velázquez's Aesop

1882 · Oil on canvas · 70 × 36 in. (177.8 × 91.4 cm)

Courtesy of Steven Israel

Louvre, the Academy of Fine Arts in Venice, and Madrid's Prado Museum. In addition to a survey of Europe's collections, the submissions also traced the paths of the young American art students who flocked to Europe's academies and art centers. Chase, who along with Robert Frederick Blum and James Carroll Beckwith, had recently returned from Spanish sojourns, supplied copies after notable works in the Prado (for more on this, see Ruud's essay in this volume).

The exhibition elicited mixed responses, but these largely focused on the merits of the copyists rather than the value of the old masters represented. One reviewer praised the exhibition as a means to trace the contours of American painting through the copyists' primary points of influence:

> Frequent suggestion is offered in the interesting series of certain predilections in style which have influenced different artists, so far as is to be inferred from the presence of repeated copies by the same hand from a favored master. In no less a degree are indicated general tendencies, as the specially noticeable one of the different spirit of appreciation grown within the younger artists, which among other signal movements, prompts the more frequent copying of Velasquez and of Franz Hals.[11]

Though many of the canvases closely replicated old masters, others, like Blum's copy after Ribera's *The Trinity* at the Prado, showcased both the copyist's technical skill and capacity for creative observation (cat. 73; fig. 35). For those unfamiliar with the original in Madrid, the exhibition's catalogue clarified that the copy was not a direct replica but rather an interpretive study: "The figure is nearly life size in the original, and is one of many in a large picture."[12] In his composition Blum focused his attention tightly on the figure of the lifeless Christ, exploring the tension between the naturalistic description of the flesh and the free approach to the application of the paint. The result is a new work of art in which Blum has closely studied the stylistic and compositional features of Ribera's canvas and synthesized these into something related to but independent of the original.

While some critics appreciated the assemblage of copies as a means to appraise the skills and aesthetic

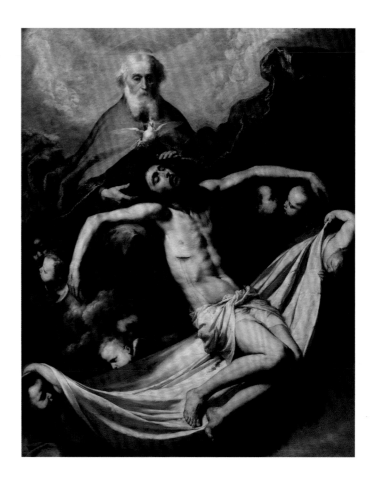

Fig. 35 Jusepe de Ribera, *The Trinity*, ca. 1635. Oil on canvas. Museo Nacional del Prado, Madrid, P001069

interests of the American copyists, not all found value in the result. Mariana Griswold Van Rensselaer deemed the exhibition to be largely without merit, with the exception of Chase's Prado copies, writing, "A few of them were very good, notably Mr. Chase's copies of the large Velasquez canvases at Madrid; but many of them were bad, served no good end either in proving the dexterity of the painters, or in informing our untraveled public of the true appearance of the famous works they professed to reproduce."[13] The presentation may have been overshadowed by the Pedestal Fund Art Loan Exhibition at the National Academy of Design, which opened in December 1883 and ran nearly concurrently to the Met's exhibition of copies. The Pedestal Fund Exhibition featured a lengthy catalogue of modern French painting, including several canvases by Manet that demonstrated his dialogue with Velázquez and

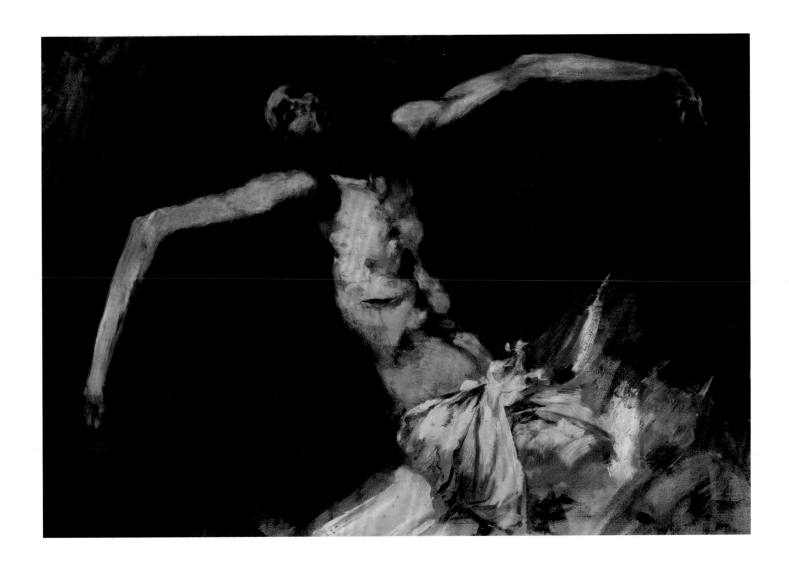

73

ROBERT FREDERICK BLUM

AMERICAN, 1857–1903

Study of Christ after Ribera

1882 · Oil on canvas · 19⅜ × 27¾ in. (49.2 × 70.5 cm)

Cincinnati Art Museum, Gift of Henrietta Haller, 1905.144

149

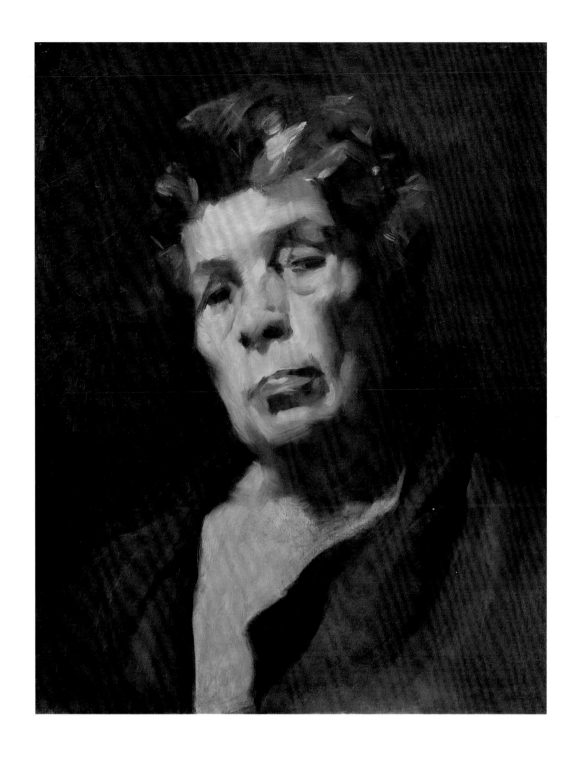

JOHN SINGER SARGENT

AMERICAN, 1856–1925

Head of Aesop

1879 · Oil on canvas · 18⁵⁄₁₆ × 14⁵⁄₈ in. (46.4 × 37.2 cm)

Ackland Art Museum, The University of North Carolina at Chapel Hill, Ackland Fund, 75.16.1

Spanish painting.[14] Chase, who served as the chair of the selection committee for that exhibition, must have relished the opportunity to highlight the influence of Velázquez upon the leading currents of modern French painting, while his own work was beginning to be recognized for the same affinities, and his copies made at the Prado were attracting attention while on view just across town.

Outside of public exhibitions, copies after Spanish old masters were sometimes encountered in painters' studios, where their reception was more carefully orchestrated. For artists like Chase and Sargent, who maintained their studios as public expressions of their artistic persona, the display of copies after old masters offered a clear declaration of their aesthetic influences and allegiances while also signaling their learnedness and eclecticism. During his 1879 visit to Spain, Sargent spent more than a month copying in the Prado, producing at least nine copies after Velázquez (or paintings then thought to be by Velázquez; cat. 74) and one copy after Ribera. Sometime shortly thereafter he installed two of these in his Paris studio: a loosely sketched copy of *Las Hilanderas* and the largest of his copies, *Dwarf with a Dog* (fig. 36).[15] A photograph of Sargent in his studio from around 1884 shows the prominence of these works, with *Dwarf with a Dog* visible in the line of sight behind Sargent's notorious *Madame X* (1883–84; Metropolitan Museum of Art), proudly displayed on the easel next to the painter (fig. 37). As both a private and public space, Chase's New York studio functioned as an immersive aesthetic environment, carefully populated by objects that expressed his artistic temperament and aesthetic sophistication.[16] Chase's copies after Velázquez, as well as copies after other old masters, were frequently singled out among the catalogue of exotic objects by the numerous authors who published accounts of his studio. Calling attention to the Velázquez copies that lined the walls of the studio, W. A. Cooper declared, "possibly, one can trace the great Spanish master's influence more than that of any other man or school in Mr. Chase's work."[17] Beyond the cornucopia of exotic bric-a-brac that populated the studio, Chase's copies after old masters not only signaled the directions of his past studies but also helped provide a reference point that subtly shaped the ongoing critical reception of his work.

The practice of copying old masters at the Prado remained an integral part of academic training and artistic

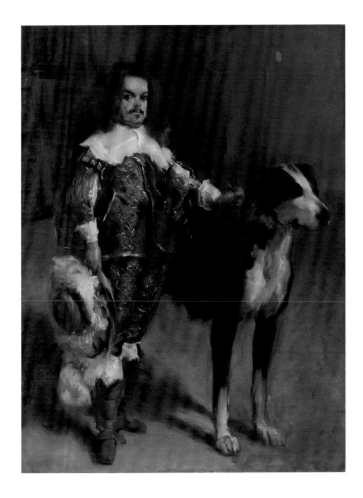

Fig. 36 John Singer Sargent, Copy after the so-called Don Antonio, *"El Inglés" (Dwarf with a Dog)*, thought to be by Velázquez, 1879–80. Oil on canvas. The Hispanic Society Museum and Library, A1960

travel to Spain well into the twentieth century, but the public prominence and exhibition of such copies diminished in significance. Upon his first visit to Spain in 1900, Robert Henri devoted time to making a number of copies at the Prado after Velázquez, an artist he had long admired, including the monumental *Queen Mariana* (see cat. 95). Despite the canvas's imposing scale and presence, Henri valued his copies primarily as personal learning tools and referents for his own independent work, rarely exhibiting them.[18] Several significant exhibitions of copies were mounted in the early years of the twentieth century, including at Boston's Copley Society in 1906 and the Art Institute of Chicago in 1910, both of which prominently featured copies after Velázquez paintings at the Prado. Perhaps owing to the growing presence of Spanish old masters in US public collections, however, the enthusiasm for such exhibitions had dampened significantly since the Metropolitan Museum's exhibition of copies several decades earlier. A critic for the *Burlington Magazine* roundly panned the exhibition at the Copley Society, but singled out Chase for a bit of withering praise: "Exception

may be made for the copies of William M. Chase, one of our most accomplished technicians. Displaying rather little temperament in his original work, he has a rare gift of conveying it from canvases as different as those of Hals, Rembrandt, and Velazquez."[19] In 1917 Beckwith sought to revive an exhibition of his large collection of copies of old masters, including those he had made nearly forty years earlier at the Prado. The artist died just before they were installed at the Cleveland Museum of Art. In the museum's bulletin, the artist Edwin Howland Blashfield simultaneously praised the copies and offered a nostalgic eulogy of his esteemed colleague's time spent studying the old masters, writing, "Mr. Beckwith's were copies made for love and without *arrierepensee* [*sic*]."[20]

American artists who traveled to Spain ventured beyond the walls of the Prado, finding subjects among the people, places, and cultural traditions of modern Spain. With often limited firsthand knowledge of the country's political and social climate, American critics frequently fell back upon the familiar barometer of old master painting in their interpretation of such subjects. George

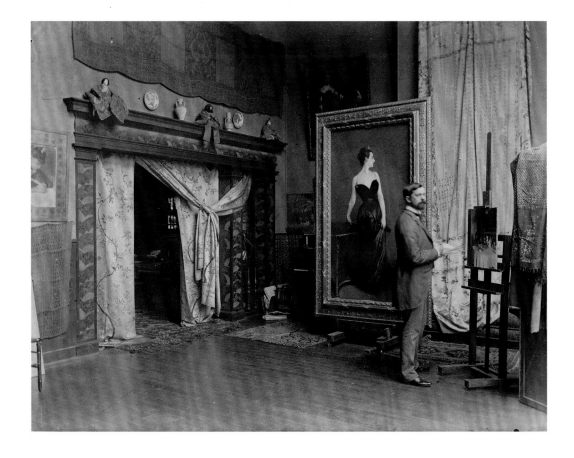

Fig. 37 Photographer unknown, John Singer Sargent in his studio, ca. 1884. Photographic print. Photographs of Artists in their Paris Studios, 1880–1890. Archives of American Art, Smithsonian Institution, 3850

75

JUSEPE DE RIBERA

SPANISH, 1591–1652

Saint John the Baptist in the Desert

1641 · Oil on canvas · 71¾ × 59 in. (182 × 150 cm)

Museo Nacional del Prado, Madrid, P001108

76

BARTOLOMÉ ESTEBAN MURILLO

SPANISH, 1617–1682

The Immaculate Conception
of El Escorial

1660–65 · Oil on canvas · 81 × 56¾ in. (206 cm × 144 cm)

Museo Nacional del Prado, Madrid, P000972

Henry Hall was among the earliest American artists to make prolonged journeys to Spain, where he focused his attention on the streets and public spaces of its cities. Best known as a painter of still lifes, his first departure in 1860 was heralded in the press as a means to refine his work among the examples of Spanish art and culture: "Mr. George H. Hall, well known as one of the best colorists, if not the best, amongst our American artists, is about to spend two years in Spain, the land of color *par excellence*, travelling, sketching, and collecting reminiscences of all kinds for future use."[21] Hall settled in Seville, the hometown of Murillo, then the most highly esteemed of the Spanish old masters in the United States. In choosing his subjects, Hall hewed closely to Murillo's secular staples of beggar children and street life, subjects which had long captivated visiting foreign artists like the British painter John Phillip, who had preceded Hall to Seville by about a decade.

Hall enjoyed a productive period in Seville, even managing to exhibit his work locally. American journals proudly published a notice that appeared in the Spanish press, extolling Hall's accomplishments: "We recommend to the lovers of the art of Murillo to visit the well-known establishment of Muxart, in which they will be able to admire two pictures, which, for some days past have with justice claimed the attention of connoisseurs."[22] Upon returning to the United States, Hall found a ready venue for his abundant catalogue of Spanish material at the National Academy of Design. Over the ensuing decade, the artist established a pattern of submitting a mix of his popular still life pieces and Spanish genre scenes to the Academy's annual exhibition. The Spanish paintings received scattered praise from critics, perhaps drawn to the novelty of his subject matter. Describing *Anita*, a painting of a young Spanish peasant exhibited in 1863, one reviewer waxed, "The sweet face, harmonious coloring, and simple pose of this little Spanish girl has made an ineffaceable impression on our memory. We should like to have her always near us."[23] In 1866 Hall embarked on a second journey to Spain, perhaps motivated more by personal longing for the country or restlessness rather than the popular demand for his Spanish subjects. Prior to his departure, he organized a sale at Somerville Art Gallery in New York, which helped finance his trip but did not burnish expectations for his Spanish subjects. A reviewer for *The Round Table* praised the fruit and flower pieces on offer, while singling out his "genre pictures of Spanish character," for harsh criticism.[24]

During his second visit to Spain, Hall continued to expand upon the themes of his earlier work and in canvases such as *La Feria de Jueves (The Thursday Fair of Seville)* incorporated an even greater emphasis on Spain's Catholic customs (cat. 11). The painting depicts a scene unfolding at Seville's weekly market, an important site for local commerce and sociality and one recommended in travelers' guidebooks to the city. Hall played to his strengths in the foreground still life, but the focus of the composition rests on the three clergymen who pause to scrutinize the books on offer, while a crowd seems to form around the principal group. Though dignified in dress, the figures' awkward poses and uncouth expressions set them apart from their rich surroundings of secular market life, highlighting the peculiarities of Spain's Catholic customs and history as arcane curiosities. As art historian Betsy Boone has argued, the decline in favor of Hall's Spanish subjects can in part be attributed to his close critical association with Murillo and a rising anti-Catholic aversion to that painter's work in the United States.[25] The weight of his connection with Murillo, which had once won him praise, had become a liability as changing tastes in old masters that coalesced during the 1870s and 1880s steadily elevated Velázquez to the top of the pantheon of Spanish painters. In response Hall's submission of Spanish subjects to the National Academy's annual exhibition soon tapered off, with scenes of Italy and Egypt taking their place alongside his ever-popular still lifes.

Mary Cassatt traveled to Seville six years after Hall made his last trip to the country in 1866 and similarly found a rich source of subjects drawn from the figures she encountered in the vibrant city. She established a studio in the sixteenth-century palace known as Casa de Pilatos, where she worked diligently on a number of canvases that depict figures drawn from modern Spain, including young women in contemporary dress and resplendent bullfighters (cats. 77-79). At the outset of 1873, Cassatt reported to her friend Emily Sartain that she was engrossed in a complex, multi-figure scene of two women and a man leaning out a window, now known as *On the Balcony* (fig. 38).[26] By June of that year she had sent the painting back to Philadelphia, where it was put on prominent display along with

another canvas, *Spanish Dancer Wearing a Lace Mantilla,* in the window of the Philadelphia picture shop Bailey & Co. facing busy Chestnut Street (fig. 39). A lengthy report in the *Philadelphia Evening Bulletin* declared the paintings "remarkably striking" and enthusiastically praised Cassatt's astute depiction of the costumes and other markers of Spanish custom.[27] Cassatt had another of her Spanish canvases, *Offering the Panal to the Bullfighter,* accepted to that year's Paris Salon, where it received a brief but positive notice in the *New York Times,* whose critic called it "a conscientious study" (cat. 78).[28]

The next year, Cassatt sent *On the Balcony* and *Offering the Panal to the Bullfighter* to the National Academy of Design exhibition in New York, a venue well accustomed to scenes of everyday life in Seville owing to Hall's submissions over the preceding decade. As with Hall's paintings before, some viewers understood Cassatt's Spanish subjects most clearly through old master associations, with the critic for the *Nation* describing them as "painted with the

Fig. 38 Mary Cassatt, *On the Balcony,* 1873. Oil on canvas. Philadelphia Museum of Art, Gift of John G. Johnson for the W. P. Wilstach Collection, W1906-1-7

Fig. 39 Mary Cassatt, *Spanish Dancer Wearing a Lace Mantilla,* 1873. Oil on canvas. Smithsonian American Art Museum, Gift of Victoria Dreyfus, 1967.40

best traditions of Murillo." The same reviewer added further that Cassatt's work had "a most cruel blighting effect on those that we remember from Mr. Hall, our own familiar guide among the scenes of Spain."[29] Despite the two painters' thematic overlap, critics distinguished Cassatt from her predecessor through her astonishing technical innovations. The critic for the *Philadelphia Evening Bulletin* had marveled at such effects, writing, "Every touch of the brush is ruthlessly exposed, and the broad, free, dashing use of the colors is so different from the miniature style of flesh painting which is usually aimed at, that ignorant people are apt to wonder and pretend to find fault."[30]

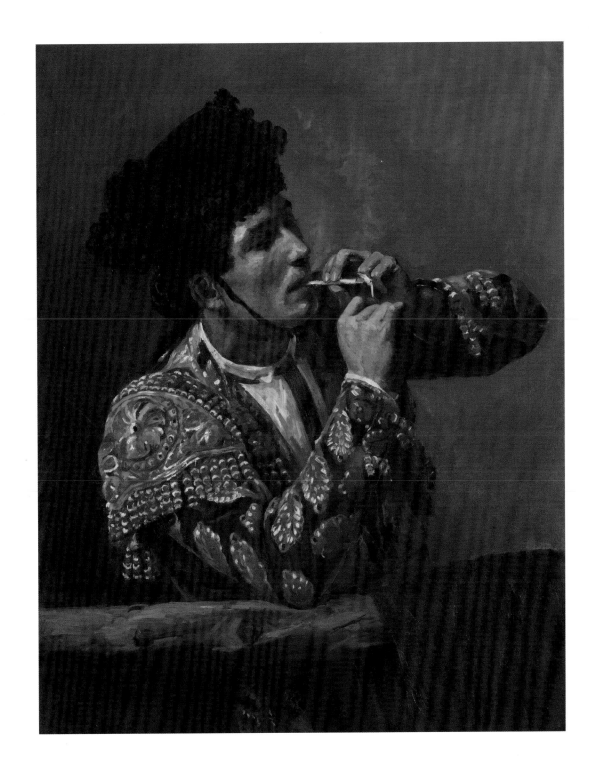

MARY CASSATT

AMERICAN, 1844–1926

After the Bullfight

1873 · Oil on canvas · 32⅛ × 25³⁄₁₆ in. (82.5 × 64 cm)

The Art Institute of Chicago, bequest of Mrs. Sterling Morton,
1969.332

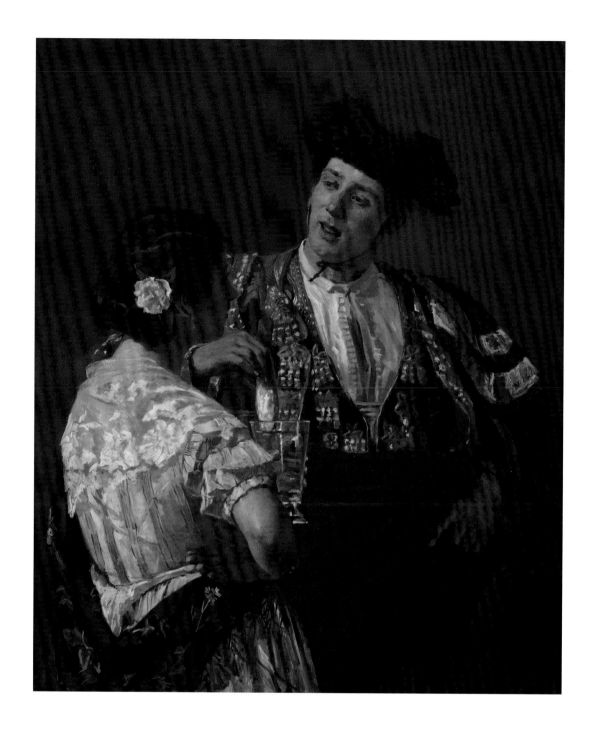

MARY CASSATT

AMERICAN, 1844–1926

Offering the Panal to the Bullfighter

1873 · Oil on canvas · 39⅝ × 33½ in. (100.6 × 85.1 cm)

Sterling and Francine Clark Art Institute, acquired by Sterling and
Francine Clark, 1947, 1955.1

While Cassatt's paintings may have been understood as studies of Spanish characters that continued upon a narrative tradition popularized by Murillo, such comments expose the lengths to which Cassatt also elaborated upon the stylistic models of Spanish painting, from Velázquez to Goya, to push her own work in new directions that resonated more closely with modern currents in painting.[31]

Cassatt did not return to Spain until nearly thirty years later, and her Spanish paintings were seldom exhibited publicly during the ensuing decades as she continued to refine her distinctive approach to painterly realism that defined her mature impressionist style. Cassatt gave one of her Spanish canvases, *Spanish Girl Leaning on a Window Sill*, to Sevillian artist Manuel Barrera, who served as an artistic guide for Cassatt during her time in the city, introducing her to other artists and patrons and helping her to establish her studio and lodgings (cat. 79). The painting depicts the same model that appears in *Spanish Dancer Wearing a Lace Mantilla* in a more direct pose, distilling the flirtatious themes of *On the Balcony* to a single figure. That the canvas descended through the Barrera family and remained in Seville offers a testament to the complex web of connections that Cassatt forged there, not only among old master sources but contemporary artists and subjects drawn from Spanish life and culture.[32]

While Murillo was the example that critics frequently fell back upon when discussing American painters' Spanish-themed work in the 1860s and 70s, by the following decade Velázquez had emerged as the prime old master referenced in appraisal of Americans' Spanish subjects. When Sargent exhibited the monumental group portrait *The Daughters of Edward Darley Boit* (fig. 40) at the 1883 Salon, with its clear compositional and thematic references to Velázquez's *Las Meninas*, critics were well primed to view his work through the lens of Spanish precedents. The critic W.C. Brownell enthusiastically recognized the canvas's formal and thematic resonance with the famous portrait at the Prado, leading him to proclaim of Sargent "that he is Velasquez come to life again."[33] Meanwhile in New York, Chase also developed a reputation as an ardent devotee of Velázquez (thanks in part to the exhibition of his numerous copies in the early 1880s), an association he expanded upon in scenes taken from modern life. In 1886 Chase submitted the outsized *A Madrid Dancing Girl* (now titled *A Tambourine Player*) to the annual

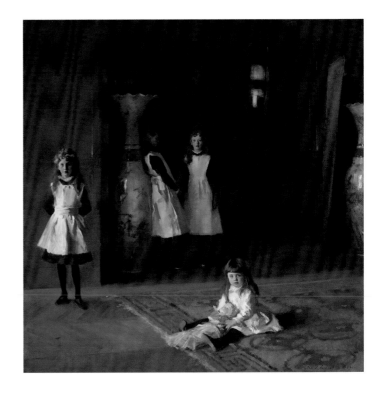

Fig. 40 John Singer Sargent, *The Daughters of Edward Darley Boit*, 1882. Oil on canvas. Museum of Fine Arts Boston, Gift of Mary Louisa Boit, Julia Overing Boit, Jane Hubbard Boit, and Florence D. Boit in memory of their father, Edward Darley Boit, 19.124

exhibition of the American Watercolor Society (cat. 80). Chase was a relatively infrequent exhibitor at the Watercolor Society but must have known that his large canvas would cause a sensation among the more modestly sized watercolors. Painted in the United States, rather than the Madrid of the title, the canvas depicts Chase's frequent model Alice Gerson (who would wed Chase that same year) dressed in a vibrant costume reminiscent of Spanish fashions and dancing with a tambourine held above her head. Chase created a smaller painting of a similar subject, showing Gerson seated with a fan, wearing the same brilliant white dress and yellow shawl (cat. 81). Beyond the style of the costume, a small graffito of a bull scrawled on the wall behind Gerson extends the allusion to Spain, as bullfights often featured prominently in popular accounts of Spanish travel and culture. In the larger canvas, Gerson occupies a stark, less determinate space in a format

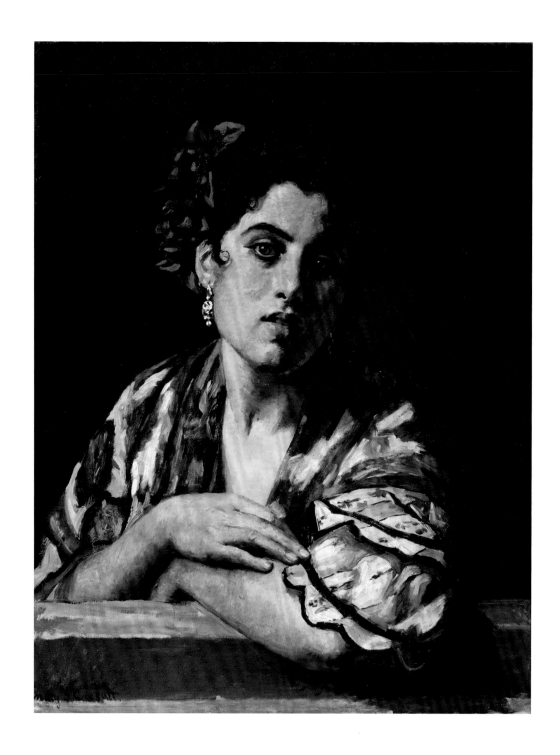

79

MARY CASSATT

AMERICAN, 1844–1926

Spanish Girl Leaning on a
Window Sill

ca. 1872 · Oil on canvas · 24⅜ × 19 in. (61.9 × 38.26 cm)

Collection of Manuel Piñanes García-Olías, Madrid

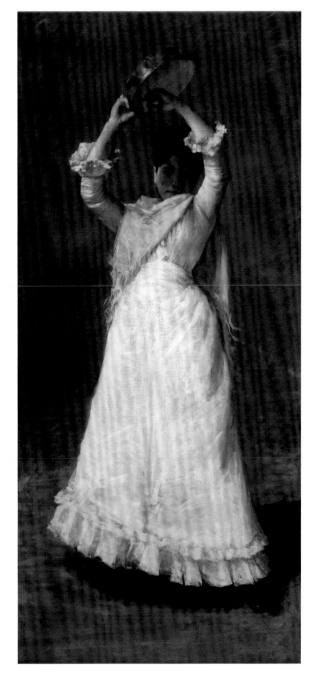

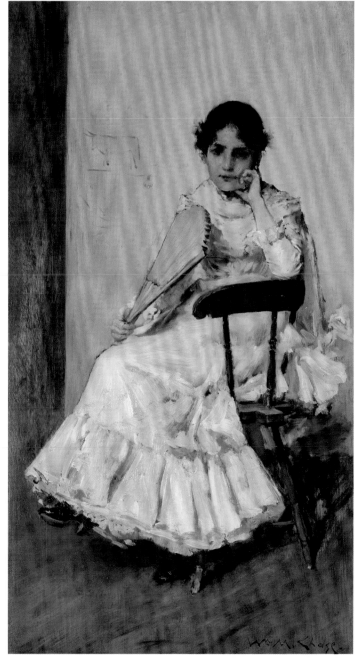

80

WILLIAM MERRITT CHASE

AMERICAN, 1849–1916

A Tambourine Player;
Mrs. Chase as a Spanish Dancer
(A Madrid Dancing Girl)

ca. 1886 · Oil on canvas · 65 × 30 in. (165.1 × 76.2 cm)

Montclair Art Museum, Museum purchase; Acquisition Fund,
1962.16

81

WILLIAM MERRITT CHASE

AMERICAN, 1849–1916

Spanish Girl in White

ca. 1886 · Oil on panel · 26¾ × 15¼ in. (68 × 38.7 cm)

Wake Forest University, Middleton Collection, Gift of Philip and
Charlotte Hanes, HC2000.2.1

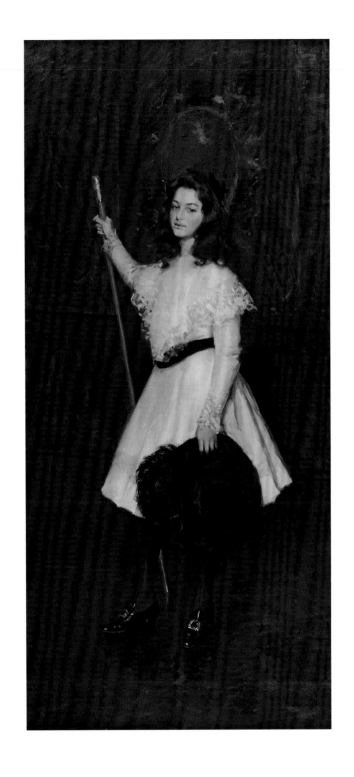

WILLIAM MERRITT CHASE
AMERICAN, 1849–1916

Girl in White

1898–1901 · Oil on fabric · 84½ × 40½ in. (214.6 × 102.9 cm)

Collection of the Akron Art Museum, Bequest of Edwin C. Shaw

reminiscent of the Velázquez figure paintings such as *Aesop* and *The Buffoon Calabacillas* that Chase had exhibited in copies just two years earlier.

Spanish dance and music proved popular themes in American painting during this period. In 1889 the famed Spanish performer Carmen Dauset Moreno, known by her stage name Carmencita, first performed in New York to great acclaim, where she also attracted the attention of a group of American painters including Beckwith, Sargent, and Chase. On April 1, 1890, Sargent arranged for Carmencita to give a private performance in honor of Isabella Stewart Gardner, which was hosted in Chase's Tenth Street Studio and included a hand-selected group of artists and friends. The evening was a mixed success, reportedly marked by the performer's temperamental outbursts as well as the audience's enthusiastic rapture. The gathering resulted in a few salacious reports in the tabloid press, but, more enduringly, the performance (and a subsequent reprisal) fostered two major full-length portraits of Carmencita, which Sargent and Chase completed shortly thereafter.[34] While Chase's portrait shows Carmencita in the throes of the dance, Sargent's painting is somewhat more in the staid manner of a formal portrait, though certainly a forceful one. The two paintings have long been linked by historians of art, but they were not executed in tandem or even necessarily in direct response to one another.[35] Sargent had begun his portrait prior to the performance at Chase's studio, while Chase seems likely to have conceived of his canvas immediately following the event. Despite the differing approaches to the pose and manner of the subject, the paintings are united by certain formal similarities such as the arrangement of the composition, the placement of the figure within the pictorial space, and the painterly approach to surface detail—all of which recall stylistic hallmarks closely associated with the portraiture of Velázquez. Of the two portraits, Sargent's canvas was more widely seen and acclaimed during the period immediately following the fortuitous performance. Sargent's version was exhibited at the Society of American Artists in New York in May 1890 and later that year at the Art Institute of Chicago. Sargent next exhibited the painting in London and finally Paris where it was purchased by the French government in 1892. Chase's canvas meanwhile was shown at the 1891 St. Louis Exposition and Music Hall Association and purchased sometime

thereafter by the New York lawyer Alexander Blumenstiel, who boasted a large collection of modern French painting. In 1906 William Van Horne, a noted Canadian-American collector of old master painting, purchased it and gave it to the Metropolitan Museum of Art shortly thereafter.

The enthusiasm for Velázquez among the American art public was bolstered throughout the 1890s by a stream of acquisitions by collectors and museums, as well as a variety of publications on the artist penned by historians, critics, and artists themselves. Early in the decade, the collector and trustee of the Metropolitan Museum, Henry Marquand, wrote to his dealer in London, "I am crazy to get that Velázquez," referring to a *Prince Baltazar Carlos* thought to be by the artist. He eventually purchased the painting and donated it to the Metropolitan along with two other canvases thought to be by Velázquez and a large collection of other European old masters.[36] Many prominent collectors echoed Marquand's enthusiasm, among them Isabella Stewart Gardner, Henry Clay Frick, and Archer M. Huntington—each of whom eagerly pursued major acquisitions by the artist to add to their own burgeoning collections. The publication in 1895 of R. A. M. Stevenson's *The Art of Velasquez* offered a richly illustrated and highly influential reappraisal of the artist that also expressed the case for the old master's importance and relevance through his influence upon modern painters like Manet, Whistler, and Sargent.[37] The presence of more of Velázquez's canvases in the United States and the swelling critical discourse on the stylistic features that defined his painting helped strengthen connections with the work of American painters like Chase, who readily encouraged such associations.

Chase's writings and lectures on Velázquez, alongside the example of his own painting, propelled critical interest in the artist as an exemplar of modern aesthetic values. In an 1896 address published in *The Quartier Latin*, Chase proclaimed of Velázquez, "of all the old masters he is the most modern." By this time, the equation of Velázquez with modern approaches to paintings had become increasingly common. When Chase painted the portrait of Irene Dimock (known as *Girl in White*) two years later, he called forth many of the modern flourishes he outlined in the article on Velázquez, including an emphasis on truth to nature, a free application of paint, and above all an "extreme want of conventionality" (cat. 82).[38] The

full-length format, angled pose, and lavish dress of the teenaged sitter provoke further associations with Velázquez's numerous portraits of the young members of the Spanish Royal Family. When the work was exhibited among a group of portraits in New York several years later, the reviewer for the *New York Times* evoked Velázquez in cheekily religious tones, noting how Chase and other American painters "worshipped at the shrine of Velasquez, making pilgrimages to Madrid."[39] Dimock's parents who commissioned the portrait seemed to have regarded it somewhat less reverently, having desired a true likeness rather than an ode to Chase's aesthetic allegiances.[40]

In later portraits like that of Marchesa Laura Spinola Núñez de Castillo, Sargent likewise synthesized elements from the portraiture of Velázquez into a distinct personal style that emphasized the international cosmopolitanism of both artist and sitter (fig. 41). Painted in London following Sargent's recent journey to Madrid, the portrait depicts the wife of the artist's close friend Benjamin del Castillo, herself a member of a notable Spanish political family.[41] Whereas two decades earlier in his portrait of the Boit children, the references to Velázquez were made more explicitly, here the traces of the Spanish master are more oblique but nevertheless call to mind many of the artist's hallmarks, from the bravura brushwork to the stately assuredness of the sitter. In a portrait made for a close friend, Sargent may have felt particularly emboldened to flaunt his own mastery of such stylistic devices, which by that time had become well recognized as markers of modernity in painting.

By the close of the nineteenth century, Spain had become a common destination for American painters and Grand Tourists, and Spanish painting could hardly be considered a novel or unfamiliar sight in the United States. Velázquez remained the champion of modern realist painters and their admirers, but other old masters like El Greco also began to compete for the admiration of forward-thinking artists and critics. On Mary Cassatt's return visit to Spain in 1901 in the company of the collectors Henry O. and Louisine Havemeyer, the group fell under the "spell" of El Greco and devoted themselves to seeking out as many examples as they as could study of his work and ultimately a canvas to add to their own collection.[42] Other American painters facilitated El Greco's growing presence in the United States: in 1900,

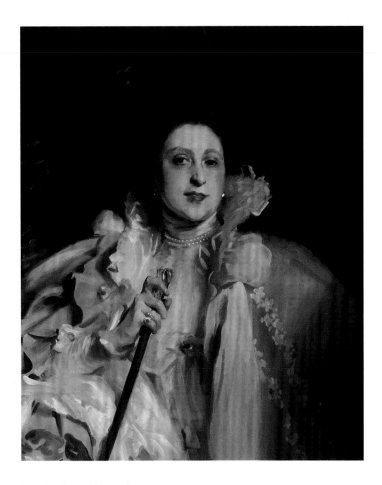

Fig. 41 John Singer Sargent, *Marchesa Laura Spinola Núñez del Castillo*, 1903. Oil on canvas. Collection of Barbara Babcock Millhouse, founding president of Reynolda House Museum of American Art, an affiliate of Wake Forest University

upon the advice of Chase, the Philadelphia Museum of Art acquired an El Greco *Crucifixion,* while Sargent acted as the intermediary for the Museum of Fine Arts in Boston's first acquisition by the artist in 1904.[43] El Greco's vivid palette and attenuated figures seemed to offer a link to directions in modern painting that emphasized expressiveness and eschewed strict naturalism. The response to the duo of Spanish painters Joaquín Sorolla and Ignacio Zuloaga, whose bold and steadfastly modern paintings were exhibited to great acclaim in the United States during the first decade of the twentieth century, broadened the critical reception of Spanish painting even further. As a result,

American artists like Robert Henri or Ernest Lawson, who traveled to the country in the twentieth century, looked to Spain—its art and subjects from modern life—as much as a source of pictorial innovation as historical tradition.

Throughout the nineteenth century, critical discussions of Spanish painting continued to frame the national school as singular and isolated from the broader historical currents of European painting.[44] As the other essays in this volume attest, American painters' Spanish-themed paintings were received and filtered through a variety of lenses, which encompassed literature and history, travel narratives, and Spain's political and economic entanglements with the rest of the world, though these were often viewed in ways that emphasized Spain's singularity or eccentricity. This supposed distinctiveness that drew many American artists to study Spain's collections also helped set apart, for American audiences, the works they created in Spain. When critics praised Cassatt for painting in the "best traditions of Murillo" or proclaimed that Sargent embodied Velázquez "come to life again," they anchored their achievements to seemingly stable points of reference, but also inadvertently called attention to their own critical limitations. Like many modern tourists, American painters who journeyed through the Spanish old masters did not merely echo and report what they saw, but surveyed, synthesized, and reinvented the styles and traditions into a pictorial language ideally suited to the perspective of their age and representing something altogether new.

NOTES

1. For more on the Montpensier Exhibition, see Carol M. Osborne, "Yankee Painters at the Prado," in Suzanne L. Stratton, ed., *Spain, Espagne, Spanien: Foreign Artists Discover Spain 1800–1900* (New York: The Equitable Gallery in association with The Spanish Institute, 1993), 65–66; "Fine Arts: The Montpensier Collection of Paintings," *Appletons' Journal of Literature, Science and Art* 12 (September 26, 1874): 412; "Fine Arts," *Appletons' Journal of Literature, Science and Art* 12 (October 17, 1874): 508.

2. W. J. Stillman, "The Montpensier Collection in the Boston Art Museum," *Old and New* 11 (December 1874): 760.

3. For the American taste for Spanish Old Masters, see Inge Reist and José Luis Colomer, eds., *Collecting Spanish Art: Spain's Golden Age and America's Gilded Age* (New York: The Frick Collection, 2012); Inge Reist and José Luis Colomer, eds., *El Greco Comes to America: The Discovery of a Modern Old Master* (New York: The Frick Collection, 2017); José Luis Colomer, Blanca Pons-Sorolla, and Mark A. Roglán eds., *Sorolla in America: Friends and Patrons* (Dallas: Meadows Museum, 2015); and Richard L. Kagan, "Yankees in the Prado: A Historiographical Overview," *Boletin del Museo del Prado* 25, no. 43 (2007): 32–45. Richard L. Kagan addressed the challenges of assessing the reception for Americans' Spanish paintings, asking, "How many Americans saw these pictures? It is difficult to say, as the majority went directly into private collections and were rarely exhibited to the general public." See Kagan, *The Spanish Craze: America's Fascination with the Hispanic World, 1779–1939* (Lincoln: University of Nebraska Press, 2019), 157. The analysis of the ties between American painting and the art of Velázquez in M. Elizabeth Boone, "Why Drag in Velázquez?: Realism, Aestheticism, and the Nineteenth-Century Response to *Las Meninas*," in Suzanne L. Stratton-Pruitt, ed., *Velázquez's Las Meninas* (New York: Cambridge University Press, 2002), 80–123, informs many parts of this essay.

4. Thomas Eakins to Benjamin Eakins, December 2, 1869, in *The Paris Letters of Thomas Eakins*, ed. William Innes Homer (Princeton: Princeton University Press, 2009), 286. No records exist that Eakins produced any copies while at the Prado, spending only a few days in Madrid. William Merritt Chase to Dora Wheeler, July 24, 1881, quoted in Boone, *Vistas de España*, 148.

5. Mary Cassatt to Emily Sartain, October 13, 1872, in *Cassatt and her Circle: Selected Letters*, ed. Nancy Mowll Matthews (New York: Abbeville Press, 1984), 107.

6. "Appendix B" in M. Elizabeth Boone, *Vistas de España: American Views of Art and Life in Spain, 1860–1914* (New Haven: Yale University Press, 2007), 214–219, is the most authoritative accounting of American copyists at the Prado. For an overall analysis of copying in the museum, see the extensive record of copyists throughout Eugenia Afinoguénova, *The Prado: Spanish Culture and Leisure, 1819–1939* (University Park: The Pennsylvania State University Press, 2018), 122, 173–174; Mary Cassatt to Emily Sartain, October 13, 1872, in *Cassatt and her Circle,* 1984, 107–8.

7. See Gary Tinterow and Geneviève Lacambre, *Manet / Velázquez: The French Taste for Spanish Painting* (New York: Metropolitan Museum of Art, 2003), 483–84, 457–58, note 1.

8. See Patricia Mainardi, "Copies, Variations, Replicas: Nineteenth-Century Studio

Practice," *Visual Resources* 15 (1999): 123–47, for a thorough examination of the ways in which copies and replicas were understood and consumed in the pre-modernist nineteenth century.

9. "The Art Students League" *Art Journal* 8 (November 1882), 63.

10. Metropolitan Museum of Art. Hand-Book No. 6. Loan Collection of Painting and Sculpture in the West Galleries, and the Grand Hall (New York: Metropolitan Museum of Art, 1883). See Dorothy Moss, "Translations, Appropriations, and Copies of Paintings at the Dawn of Mass Culture in the United States, Circa 1900" (PhD diss., University of Delaware, 2012), 52–57, for a thorough account of the exhibition and its organization.

11. "The Metropolitan Museum of Art. In Two Articles. Second Article," *The Decorator and Furnisher* 3 (January 1884): 126.

12. Metropolitan Museum of Art. Hand-Book No. 6, 1883, 23.

13. Mariana Griswold Van Rensselaer, "Pictures of the Season in New York," *The American Architect and Building News* 15 (March 22, 1884): 137.

14. Three paintings by Manet were exhibited: *Boy with a Sword* (Metropolitan Museum of Art); *Portrait of a Lady* (now *Woman with a Parrot*, Metropolitan Museum of Art); and *Toreador,* which may have been a watercolor version of *Mademoiselle V . . . in the Costume of an Espada* (Museum of Art, RISD). *Catalogue of the Pedes-tal Fund Art Loan Exhibition at the National Academy of Design* (National Academy of Design, 1883). See also H. Barbara Weinberg, "American Artists' Taste for Spanish Painting," *Manet / Velázquez: The French Taste for Spanish Painting* (New York: Metropolitan Museum of Art, 2003), 289, and Maureen C. O'Brien, *In Support of Liberty: European Paintings at the 1883 Pedestal Fund Art Loan Exhibition* (Southampton, NY: Parrish Art Museum, 1986), 160–62.

15. See Richard Ormond and Mary Pixley, "Sargent after Velázquez: The Prado Studies," *Burlington Magazine* 145 (September 2003): 632–40.

16. Accordingly, the subject of Chase's studio has received a great deal of attention from art historians. Key sources include Nicolai Cikovsky, Jr., "William Merritt Chase's Tenth Street Studio," *Archives of American Art Journal* 16 (1976): 2–14; Sarah Burns, "The Price of Beauty: Art, Commerce, and the Late Nineteenth-Century American Studio Interior," in *American Iconology: New Approaches to Nineteenth-Century Art and Literature*, ed. David C. Miller (New Haven and London: Yale University Press, 1993), 209–38; Bruce Weber and Sarah Kate Gillespie, *Chase Inside and Out: The Aesthetic Interiors of William Merritt Chase* (New York: Berry-Hill Galleries, Inc., 2004); and Isabel L. Taube, "William Merritt Chase's Cosmopolitan Eclecticism," *Nineteenth-Century Art Worldwide* 15, no. 3 (Autumn 2016), https://doi.org/10.29411/ncaw.2016.15.3.6 (accessed July 22, 2019).

17. W. A. Cooper, "Artists in their Studios," *Godey's Magazine* 130 (March 1895): 295.

18. Valerie Ann Leeds, "Seeking the Spirit of Old Spain: Robert Henri and Spanish Themes, 1900 to 1924," in *Spanish Sojourns: Robert Henri and the Spirit of Spain* (Savannah, GA: Telfair Museum, 2013), 14.

19. "Art in America," The Burlington Magazine for Connoisseurs 9 (May 1906): 142.

20. Edwin Howland Blashfield, "The Value of Carroll Beckwith's Copies," *The Bulletin of the Cleveland Museum of Art* 8 (November 1917): 144.

21. "Literary and Art Items," *New York Times,* February 20, 1860, 2.

22. "Sketchings. Domestic Art Gossip," *The Crayon* (March 1861): 69.

23. "Visit to the National Academy of Design," *The Continental Monthly* 3 (June 1863): 718.

24. "Art Notes," The Round Table. A Saturday Review of Politics, Finance, Literature, Society and Art 3 (March 10, 1866): 151.

25. Boone, *Vistas de España*, 57.

26. Mary Cassatt to Emily Sartain, New Year's Evening, 1873, in *Cassatt and her Circle,* 1984, 114.

27. "The Fine Arts, Pictures by Miss M. S. Cassatt," *Philadelphia Evening Bulletin,* June 17, 1873, 4.

28. "Art in France. The Paris Salon," *New York Times,* June 16, 1873, 1.

29. "Fine Arts: The National Academy Exhibition; II," *Nation,* May 14, 1874, 321.

30. "The Fine Arts, Pictures by Miss M. S. Cassatt," *Philadelphia Evening Bulletin,* June 17, 1873, 4.

31. See M. Elizabeth Boone, "Bullfights and Balconies: Flirtation and Majismo in Mary Cassatt's Spanish Paintings of 1872–73," *American Art* 9 (Spring 1995): 54–71, in which the author catalogues the broad range of sources that can be extrapolated from Cassatt's Spanish figures.

32. Betsy Boone uncovered this previously unknown painting and another study by Cassatt with the assistance of the collector and published her findings in M. Elizabeth Boone, "The Paintings Left Behind: Two New Paintings by Mary Cassatt from Seville," *Panorama: Journal of the Association of Historians of American Art* 4, no. 2 (Fall 2018), https://doi.org/10.24926/24716839.1666 (accessed January 14, 2020).

33. W. C. Brownell, "American Pictures at the Salon," *The Magazine of Art* 6 (January 1883): 498.

34. Carmencita's experiences with American painters in New York have been well documented in art historical literature. See Trevor J. Fairbrother, "John Singer Sargent in New York, 1888–1890," *Archives of American Art Journal* 22 (1982): 27–32, and Boone, *Vistas de España*, 139–145.

35. Though Chase may have initiated the idea for his portrait in competition with Sargent, even years later Sargent

may have been completely unaware of Chase's rival portrait. See the entry on Chase's painting in Doreen Bolger Burke, *American Paintings in the Metropolitan Museum of Art,* vol. 3, (New York: Metropolitan Museum of Art, 1980), 87–89.

36. Henry G. Marquand to Charles William Deschamps, August 26, 1882, quoted in José Luis Colomer, "Competing for a Velázquez: New York Collectors after the Spanish Master," in Reist and Colomer, eds., *Collecting Spanish Art*, 252-3.

37. R. A. M. Stevenson, *The Art of Velazquez* (London: George Bell and Sons, 1895), 109.

38. William Merritt Chase, "Velasquez," *The Quartier Latin* 1 (July 1896): 4.

39. "Portraits by Wm. M. Chase," *New York Times,* April 9, 1901, 9.

40. William Robinson, The Edwin C. Shaw Collection of American Impressionist and Tonalist Painting (Akron Art Museum, 1986), 44.

41. Richard Ormond and Elaine Kilmurray, *John Singer Sargent: The Later Portraits*, vol. 3, *Complete Paintings* (New Haven and London: Yale University Press, 2003), 118.

42. Louisine W. Havemeyer, *Sixteen to Sixty: Memoirs of a Collector* (New York: privately printed, 1961), 131-2.

43. Philadelphia's canvas is now attributed to El Greco and Workshop. Richard L. Kagan, "The Cult of El Greco: *El Grecophilitis* in Philadelphia," in Reist and Colomer, eds., *El Greco Comes to America*, 50.

44. See Richard Kagan, "Yankees in the Prado: A Historiographical Overview," *Boletin del Museo del Prado* 25, no. 43 (2007): 32-45. As Kagan charts through the essay, the critical response to Spanish painting was broad and multifaceted and evolved throughout the century, but the notion of Spanish painting's "distinctiveness" endured well into the twentieth century.

WILLIAM MERRITT CHASE
AMERICAN, 1849–1916

My Little Daughter Helen
Velázquez Posing as an Infanta

1899 · Oil on canvas · 30¼ × 24⅛ in. (76.84 × 61.26 cm)

Courtesy of Joel Strote and Elisa Ballestas

84

FREDERICK MACMONNIES
AMERICAN, 1863–1937

Young Chevalier

ca. 1898 · Oil on canvas · 75⅛ × 50⅝ in. (190.82 × 128.59 cm)

Virginia Museum of Fine Arts, Richmond, J. Harwood and Louise B.
Cochrane Fund for American Art, 2013. 172

85

WILLIAM MERRITT CHASE
AMERICAN, 1849–1916

The Antiquary Shop

ca. 1879 · Oil on canvas · 27 × 34½ in. (68.6 × 87 cm)

Brooklyn Museum, gift of Mrs. Carll H. de Silver in memory of her
husband, 13.53

86

WILLIAM MERRITT CHASE
AMERICAN, 1849–1916

Still Life with Ladle

1917 · Oil on canvas · 18 × 32 in. (45.72 × 81.28 cm)

Milwaukee Art Museum, Maurice and Esther Leah Ritz Collection,
M2004.115

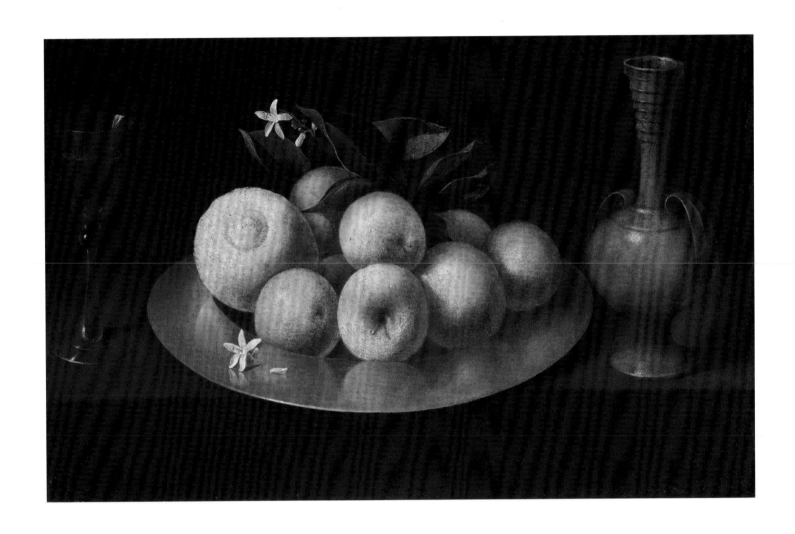

CIRCLE OF FRANCISCO DE ZURBARÁN

Still Life with Glass, Fruit, and Jar

ca. 1650 · Oil on canvas · 15½ × 24½ in. (39.4 × 62.2 cm)

North Carolina Museum of Art, Purchased with funds from the
North Carolina State Art Society (Robert F. Phifer Bequest),
G.52.9.171

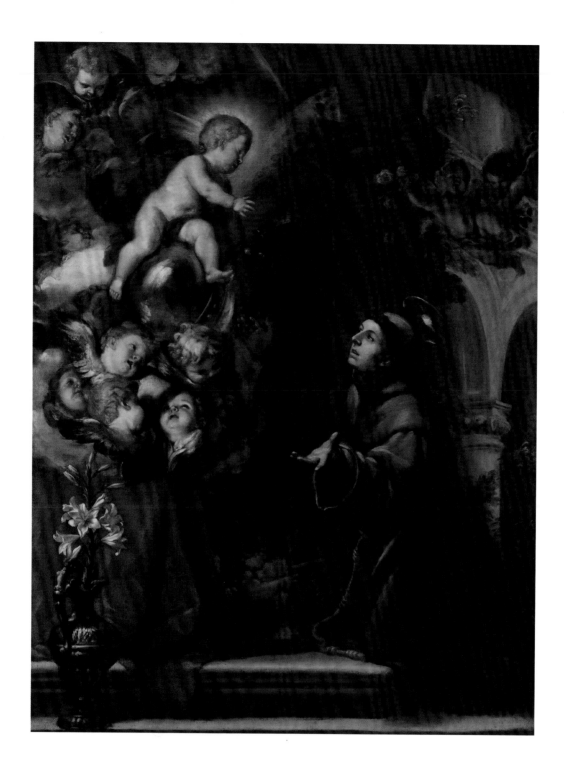

CLAUDIO COELLO
SPANISH, 1642–1693

The Vision of Saint Anthony of Padua

1663 · Oil on canvas · 67 × 50½ in. (170.2 × 128.3 cm)

Chrysler Museum of Art, gift of Walter P. Chrysler, Jr., 71.542

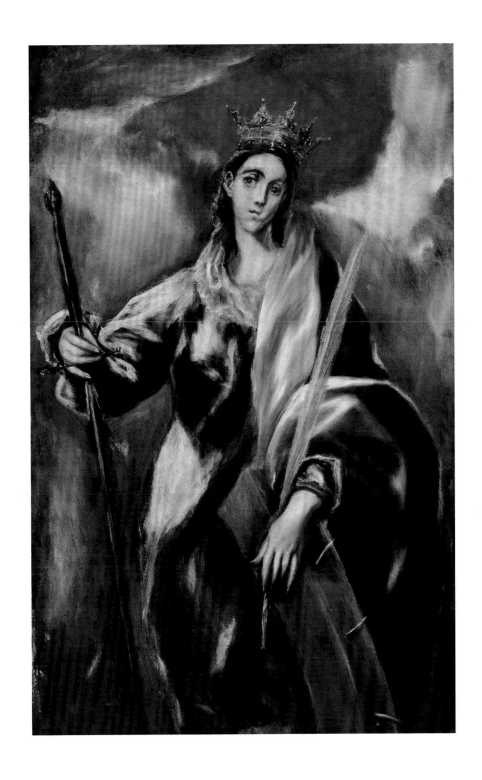

89

EL GRECO (DOMÉNIKOS THEOTOKÓPOULOS)

GREEK, ACTIVE IN SPAIN, 1541–1614

Saint Catherine

1610–14 · Oil on canvas · 39⁹⁄₁₆ × 25⅛ in. (100.5 × 63.8 cm)

Museum of Fine Arts, Boston, Bequest of William A. Coolidge, 1993.38

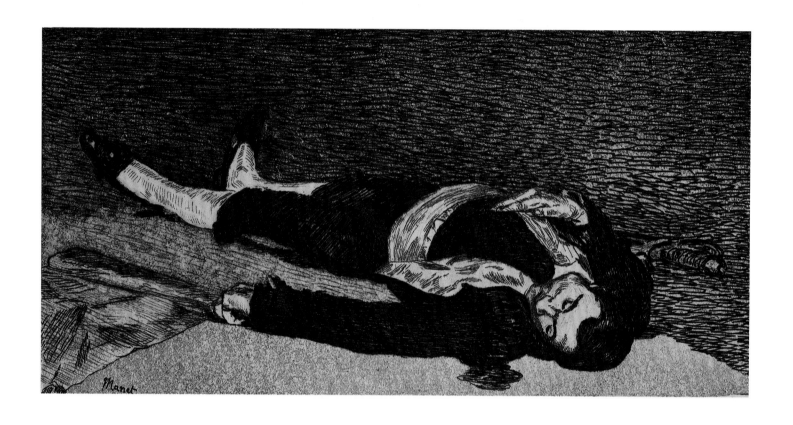

90

ÉDOUARD MANET

FRENCH, 1832–1883

Dead Toreador

1867–68 · Etching and aquatint · 12⅞ × 17⅝ in. (32.7 × 44.77 cm)

Milwaukee Art Museum, purchase, with funds from the Ralph and
Cora Oberndorfer Family Trust, M2017.92

176

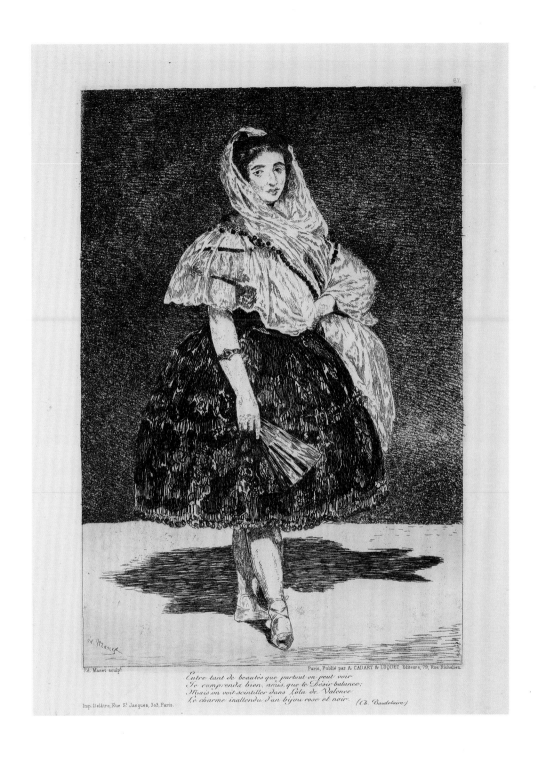

Entre tant de beautés que partout on peut voir
Je comprends bien, amis, que le Désir balance;
Mais on voit scintiller dans Lola de Valence
Le charme inattendu d'un bijou rose et noir.

(Ch. Baudelaire)

91

ÉDOUARD MANET

FRENCH, 1832–1883

Lola de Valence

1862–63 · Etching and aquatint · 10⅜ × 7⅛ in. (26.4 × 18.1 cm)

Milwaukee Art Museum, purchase, with funds from the Ralph and
Cora Oberndorfer Family Trust, M2017.91

92

THOMAS EAKINS
AMERICAN, 1844–1916

James Carroll Beckwith

1904 · Oil on canvas · 83⅜ × 48⅛ in. (211.77 × 122.24 cm)

San Diego Museum of Art, gift of Mrs. Thomas Eakins, 1937.30

93

DIEGO VELÁZQUEZ

SPANISH, 1599–1660

Portrait of a Man

ca. 1651–52 · Oil on canvas · 25¼ × 17½ in. (64.1 × 44.5 cm)

Chrysler Museum of Art, gift of Walter P. Chrysler, Jr., 83.587

"Spain Is Different"

THE PRADO, VELÁZQUEZ, AND COPYING IN THE ART AND TEACHINGS OF ROBERT HENRI

Valerie Ann Leeds

"SPAIN IS DIFFERENT," DECLARED NAPOLEON IN 1808, a slogan later adopted for luring travelers to the country. Spain was indeed different for American painter and teacher Robert Henri, and it was an essential influence on his art and his teaching. The popularity of the country as a destination did not blossom until 1905, when the state and the crown created a commission to attract tourism, right around the time when Henri began visiting Spain.

What remained of Spain's traditions held special allure for Henri, and it was the destination to which he returned more than any other, visiting Spain seven times from 1900 to 1926 and calling it "the most interesting foreign country in which to work."[1] Each of Henri's seven trips there fostered an intensifying infatuation; he spent the greater part of his time in Madrid but also visited Gibraltar, Malaga, Algeciras, Seville, Granada (and the Alhambra), Córdoba, El Escorial, Segovia, and Toledo.[2] The slow rate of Spain's industrialization, compared to other European countries, made it especially attractive to Henri, whose preference was for less modernized locales with rich intact cultures and varied and distinctive models to paint. Even more important for Henri was the momentous artistic resource that the Museo del Prado provided as a repository of art by Spanish masters, and Diego Velázquez in particular, which he set out to study and copy; it proved paramount to his own development and teaching and greatly informed the course he followed with his own portraiture.

Henri's many years as an art instructor were a key component of his artistic life and legacy. He mentored several generations of artists through classes he conducted at various art organizations.[3] One of his methods of instruction was to lead classes abroad, including three trips to Spain, in 1906, 1908, and 1912. These ventures left an indelible impression on those who accompanied him, with a curriculum he planned around studying and copying the work of Velázquez in the Prado (as he did on his own in 1900), and also working *en plein air* and directly from subjects.

Spain inspired a significant and compelling body of work in Henri's own oeuvre, which includes some of his most powerful characterizations. The models he pictured were from a broad spectrum of society and distinct from what he painted on other travels in their focus on adult subjects and emotional substance. And he was also guided by what he saw at the Prado, in particular the paintings of Velázquez, in terms of subject matter, creative expression, and technical virtuosity.[4]

The Prado and Copying, 1900

A monetary gift from his father enabled Henri and his wife Linda to travel to Madrid, where they spent about six weeks during May and June 1900. Henri had wanted to visit and study the collection of the Museo del Prado because he had some familiarity with the museum's holdings from his own art education; his teacher at the Pennsylvania Academy, Thomas Anshutz, had studied with Thomas Eakins, who had made his own earlier influential pilgrimage to Spain and the Prado.[5] Henri had had some firsthand exposure to the art of Velázquez himself when he decided in February 1896 to travel from Paris to London for an exhibition that featured the Spanish master's

work. There, he was overwhelmed by Velázquez's expressive ability and capacity for infusing meaning into his compositions:

> I saw the Velasquez pictures. I was in the Gallery for hours, and then wandered the streets thinking much to the glory of Velasquez. His paintings were clear of all the tricks of the art of the Salons, free from much of the clutter of the Ancients; simple and direct about men rather than the incidents surrounding them. To me they were great compositions. Each head or figure seemed to tell all the tragedy or comedy possible to man.[6]

In May 1900, when he encountered the Prado collection directly, Henri was thunderstruck, exclaiming to his parents: "And the gallery! If I had only known I would have come here long ago."[7] He had wanted to see the work of Tintoretto, Titian, and Ribera, yet once there, his interest was quickly subsumed by Velázquez, as he reported:

> For the first week I could look at nothing but Valasques. Everything else looked as poor artificial and labored, after him. His work (without any romance) is really marvelous and you wonder at it the more you see it. As a colorist he beats them all even including Titian and Giorgioni and the mastery of handling he has simply staggers one.[8]

Henri had long considered the practice of copying works. For example, while in Paris in the fall of 1898, he wrote of copying old masters in the Musée du Louvre and completed a smaller version of *The Standard Bearer* (1664) by Flemish painter Victor Boucquet.[9] Once in Madrid, he soon took to actively reproducing Velázquez for his own edification, relating that he and Linda had each gained permission cards from the museum to copy works; Linda began copying a portrait of a dwarf and he started on a painting of the court jester and actor Pablo de Valladolid. Henri overcame any reservations he had about copying as an artistic practice, and he enthusiastically wrote to his parents about finally having the opportunity to study and copy works at the Prado:

> [I] have so often intended to do some copys [sic] but have always put it off for I was never quite sure that I would learn as much as I desired for the outlay of my time . . . The whole collection here is wonderful. . . . I wish we had two or three months to study . . . in the gallerys [sic] making copys. There would be so much to learn in the direct line I care to work in. . . . [I]t would be so great an advantage to be able to make comparisons of what I do myself with the copys of the Valasques [sic].[10]

When he began copying the actor Valladolid, Henri noted the large numbers of other artists in the Prado galleries: "There are a good many artists and copyists at work there. Occasionally there are some students who make small and pretty bad 'copys.'"[11] But many well-known artists had tread this same path years earlier; John Singer Sargent made repeated visits to the Prado to study and copy works by Murillo, Ribera, and Velázquez in 1879, as did noted fellow painter and teacher William Merritt Chase in 1882. Spanish artist Joaquín Sorolla painted a fragment of a portrait of Queen Mariana after Velázquez, in 1883 (cat. 94) and a life-size replica of the same subject in 1884 (Fundación María Cristina Masaveu Peterson, Madrid).

Copying the work of others, especially historical masterworks in museums such as the Louvre and the Prado, is a traditional method for artists to acquire skill by developing the techniques of color, composition, and brushwork (for more on this, see Piper's essay in this volume). The Prado has maintained registers of copyists since 1843, attesting to the popularity of the practice by the later nineteenth century.[12] Because of the large numbers of copyists in the museum, Eugenia Afinoguénova has noted that it became necessary to set up rules to "to regulate the copyists' behavior . . . to prevent the copyists not only from coming too close to the canvases or measuring their surfaces, but also from 'smoking, singing, whistling, placing announcements or drawings on the walls, speaking in loud voices, reading newspapers or other print media, walking up and down the room, gathering in a circle with other copyists, thereby distracting others. . . .'"[13] And Henri complained in letters home that work was not proceeding as well as it might have due to frequent interruptions, museum closings, limited hours, and availability of good light. He approached the director to gain

JOAQUÍN SOROLLA Y BASTIDA
SPANISH, 1863–1923

Copy of a Fragment of a Portrait of Queen Mariana of Austria after Velázquez

1883 · Oil on canvas · 21⅝ × 25¼ in. (55 × 64 cm)

Museo Sorolla, n° inv. 00023

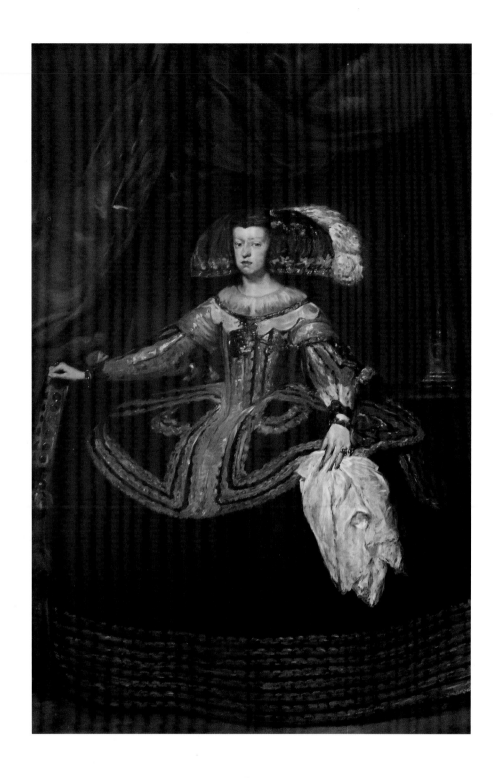

95

ROBERT HENRI

AMERICAN, 1865–1929

Queen Mariana

1900 · Oil on canvas · 91½ × 48 in. (190.82 × 128.59 cm)

The Robert Henri Museum and Gallery, Gift of Janet LeClair,
2019.8.1

entry to the museum when it was closed so he would have consistent access to the collection.[14] Nonetheless, from this extended study of Velázquez, Henri seemed to continually gain insights, seeing the mastery and assurance in the realism and approach to the subjects that the Spanish master applied to his subjects. As Henri described it, "Velasquez was never approached by any other painter in his simple directness of working. He never put a stroke on his canvas until it was just the time for that stroke, and the stroke itself was so well understood before it reached the canvas that it was decisive—final."[15]

Velázquez's realism and focus on the subject without regard for social standing struck a deep, sympathetic chord with Henri. He expressed particular enthusiasm for the master's dwarfs, declaring them "among the best of his work," one of which he copied, *The Buffoon El Primo* (1644; Museo del Prado).[16] He also completed four other works: *Pablo de Valladolid* (ca. 1635; Museo del Prado); *The Surrender of Breda* (ca. 1635; Museo del Prado); *Menippus* (ca. 1638; Museo del Prado); and *Queen Mariana of Austria* (1652–53; Museo del Prado).[17]

Queen Mariana (1634–1696) was the daughter of the Emperor Ferdinand III and Maria Anna of Hungary, and mother to the Infanta Margarita Teresa, the subject of Velázquez's most famous work, *Las Meninas* (1656; Museo del Prado).[18] Henri described the Velázquez painting of her as "a most beautiful portrait. It is a wonderful fine thing, and applys [*sic*] directly to my work. The costume is interesting being one of those immense skirts as broad as long. It is wonderfully painted. I am most anxious to get a good copy of it."[19] Seeing this painting at the Prado was likely not Henri's first exposure to the subject. He had surely seen other Velázquez portraits of Queen Mariana in 1896 in a London exhibition of Spanish art that included six different likenesses of her by the Spanish master.[20]

Henri prepared to begin the life-size copy of the Velázquez portrait of Queen Mariana and ordered a large canvas for it by May 18.[21] By May 25, he reported that he had completed his copy of the life-size portrait of the young royal, although he apparently kept working on it for a few more days. He ably captured the queen's inscrutable expression that has invited speculation—she experienced hardship and a repressive court atmosphere, yet she was also known for gaiety and had a penchant for extravagance.[22] Despite her generally noble mien and

deportment and an expression that suggests a pout, Henri saw only great beauty in the painting and was enamored of the earlier master's rendering of her character and setting. "It is a beautiful picture and the more I work from it the more wonderful it is—in fact that is what I think of all these works of Valasques [*sic*] the more I see of them," he asserted.[23] In the Prado Velázquez portrait of the young queen, she appears physically diminutive, yet there is a majesty and monumentality to the work that Henri also captures in his version. Subtle differences in color and manner of painting between the Velázquez portrait and Henri's copy are visible, but Henri's painting closely hews to the original, as does Sorolla's earlier, literal copy of 1884.[24] Henri averred that his Queen Mariana painting (cat. 95) "is considered a fine copy. It has its quality and has its defects, but as copys [*sic*] go I think myself it is unusually good."[25] On June 8, he wrote that he had completed copies of Velázquez's portraits of the actor, the queen, and Menippus, and had done a sketch of *The Surrender of Breda*; however, because of Linda's poor health, they were departing for Paris, but would hopefully return to Spain at a later time.[26]

Henri found that sustained exposure to the work of Velázquez increased his appreciation for the copies he could take home as educational tools and inspiration: "Every day the work of this great Valasques [*sic*] appears more wonderful and he did it all so simply and directly. I have learned a great deal and instead of my work being drudgery—copying—it has been most interesting and even were I not to have the copy after it is done I would be well repaid just in the doing of it."[27] He also recounted that he was "most anxious to get down to work soon after this study of Valasques [*sic*] to fix its influence."[28] By copying Velázquez, Henri explored characterization, modeling, and expression, and he gained technical insights not only into composition and palette, but how to sympathetically picture his subjects and render detail and character. Henri's canvases evolved from literal transcriptions of Velázquez, while also letting the underlying principles that he gleaned from his extensive study of the Spanish master's works shine through:

> Everybody he [Velázquez] painted had dignity, from a clown to a king. . . . He drew greatness out of his models. . . . He had the utmost respect for the king, the beggar and the dwarf. He painted with

easy large movements, and his work has great finish combined with great looseness.[29]

Indeed, by making these copies, Velázquez's superb characterizations of vastly different social types and a strong emphasis on technique established a formative foundation for Henri upon which he ultimately modeled his own portrait career.[30]

Spain 1906

Henri's 1906 trip to Spain differed markedly from his first visit. This time he was teaching—leading a group of art students under the auspices of the New York School of Art—but he made several sojourns outside the Spanish capital, including one to Segovia. Henri often acclimated to a new setting by initially painting landscapes, as he did in an oil sketch of the historic city of Segovia upon visiting there and seeing the stunning setting framed by mountains, with its rich coloration, and distinctive architectural profile (cat. 96). Overall, however, the trip was concentrated in Madrid and the Prado, offering pupils the same opportunity he had had of studying and copying old master paintings in the collection. This trip also provided Henri the occasion to produce his own original work and his first truly Spanish subjects, which number among his most important artistic efforts.[31]

A brochure from the New York School of Art announcing that he would lead a class in Spain highlighted Henri's "worldwide reputation," and further specified that "the objective of the class was to paint and sketch from the living model and landscape; to study and copy the work of Velázquez and other great masters in the Prado Museum. To see picturesque Spain, where the street life of the ancient cities is full of interesting material for pictures."[32] In his diary, he lists nineteen students accompanying him on the 1906 trip, five of whom were men. Those who participated in these sojourns were largely from privileged backgrounds with financial means, since the expense of such an extended trip abroad was significant. Among the students were Walter Pach, Helen Niles, Louise J. Pope, and Elizabeth Campbell Fisher.[33] Henri was known for his charismatic personality, and many of his art classes were dominated by female students, a few of whom harbored romantic hopes involving him since he was a recent widower (his wife Linda died in 1905).[34]

His method of instruction endorsed close observation, and he declared that art students should "know what the old masters did. Know how they composed their pictures, but do not fall into the conventions they established. . . . They can help you. All the past can help you."[35] Yet Henri also believed that artists should be original and that "we are not here to do what has already been done."[36] He made arrangements with the Prado director for the class to have access to the galleries during and after hours to study and copy paintings, especially those by Velázquez.[37]

Henri began working on his own original efforts while still holding classes. These works initiate a more essential realism in his likenesses. One work in this new vein was a portrait of a young matador he befriended in a café, Felix Asiego (cat. 97). Henri quickly became captivated by the romanticism, high emotion, and spectacle of bullfighting, which he came to see as an art form and emblematic of Spanish masculine culture.[38] He attended an impressive fight in which Asiego was the matador, and he asked him to pose (fig. 42). About twenty-two at the time, Asiego was a former law student from Malaga whom Henri met through Louis Monté, who was helping to manage the art class.[39] For Henri, finding a subject that inspired him and with whom he had a rapport was his preferred way of working, as he explained: "[a]n interest in the subject; something you want to say definitely about the subject; this is the first condition of a portrait. The processes of painting spring from this interest, this definite thing to be said."[40] In preparation for painting Asiego's portrait, he visited him right before his fight on July 29, 1906.[41]

Niles photographed Asiego before he entered the ring and documented the session in Henri's studio as the matador posed in a dazzling costume and was attended by his manservant (fig. 43).[42] Henri started the canvas from the photographs, intending to suggest the moment just before the matador's grand entry to the ring when he salutes and makes a short address. However, he primarily worked directly from Asiego in the studio, painting *alla prima*, directly on the canvas.[43] In the painting, Henri establishes a balance between a sympathetic likeness and a realistic sense of emotional drama in his awareness for the potential tragedy that weighs on the matador. As he observed: "[T]here seems to be always a cool sort of prospect of injury which they look in the face and the fights I have seen this time have had so many accidents

96

ROBERT HENRI

AMERICAN, 1865–1929

Segovia, Spain

1906 · Oil on panel · 8 × 10 in. (20.32 × 25.4 cm)

Collection of Stephen and Miriam Seidel

187

97

ROBERT HENRI
AMERICAN, 1865–1929

El Matador (Felix Asiego)

1906 · Oil on canvas · 78 × 37½ in. (198.12 × 95.25 cm)

Milwaukee Art Museum, Purchase, the Mr. and Mrs. Donald B. Abert and Barbara Abert Tooman Fund and with funds in memory of Betty Croasdaile and John E. Julien, M2019.1

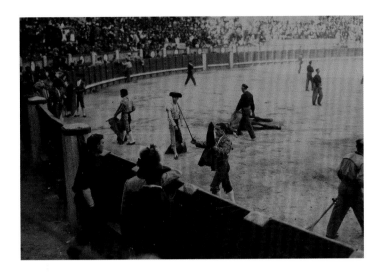

Fig. 42 Photographer unknown, Felix Asiego in the Ring, September 8, 1906. Photograph. LeClair Family Collection

Fig. 43 Helen Niles, Felix Asiego with his man-servant, 1906. Photograph. LeClair Family Collection

almost fatal and otherwise that it looks like a very foolish business."[44]

Bullfighting, however, became a near-consuming obsession for Henri. His idealized sentiments about Spain played into his broader interest in foreign cultures, and his love of pageantry and cultural "exoticism," extended to his art, celebrating in portraiture what he saw as representative individuals. Henri appraised the portrait of the matador as achieving his objective: "[I]n my portrait I think I got the sense of that look on the face I noticed particularly in Asiego. He said when I asked him afterward that he was always a bit nervous before the fight and that he remained so until after his first meeting with the bull's charge—after that he feels no more."[45]

Henri's interest in Spain's culture also eventually led him to paint *gitanos*, the Spanish term for the Romani people, who contributed to the rich and blended Christian, Jewish, and Muslim cultures in Andalusia and Madrid after migrating from northwest India. The equivalent of the problematic term "Gypsy," the word *gitano* derived from the inaccurate belief that the group migrated to Spain directly from Egypt (*egiptano*).

During Henri's time, Romani typically worked as street entertainers and vendors for meager handouts but were an integral part of contemporary Spanish society. While in Spain, Henri pictured more Romani people than any other theme; it was, however, an uncommon subject for American artists. A woman and her baby appeared at Henri's door one day when Asiego was to have modeled, possibly sent as a substitute by him. The mother was a willing model (as she was paid for posing), and *María y Consuelo* was the second of three versions Henri painted of her and her baby, and the only full-length composition (cat. 98). Few other American artists had painted such subjects, and these standing portraits challenge the traditional concept of grand manner portraiture by presenting subjects lacking social privilege in a formal way.[46]

Henri reported that, in conversation, María made aspects of her "life . . . more clear to me," and he aspired to convey some truth about her circumstances through his painting of her. He took pride in the result, calling it "a great piece of portraiture."[47] Henri also executed two portraits of María's husband, Ramon; a standing portrait of him playing a guitar and singing, *Gypsy with Guitar (Gitano)* (cat. 99); and a bust-length portrait. He found the husband less appealing, and Henri's paintings of Ramon cast him as a roguish street entertainer.[48] Although María told fortunes on the street, Henri found her more sympathetic, noting in his diary that "since the 20th have been working in the studio with Miss Pope and Miss Niles working with me from the Gitanos—the man Ramon, his wife (María) & baby."[49] As Henri had himself copied the work of old masters in the Prado and taught his students to do the same, here his students were painting side by side with him in his studio, working from the same models.[50] In the manner of Velázquez, Henri and his students portrayed Romani people honestly, yet he idealized them to a degree that made the subjects accessible for the audience back home. The 1906 trip, in fact, marks a point when Henri wholeheartedly embraced the painting of "authentic

98

ROBERT HENRI

AMERICAN, 1865–1929

María y Consuelo

1906 · Oil on canvas · 78 × 38½ in. (198.2 × 96.79 cm)

Sheldon Museum of Art, University of Nebraska–Lincoln, Gift of
Mrs. Olga N. Sheldon, U–3362.1982

99

ROBERT HENRI

AMERICAN, 1865–1929

Gypsy with Guitar (Gitano)

1906 · Oil on canvas · 78 × 37¾ in. (198.1 × 95.9 cm)

Chrysler Museum of Art, gift of Walter P. Chrysler, Jr., 71.501

types," which became his lifelong mission following his painting of Spanish models on Spanish soil.[51]

Spain 1908

Henri returned to Spain again in 1908 with another class sponsored by the New York School of Art. They sailed from New York on June 2 on the SS *Moltke*. Shortly before leaving on the trip, Henri secretly married Marjorie Organ, a young syndicated cartoonist and illustrator whom he had met in February.[52] The trip was also their honeymoon, and they traveled to places he had visited before: Gibraltar, Algeciras, Granada, the Alhambra, Seville, Córdoba, and then Madrid.[53] Among the students on this sojourn were Pope, Niles, Kathleen McEnery, and Leora Dryer and her brother, Rufus, accompanied by former student and friend Randall Davey, who managed the class.[54] A number of the students became working artists, including Davey, McEnery, the Dryers, and Niles.[55]

During the 1908 visit, Henri painted various Spaniards, including both a bust- and full-length portrait of a picador, Antonio Baños (fig. 44). As with Asiego, the two became friends, spending many evenings together, which resulted in him posing.[56] While Henri painted the picador, his friend and protégé Niles also produced her own accomplished and similar portrait (fig. 45). In Henri's version, the red sash that is a regular part of the costume is evident, while Niles cropped her portrait higher up. As expected of two painters working side by side, the subjects are presented from slightly different perspectives. Picadors, like matadors, are known for their elaborate costumes: Baños wears a *traje de luces* (suit of lights), the highly decorated gold brocade costume that catches reflected light, and also the buff-colored cocked hat with colorful ribands and a leather chin strap that holds it in place, all parts of the standard costume.[57] After the class ended, the Henris stayed on, leaving Spain for Paris on September 21, via Malaga and Gibraltar, and arriving back in New York by November 1.[58]

This time, Henri returned with fewer major works. His most frequent subjects were Gypsies as he developed the type of character studies he had begun in 1906, yet these works illustrate his burgeoning originality and retreat from the direct influence of Velázquez.

Spain 1910

The Henris returned to Madrid in 1910, this time without students. They traveled from Holland on August 16, and again rented a studio at 36 calle de San Marcos and stayed at the Gran Hotel de Londres.[59] Friends Davey and Niles were also with them in Spain. Among the works Henri produced on this visit was a series of likenesses of a dancer, Josefa Cruz, called *La Madrileñita*. Davey

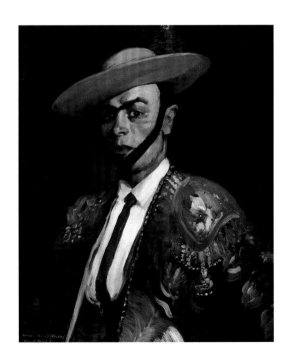
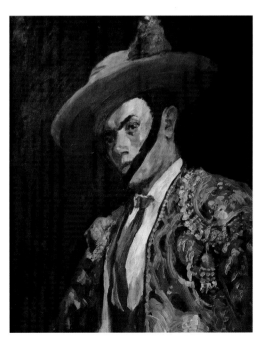

Fig. 44 Robert Henri, *Calero (Antonio Baños)*, 1908. Oil on canvas. Museum of Fine Arts, Houston, Gift of Ernest M. Closuit through Meredith J. Long, 57.18

Fig. 45 Helen Niles, *Antonio Baños*, ca. 1908. Oil on canvas. Collection of Russell and Judy Eaton

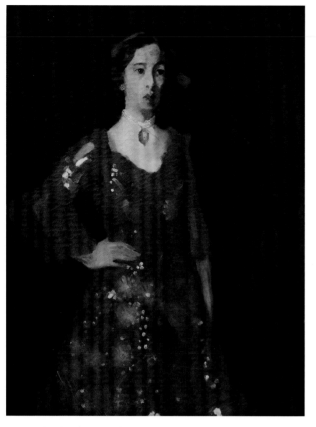

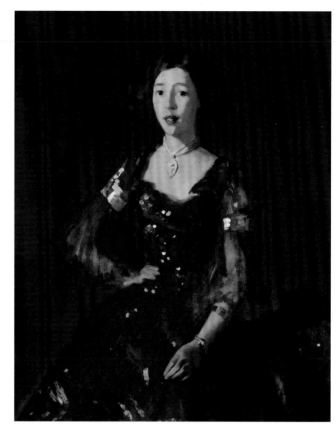

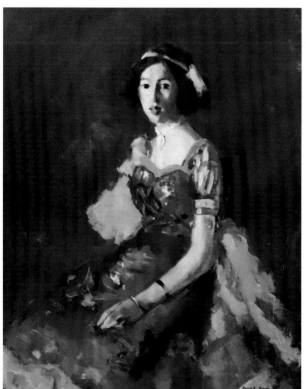

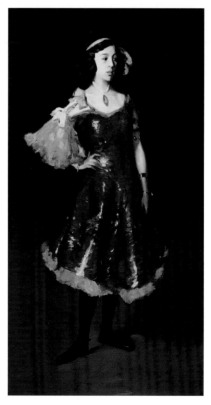

Fig. 46 (upper left) Randall Davey, *La Madrileñita*, 1910. Oil on canvas. Gertrude Vanderbilt Whitney Studio, New York

Fig. 47 (upper right) Robert Henri, *La Madrileñita*, 1910. Oil on canvas. Telfair Museums, Museum purchase, 1919.1

Fig. 48 (lower left) Randall Davey, *La Madrileñita*, 1910. Oil on canvas. Penrose Heritage Museum, El Pomar Foundation

Fig. 49 (lower right) Robert Henri, *La Madrileñita*, 1910. Oil on canvas. Terry and Margaret Stent Collection

continued the practice of painting from the same model alongside his former teacher. He painted at least two three-quarter-length portraits of the young dancer: one in the same red costume (fig. 46) in which Henri had represented her in a seated portrait (fig. 47), and another exceptional painting of the dancer in the same iridescent green and pink costume (fig. 48) as Henri's standing pose of Cruz (fig. 49), as well as several other compositions.[60] Davey's overall approach was more modern and exuberant, with liberal, dexterous brushwork, as he worked to achieve his own style, exercising his great facility for blunt, unrestrained characterizations. He, like Henri, often painted variant canvases, altering the pose or costume, as he did with another subject, a Spanish boy, whom he painted on the same trip (figs. 50, 51). This likeness of the boy differs from the colorful images of the dancer, employing a somber palette against contrasting dazzling white areas that highlight the model's face and figure. Henri also used this contrasting technique, whose precedent can be found in work by Spanish masters. While in Spain, Davey gifted Henri an inscribed portfolio of Goya prints (see, for example, cat. 100), a further testament to the fact that the old masters were never far from their minds and artistic practice.[61] Davey painted local Spaniards, choosing subjects that often appear markedly similar in type to those his mentor would have chosen, likewise selecting subjects he saw as characteristic of Spain.[62]

When Marjorie Organ married Henri, she gave up her professional career but continued to produce caricatures and sketches. Henri noted that on this trip "Marjorie has done many drawings—Holland & Spain."[63] Among those is likely *Relaxation* (cat. 101), a wonderfully personal image that shows Organ's deft ability for caricature, which eliminates all but the most salient features. She captured her dapper, lanky husband stretched out in a characteristic pose on the right, one hand in his pocket while puffing on his ever-present cigar. His companion, Davey, is reclining on what appears to be a hotel bed, playing a guitar and singing; Davey was known for his musical talents as he played both the guitar and the cello.[64] Henri described such a scene in a 1912 letter to his mother from Madrid: "There are few events to write about.... Evenings we generally stay in the hotel.... [S]ometimes everybody collects in one room ... and Davey plays guitar and sings."[65] The drawing has such spontaneity that it was surely done from life. It is, however, dated 1911 and bears the inscription "Madrid," even though the Henris did not travel abroad that year and were instead on Monhegan Island, Maine, where Davey was also present. Given the Spanish location, it could be a memory drawing or have been misdated from the 1912 trip.[66] The precise draftsmanship, whimsy, and characterizations are typical of Organ's production and are also a testament to her superior and under-recognized talents as an illustrator and caricaturist.

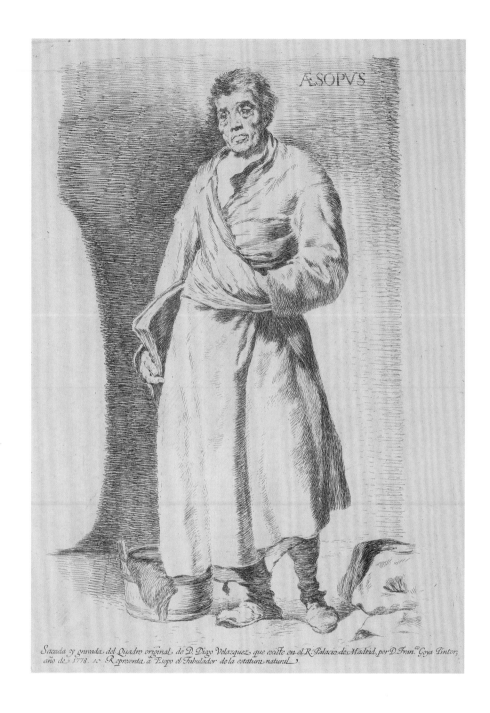

FRANCISCO DE GOYA

SPANISH, 1746–1828

AFTER DIEGO VELÁZQUEZ

SPANISH, 1599–1660

Aesop (Aesopus)

1778 · Etching · 16⅜ × 12¾ in. (41.59 × 32.39 cm)

Milwaukee Art Museum, purchase, with funds in memory of Betty
Croasdaile and John E. Julien, M2017.22

MARJORIE ORGAN HENRI
AMERICAN, 1886–1931

Relaxation

1911 · Graphite, ink, wash, and colored pencil on paper ·
$18^{13}/_{16} \times 24^{11}/_{16}$ in. (481 × 627 cm)

Sheldon Museum of Art, University of Nebraska-Lincoln, Gift of
Olga N. Sheldon, U-3502.1984

Spain 1912

In 1911, Henri began formulating plans for another class trip to Spain, informing his mother: "We are planning for a trip to Spain next summer—a class, Randall Davey is to take care of the management and business end of it, such things have to be started early."[67] This would be an independent class as outlined in the brochure, announcing that the group would be based "in Madrid where nearly three months will be spent studying in the gallery of the Prado, famous for the finest examples of Velasquez, Goya, Greco, Titian, Veronese, Tintoretto, Rubens and others, and painting out of doors and in the school studio from the models." The rate for the trip was $650. For eleven weeks, the class would be "painting from the model and landscape and studying the works of the great Spanish and Italian masters in the gallery of the Prado. An excellent studio will be provided for the students. Models from interesting Spanish and Gypsy types will pose daily. Criticism and assistance will be tendered to those wishing to make copies from the old masters in the Prado Gallery." Henri was slated to give biweekly critiques and a weekly talk on composition and the "making of pictures."[68]

With each visit, and as his Spanish language skills increased, Henri continued to be enthralled with Spain. In late June, he wrote home, "We are in Madrid at last.... Madrid is as fine as ever...."[69] There were fourteen students on this trip, including Alice Klauber, Meta Gehring (Cressey), Bert Cressey, Elizabeth Grandin, Clara Greenleaf Perry, Wayman Adams, and Esther Stevens; they were accompanied by Marjorie, Davey, and his wife, Florence, and housed at the Gran Hotel de Londres where they had stayed in 1910 (fig. 52).[70] Klauber reported that upon arriving in Madrid, she headed directly to the Prado to immerse herself. She recalled that the museum and its installation of the Spanish master greatly impressed her (fig. 53):

> Among the most hospitable masters none is so charmingly housed as is Velasquez in the Prado. ...So well hung, so beautifully lighted, so dignified and yet so modest...the only miracle is the light...demonstrating everywhere the absolute power of the brush....[71]

After numerous hours spent studying the collection, Klauber affirmed that she had "the Prado pretty well catalogued" in her memory.[72] She chronicled the trip and detailed that "mornings from 9:30 to 12:30 were spent working in the studio from models. Monday, Wednesday and Friday afternoons replaced morning work soon after the schedule was planned, however, to allow more outdoor work and for studying the Prado collections, the real studio by all indications."[73]

Henri urged the students to paint their surroundings at the same time as he encouraged them to learn by copying. The work of some of his most accomplished students

Fig. 52 Photographer unknown, Robert Henri with his class in the studio in Madrid, 1912. Photograph. LeClair Family Collection

209. - MADRID. — Museo del Prado: Sala de Velázquez. Centro.

Fig. 53 José Lacoste y Borde, Museo del Prado, view of the Velázquez room, 1904–1905. Phototype on cardboard. Museo Nacional del Prado, HF05033

reflects his foundational influence, yet each developed an individual style and pictured varied subjects.[74] He again had students working alongside him, such as Meta Gehring Cressey, who painted *Segovia Girl in Fiesta Costume (La Montera)* (1912; private collection), a subject that Henri also painted, *La Montera* (1912; Hirshhorn Museum and Sculpture Garden, Smithsonian Institution).[75] Henri and Davey initially shared a studio, but Henri later rented a furnished studio on calle Olagazo that Marjorie reported to Niles he was "crazy about" as it was "very grand but it has great light," and that he "is painting very different types from before. Somehow the models are better and there have been practically no disappointments. He is well pleased."[76]

During his 1912 trip, Henri's work achieved a new emotional authority and depth. Among his most affecting works is *Blind Singers* (cat. 102), one of two haunting and unflinching portraits he did of blind women who poignantly sang and played guitar. In their company, he experienced discomfort but empathy for their circumstances. With subdued tonalities, Henri presents the women in a candidly realistic manner not dissimilar to that of Velázquez. He harnessed the emotional response that the women and their music elicited from him, and he confessed to having complex feelings about them, but he considered the work "one of his very best pictures,"

and thought that his idea about the subject "was to meet it frankly . . . and without sentimentality."[77] As he was departing Madrid for Paris, he declared that he had "had a big season of work," and that his independent class "was a success, everybody highly pleased."[78]

Spanish-Inspired Work and the Prado and Velázquez in the Late Years

Spain's grip on Henri's imagination dated to even before he first visited in 1900 and had the idea of copying in the Prado. Although he advocated working directly from the subject and was intent on authenticity in his likenesses, he was at the same time not averse to altering and staging subjects for a desired effect. It was through these means that he first produced a number of Spanish-inspired subjects back in America, beginning with a series he produced in 1904 and again at other junctures. Like William Merritt Chase and other painters who visited Spain, Henri acquired Spanish accessories in order to stage compositions, including a wooden folding chair and various garments—shawls, mantillas, fans, and castanets—to use in studio compositions. In 1904 in New York, he produced a series of full-length portraits of a model pictured as a Spanish dancer. Over subsequent years, the idea took hold and he painted several professional models in Spanish costume as Spanish dancers, including the most frequent

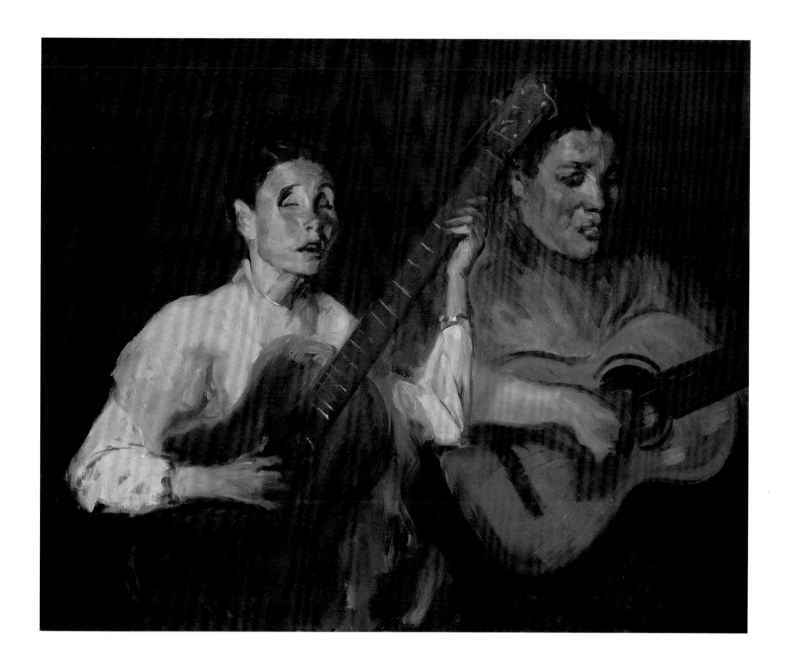

102

ROBERT HENRI
AMERICAN, 1865–1929

Blind Singers

1912 · Oil on canvas · 33¼ × 41¼ in. (84.45 × 104.6 cm)

Hirshhorn Museum and Sculpture Garden, Smithsonian Institu-
tion, gift of the Joseph H. Hirshhorn Foundation, 1966, 66.2434

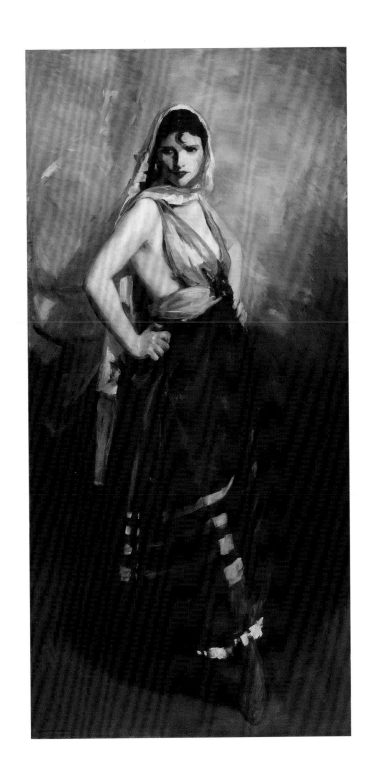

103

ROBERT HENRI

AMERICAN, 1865–1929

Betalo Rubino, Dramatic Dancer

1916 · Oil on canvas · 77¼ × 37¼ in. (196.2 × 94.6 cm)

Saint Louis Art Museum, Museum Purchase, 841:1920

subject, a dancer and model, Betalo Rubino.[79] *Betalo Rubino, Dramatic Dancer* (cat. 103), a full-length likeness that Henri worked on from November 1915 to January 1916, is among his latest paintings of her. She is dressed in a theatrical costume of opulent tones in a vivid chromatic range, and the work belongs to an exceptional group of richly colored female likenesses he did in the mid-teens.[80] Her pose with hands on her hips and pointed toe suggests a dancer's movement, and the costume with red shoes and stockings is flamboyant and theatrical; Henri described her as a Spanish dancer wearing a mantilla, although there is little about the costume itself that denotes it as especially Spanish.[81] A review of a dance performance by Rubino that same year touts her as "a gifted young woman whose pantomime work is wonderfully effective and who . . . possesses a rare grace . . . that is worthy of the ambitions of the greatest of dancers."[82] As exemplified by the painting of Betalo, the outward influence of Velázquez on Henri's approach faded by the early teens with regard to technique, subject matter, and conception, yet the lessons he learned were deeply ingrained in his general ideology and conception of his art.

Ever the artist, student, and teacher, Henri actively studied and investigated new ideas relating to his painting during an extended stay in Madrid in 1923 and 1924, his last productive period in Spain. While no longer pressured for artistic output, he freely pursued his creative impulses: "I have been working like a steam engine for the last two months from good, bad, and indifferent models doing indifferent, bad and maybe some few good things. The study spirit has been strong on me."[83]

The Prado continued to be an immense draw for Henri even into his late years, as did the study of Velázquez, even though the overt visual references to the old master in his work had long since waned by the 1920s. However, after all the time Henri had spent at the Prado over the years, he was still entranced by it in 1923, declaring to John and Dolly Sloan that "the Prado is a wonder—nowhere are there more wonderful or more perfectly seen pictures."[84] And even on the 1926 visit, his last, he still spent considerable time studying the collection, as Marjorie reported: "The Prado got the greater part of our time. Almost every afternoon we were there from three to five and often we spent the morning there too."[85] After so many years of continual study, his appreciation of Velázquez also never diminished, as he remarked to George Bellows in 1924, "that Velasques [*sic*] is as great a master as anyone ever thought he was."[86]

The Prado, Velázquez, and Spain ensnared Henri's spirit, especially the Andalusian culture—bullfighting, dance, and the music of the region (although he spent most of his time in Madrid). He nurtured a great passion for Spain, which he transmitted to an important body of his own art and also conveyed to his students. He tried to instill in them a love and appreciation of Spanish art and culture that began with the trips and visits to the Prado, and which ultimately carried forth into their own painting practices and lives.

NOTES

1. Robert Henri, as quoted in "In the World of Art and Artists: Art Notes," *New York Times*, November 25, 1906, 4.

2. Henri visited Spain in 1900, 1906, 1908, 1910, 1912, 1923, and 1926, and he was partial to Granada and Seville; see, for example, Henri to his parents, June 20, 1906, Henri Papers, Beinecke Rare Book and Manuscript Library, Yale University, New Haven (henceforth referred to as Henri Papers), in which he wrote: "There is no place I have ever seen quite as romantically beautiful as Granada is." Also Henri to his mother, June 28, 1912, Henri Papers: "I never liked Sevillia [*sic*] so much as I did this time. It's a beautiful old place with a lot of dramatic suggestion in the streets."

3. Henri taught art for the better part of his life at various institutions, including the School of Design for Women, Philadelphia; the Veltin School for Girls; the New York School of Art, and the Art Students League.

4. For the most thorough treatment to date of the time Henri spent in Spain and the work he produced there, see Valerie Ann Leeds, "Seeking the Spirit of Old Spain: Robert Henri and Spanish Themes, 1900–1924," in *Spanish Sojourns: Robert Henri and the Spirit of Spain*, exh. cat. (Savannah, GA: Telfair Museums, 2013). Also see Margaret A. Stenz, chapter two, "Matadors, *Guitarreros* and *Gitanos:* Henri's Spanish Types," in "Primitivism and Nationalism in the Portraiture of Robert Henri" (PhD diss., City University of New York, 2002), 91–194.

5. In December 1869, Eakins waxed enthusiastic to his father with a similar

response to Henri's over thirty years later, declaring, "I have seen big painting here. . . . O what a satisfaction it gave me to see the good Spanish work so good so strong so reasonable so free from every affectation. It stands out like nature itself." See William Innes Homer, *Thomas Eakins: His Life and Art* (New York: Abbeville Press, 1992), 43–44.

6. Violet Organ, "Robert Henri: His Life," unpublished biography, Estate of Robert Henri, LeClair Family Collection, 45. There was not a specific Velázquez exhibition in London, but what Henri no doubt saw was an enormous survey of Spanish art held at the New Gallery, which included many works by Velázquez (*Exhibition of Spanish Art under the Patronage of Her Majesty the Queen Regents of Spain*, exh. cat. [London: New Gallery, 1895–96]).

7. Henri to his parents, May 4, 1900, Henri Papers.

8. See "Valasques," from a letter written from Henri to his parents in May, and copied June 15, 1890, Henri Papers. Velázquez quickly becomes the most important influence on Henri's work and the one he cites the most frequently. Also, Frans Hals was a figure of major significance to Henri and his work, and, probably to a lesser degree, so was Rembrandt van Rijn.

9. *The Standard Bearer* depicts a flag bearer in formal attire. Henri's copy of the painting is in considerably smaller proportions than the original work, unlike his later Prado copies. His copy measures 20 × 24 in.,

collection of Janet LeClair. The original painting is 72.4 × 44 in. He also mentions copying other works in the Louvre in letters home. Also see Henri to his parents, October 10, 22, and 31, 1898, Henri Papers.

10. Henri to this parents, May 4, 1900, Henri Papers.

11. Henri to his parents, May 10, 1900, Henri Papers.

12. See Registros de Copistas, 1906–1914, Museo del Prado. As Eugenia Afinoguénova has noted, there were so many in the galleries that "it would be hard to imagine that these people were quietly immersed in their work . . . in an 1856 letter, Jose de Madrazo admitted that he had to move Velázquez's *The Surrender of Breda* to another room so that it could be copied without disturbance." See Eugenia Afinoguénova, *The Prado: Spanish Culture and Leisure, 1819–1939* (University Park: The Pennsylvania State University Press, 2018), 91. And this was also the case during the period when Henri was copying at the Prado.

13. These rules were put in place in 1863. For more on the Prado, rules, practices, and artists copying works in the collection, see Afinoguénova, *The Prado*, 125. She points out that copyists were no longer allowed exclusive access on weekdays, a rule that was instituted in the 1870s. The copyists complained about this both privately and in the press.

14. See Henri to his parents, May 4 and 18, 1900, Henri Papers. The museum hours were from ten to four.

15. Henri to his parents, June 8, 1900, Henri Papers.

16. See "Valasques," from a letter Henri wrote to his parents in May 1900 but copied June 15, 1900, Henri Papers.

17. Artist's record book, LeClair Family Collection. Henri mentions copying Velázquez's *Aesop* and that he will complete it in a few days, but it is not included in the record book with the other copies he made at the time. Also see "Valasques," from a letter written to his parents in May 1900 but copied June 15, 1900, Henri Papers.

18. At the time Velázquez painted her portrait after he returned from Italy, Mariana was nineteen years old. She was apparently a favorite subject and patron of Velázquez, since he executed a number of portraits of her, including a full length at the Musée de Louvre and the three-quarter length at The Metropolitan Museum of Art, including other related versions with variations in proportion, costume, and backdrops, some done by or in collaboration with his workshop. Other portraits of Mariana by Velázquez, some of which include the artist's workshop, are in the John and Mabel Ringling Museum of Art; the Thyssen-Bornemisza Collection; and the Meadows Museum.

19. Henri to his parents, May 18, 1900, Henri Papers.

20. See *Exhibition of Spanish Art*, cat. nos. 19, 55, 79, 106, 108, and 144.

21. Henri to his parents, May 18, 1900, Henri Papers. He ordered a canvas measur-

ing about seven and a half by four and a half feet in size.

22. Henri to his parents, Friday May 25 and June 1, 1900, Henri Papers. For more on Queen Mariana and the Velázquez portraits of her, see, for example, Antonio Domínguez Ortiz, Alfonso E. Pérez Sánchez, and Julián Gállego, *Velázquez*, exh. cat. (The Metropolitan Museum of Art in association with Harry N. Abrams, 1989), 244–55; and José Luis Colomer, "Competing for a Velázquez: New York Collectors after the Spanish Master," in *Collecting Spanish Art: Spain's Golden Age and America's Gilded Age*, ed. Inge Reist and José Luis Colomer (New York: The Frick Collection in association with Centro de Estudios Europa Hispánica and Center for Spain in America, 2012), 253–54.

23. Henri to his parents, May 25, 1900, Henri Papers.

24. For more on Sorolla and the copies, see M. Elizabeth Boone, "William Merritt Chase, Joaquín Sorolla, and the Art of Masquerade," in *Sorolla in America: Friends and Patrons*, ed. José Luis Colomer, Blanca Pons-Sorolla, and Mark Roglán (Madrid: Centro de Estudios Europa Hispánica and Center for Spain in America, 2015), 44–47.

25. Henri to his parents, June 1, 1900, Henri Papers.

26. Henri to his parents, June 8, 1900, Henri Papers. It is curious that while many artists chose to copy Velázquez's most celebrated masterwork, *Las Meninas*, a painting that Henri thought "the most wonderful picture

that has ever been painted," he did not. *The Surrender of Breda* was the only multi-figure composition he copied.

27. Henri to his parents, May 10, 1900, Henri Papers.

28. Henri to his parents, May 25, 1900, Henri Papers.

29. Robert Henri, *The Art Spirit*, ed. Margery Ryerson (Philadelphia: J. B. Lippincott, 1923), 280.

30. Henri, "Valasques," from letter written in May and copied June 15, 1890, Henri Papers.

31. See Henri diary, August 16, 1906, LeClair Family Collection. Henri made a trip to Segovia, staying for about three days. He also made a side trip to Toledo. See Henri to his parents, July 16, and July 25, 1906, Henri Papers.

32. The trip was to leave on the SS *Romanic* and arriving in Madrid on June 23, with visits to Gibraltar, Algeciras, Granada (which included the Alhambra), Seville, Cordova, Madrid, The Escorial, Toledo, Cadiz, and Tangiers, the cost of which would be $500 for 103 days. See New York School of Art "Henri Class in Spain" brochure, 1906-07-08. My thanks to Roy Pedersen for sharing the brochure with me. Roy Pedersen to the author, February 4, 2015.

33. See Henri diary, June 5, and other June entries 1906, LeClair Family Collection; and Henri to his parents, June 29, 1906, Henri Papers. Pach was hired as an administrator for the class, as was Louis G. Monté. See Laurette E. McCarthy, *Walter Pach (1883–1958): The Armory Show and the Untold Story of Modern Art in America* (University Park: The Pennsylvania State University Press, 2011), 21; and *American Artists, Authors, and Collectors: The Walter Pach Letters, 1906-1958* (Albany: State University of New York Press, 2002), 178–79. Also see Registros de Copistas, 1906–1914, Museo del Prado. The 1906 Prado registry of visitors lists thirteen students coming to copy at the Prado. Names of those coming to copy at the Prado do not always appear in the registry, and in fact Henri's students are not always listed on subsequent trips. Henri's name appears on the records for 1910 and 1912, but most of his students do not. There are discrepancies as to who was on the 1906 trip, but the Henri diary list appears the most complete. For example, it has been asserted that Kathleen McEnery was on the 1906 trip, but she appears neither on Henri's list of students, nor on the Prado registry. See Janet Wolff, *The Art of Kathleen McEnery*, exh. cat. (Rochester, NY: Hartnett Gallery, University of Rochester, 2003), 9. McEnery did, however, go on the 1908 trip to Spain.

34. See, for example, "The Diaries of Elizabeth Campbell Fisher Clay," comp. Harriet Fisher Bemus, 2003, collection of the author. My thanks to Dick Ellis for sharing this reference with me. Pope, Fisher, and the Dryers typify the type of female art students who went on Henri's European sojourns. For more on the female students of Henri, see Marian Wardle, ed., *American Women Modernists: The Legacy of Robert Henri*, exh. cat. (New Brunswick, NJ: Rutgers University Press in association with Brigham Young University Museum of Art, 2005).

35. Henri has erroneously been said to have been opposed to copying; instead, he actually promoted the activity as a means of learning, implementing the practice himself and advocating it to his students. See, for example, Rebecca Zurier, *Picturing the City: Urban Vision and the Ashcan School* (Berkeley: University of California Press, 2006), 115, although no source is provided for this claim.

36. Henri, *The Art Spirit*, 6. Another means of instruction that he used for his own study and for teaching was a postcard collection of great works by the masters. Henri postcard collection, LeClair Family Collection.

37. Henri to his parents, June 29, 1906, Henri Papers. Henri's largely female classes differed from the legions of male copyists at the Prado. See Registros de Copistas, 1906–1914, Museo del Prado; and Afinoguénova, *The Prado*, 173, 215–16. Afinoguénova has noted that the preponderance of those copying at the Prado were men; however, dating from the 1850s, there was a growing presence of women copyists, and especially after 1900, yet still more men than women.

38. Henri, "In the World of Art and Artists: Art Notes," 4.

39. Henri to his parents, July 25 and August 7, 1906, Henri Papers. He saw Asiego fight in the beginning of July in the Plaza de Toros in Madrid. He met him later in the month in a café through Monté. Asiego was eager to learn English and come to America, and they struck up a friendship. For more on the painting *El Matador, Felix Asiego*, see Leeds, "Seeking the Spirit of Old Spain," 20–22.

40. Henri, *The Art Spirit*, 10.

41. Henri to his mother, August 7, 1906, Henri Papers

42. He secured a studio at 36 calle de San Marcos. Henri to his parents, July 8, 1906, Henri Papers.

43. Henri to his parents, July 28 and August 7, 1906; and Henri to Helen Niles, December 2, 1906, Henri Papers. Some photographs from this session are extant and are marked as taken by Niles, LeClair Family Collection. For Henri's ideas about photography, for example, see John Cournos, "'What is Art?' Answered by Henri, Art 'Insurgent,'" *The Philadelphia Record*, December 25, 1910, 3.

44. Henri to his parents, July 25, 1906, Henri Papers.

45. Henri to his parents, August 7, 1906, Henri Papers. "Before going into the fight they are all very serious and one can see in their faces that they . . . do not get over the sense that they are about to take risks that may end in death or injury." The two men continued their friendship after Henri left Spain. Henri wrote Asiego in December 1906 asking for details of his proposed trip to the States, but that is the last known correspondence between them. Henri writes to Asiego that he sees Miss Pope and relates

that they always talk of Asiego and their little group of the Café St. Sebastian of Spain—and of the bullfights. Henri to Asiego, December 2, 1906, Henri Papers.

46. Henri to his parents, September 23, 1906, Henri Papers. For an extended discussion of the paintings of the Romani couple, María and Ramon, see Leeds, "Seeking the Spirit of Old Spain," 22–24.

47. Henri to Helen Niles, December 2, 1906, Henri Papers.

48. Henri to his parents, September 23, 1906, Henri Papers. He called Ramon the usual "cheap article." Also see Henri diary, September 20 and 29, 1906, LeClair Family Collection.

49. Henri diary, September 20 and 29, 1906, LeClair Family Collection.

50. Niles also painted some other portraits of Spanish female subjects in compositions that differ from those of Henri. A number of these are held in collections of Niles relatives.

51. It can be surmised that Henri believed in the authenticity of his portraits; however, some staging of models in his studio occurred. Most of his portrait work after 1904 was painted in his own studio(s) with models coming there to pose for him. For the most part, modifications and additions were principally made in terms of accessories and backgrounds for balance, color, and design, and occasionally with costuming.

52. Organ was reputed to have met the widowed Henri on February 3, 1908, and

they were secretly married on May 5, an event hidden from even Henri's closest friends and family, including his mother and his best friend, John Sloan. See Bruce St. John, ed., *John Sloan's New York Scene from the Diaries, Notes, and Correspondence (1906–1913)* (New York: Harper and Row, 1965), 223. Sloan notes that he heard on June 1 that Henri had gotten married and that, unbeknownst to him, he had already been married for a month. Henri wrote Sloan on June 2, 1908, just as he was departing for Spain. See Henri to the Sloans, June 2, 1908, in Bennard B. Perlman, ed., *Revolutionaries in Realism: The Letters of John Sloan and Robert Henri* (Princeton: Princeton University Press, 1997), 177. A wedding announcement reading "Robert Henri Weds a Pupil" appeared in the *New York Times* on June 7, 1908, but it contains factual errors.

53. New York School of Art "Henri Class in Spain" brochure, 1906-07-08.

54. Pope and Niles were among those who also accompanied Henri to Holland in 1907. Henri to the Sloans, July 28, 1907, from Haarlem, Holland, Henri Papers. On the 1908 trip to Spain, Henri's marriage was also unknown to those in the class prior to the trip. See Helen Niles diary, entry of summer 1908 from on board steamer, collection of Judy and Russell Eaton.

55. Aside from Davey, who achieved national recognition, McEnery earned the most critical success. See Wolff, *The Art of Kathleen McEnery*, and in particular,

see the essay included within the volume by Douglas W. Howard, "At the Margins of Modernism: Rufus J. Dryer and Kathleen McEnery," 14–20. McEnery moved to Rochester after marrying and continued to produce and exhibit her work, in New York and elsewhere, even in the 1913 Armory show.

56. Picadors play a key role in the spectacle of bullfighting: their effort is the first part of the event; riding in on horseback, they jab the bull with a lance to provoke it in preparation for the later entry of the matador. Also see Henri diary, September 6, 1908, LeClair Family Collection; and Organ, "Robert Henri: His Life," 78. For more on the painting of Baños, see Leeds, "Seeking the Spirit of Old Spain," 27–28.

57. See Thomas Brown, *Popular Natural History and Characteristics of Animals* (London: James Blackwood, 1869), 57–60, in which he describes the appropriate bullfighting costumes in detail.

58. Henri to his mother, September 16, 1908, Henri Papers; and Henri diary, September 21, 1908, LeClair Family Collection.

59. Henri diary, September 5, 1910, LeClair Family Collection.

60. For more on Josefa Cruz and Henri's paintings of her, see Leeds, "Seeking the Spirit of Old Spain," 29–30. A bust-length version of the sitter from 1910, for example, is at the Art Institute of Chicago.

61. The publication of Goya prints is a ninth edition and is in the collection of the

National Arts Club, where Janet LeClair donated Henri's personal library. William Grimes to the author, December 31, 2014. The portfolio contains a nonsensical inscription to Henri: "With mucho muscles de rédês et quarente thinkoz, from Randall B. Davey, Madrid, Espana, September 21, 1910." My thanks to William Grimes for calling this publication and its inscription to my attention.

62. My thanks to Kim Straus and Sarah Rogers for sharing information and images of Davey's related Spanish works. Also, the likenesses of a young girl, whose name is Margarita, likely painted on this trip to Spain, are held in the Randall Davey Audubon Center, Santa Fe, New Mexico. Davey eventually broke from Henri's artistic influence some years later after his move to Santa Fe and the focus of his painting changed to horse and polo subjects.

63. Henri diary, September 26, 1910, LeClair Family Collection.

64. The figure in the illustration has long been misidentified as a likeness of the couple's close friend William Glackens, although it in fact bears no resemblance to that artist, who also had no musical knowledge. See Ira Glackens to Norman Geske, May 1984, curatorial files, Sheldon Museum of Art.

65. Robert Henri to his mother, August 21, 1912, Henri Papers.

66. Organ remained active in terms of sketching and doing caricatures. In Spain, 1912, Henri reported that

Marjorie had made some fine drawings of street people; see Henri to his mother, July 6, 1912, Henri Papers. And Marjorie related that she was going out with Miss Perry and sketching in the streets; Marjorie Organ to Helen Niles, July 29, 1912, Henri Papers.

67. Henri to his mother, 1911, undated, but refers to his November 15 exhibition at Macbeth Gallery, Henri Papers.

68. All quotations regarding the class are from the published brochure *Henri Class in Spain: For Artists and Students, 1912, Robert Henri, Randall Davey, Manager.* My thanks to Roy Pedersen for sharing the brochure with me. Roy Pedersen to the author, March 14, 2014.

69. Henri to his mother, June 28, 1912, Henri Papers. Autographs of members of 1912 Henri class, verso of class photo, Alice Klauber Collection, San Diego Museum of Art Archives.

70. Martin Petersen, "San Diego's First Lady of the Arts: Alice Ellen Klauber and Friends" (San Diego Museum of Art Archive, 2007), 26-27. Klauber may have become acquainted with Henri through her fellow San Diego resident Esther Stevens (Barney), who had studied with the artist the preceding winter. Klauber detailed much about the trip in her notes. Among Klauber's papers is an autographed class list of those who went on the 1912 trip to Spain. Klauber Papers, San Diego Museum of Art, 29. My thanks to April Smitley for making this document available to me. Also see Marjorie Organ Henri to Helen

Niles, July 29, 1912, and Henri to his mother, June 28, 1912, Henri Papers.

71. Alice Klauber, 1st Trip Abroad (Chiefly Galleries of Paintings), dated at home March 14, 1913, as quoted in Petersen, "San Diego's First Lady of the Arts," 26.

72. Petersen, "San Diego's First Lady of the Arts," 27.

73. See chapter three, "An Early Spanish Venture: With Henri in Spain, 1912," in Petersen, "San Diego's First Lady of the Arts," 26-28.

74. Indiana native Wayman Adams became the most recognized of the group, known for painting portraits; New Jerseyan Elizabeth Grandin primarily painted portraits and some landscapes in a modernist style; Meta Gehring (Cressey), originally of Cleveland, who met and married Bert Cressey and later settled in Los Angeles, worked in a modernist style, as did her husband; and Elizabeth Campbell Fisher painted street scenes of everyday life, including a bullfight.

75. For more on this painting and related works, see Leeds, "Seeking the Spirit of Old Spain," 31-32. *La Montera* would be translated as a bull-fighter's hat, although in this case it refers to the hat in her folk costume.

76. Henri to his mother, July 6, 1912. Henri Papers. He further notes that he has "been painting a little dancer and gypsys [*sic*]. It has been three months since I have really worked—on acc of the knee and the travel. The longest time I have ever stopped." See Marjorie Organ

Henri to Helen Niles, July 29, 1912, Henri Papers.

77. Henri wrote of them: "I have done one picture which I think is a very strong painting of a blind woman playing a guitar and singing—but it will not be a popular picture because it is of a terrible human tragedy and not a sentimental tragedy . . . they sing in the street for a living—sing beautifully and with a sadness that belongs to blind singers—and a sweetness despite the rigor and occasional shrill notes of the Spanish folk songs. While I painted—for 5 hours they sang and played the guitars . . . I had to get used to being alone with them in the studio—during the rests—when they were singing it was different." As quoted in *Catalogue Exhibition at the Anderson Galleries of Works of Art Donated for the Benefit of the American-British-French-Belgium Permanent Blind Relief War Fund*, exh. cat. (May 11-25, 1918), cat. no. 48, 16. For more on this work, see Leeds, "Seeking the Spirit of Old Spain," 32-33.

78. Henri to his mother, September 14 and 21, 1912, Henri Papers.

79. See Leeds, "Seeking the Spirit of Old Spain," 16-19, for more on Henri's Spanish inspired compositions picturing these models.

80. Henri's use of richer and brighter tonalities after 1909 was largely informed by his adoption of the pseudo-scientific Maratta color system. For the most comprehensive discussion of Henri's use of color theory, see Michael Quick, "Robert Henri: Theory and Practice,"

47-62, in *"My People": The Portraits of Robert Henri*, Valerie Ann Leeds, exh. cat. (Orlando: Orlando Museum of Art in association with University of Washington Press, 1994).

81. Artist's diary, November 30, 1915, and artist's record book, LeClair Family Collection.

82. It was written about Rubino in a 1916 performance of *The Dancing Girl of Delhi*, in "With the First Nighters: Orpheum," *Goodwin's Weekly* 27 (January 13, 1917): 10.

83. Henri to Sloan, December 28, 1923, as quoted in Perlman, *Revolutionaries in Realism*, 296.

84. Henri to the Sloans, August 23, 1923, as quoted in Perlman, *Revolutionaries in Realism*, 285. Also the same idea was expressed in a letter to Margery Ryerson, Henri to Ryerson, September 27, 1923, Ryerson Papers, Archives of American Art.

85. Marjorie Henri to Helen Niles, September 10, 1926, Henri Papers.

86. Robert Henri to George Bellows, January 31, 1924, Bellows Papers, Amherst College Library Special Collections, MA.

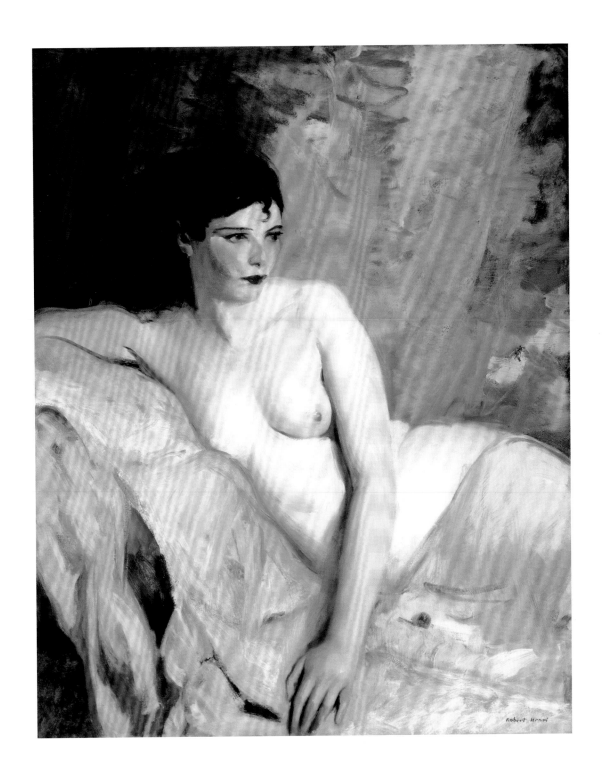

104

ROBERT HENRI
AMERICAN, 1865–1929

Betalo Nude

1916 · Oil on canvas · 41 × 33 in. (104.14 × 83.82 cm)

Milwaukee Art Museum, gift of Mr. and Mrs. Donald B. Abert, M1972.24

205

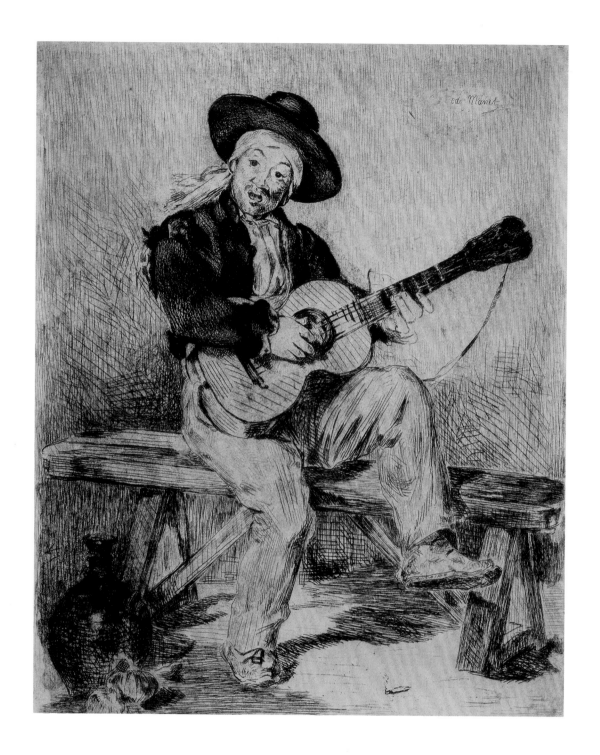

ÉDOUARD MANET

FRENCH, 1832–1883

The Spanish Singer

1861–62 · Etching and bitten tone · 17¾ × 12⅞ in. (45.09 × 32.7 cm)

Milwaukee Art Museum, purchase, George B. Ferry Memorial
Fund, M1934.104

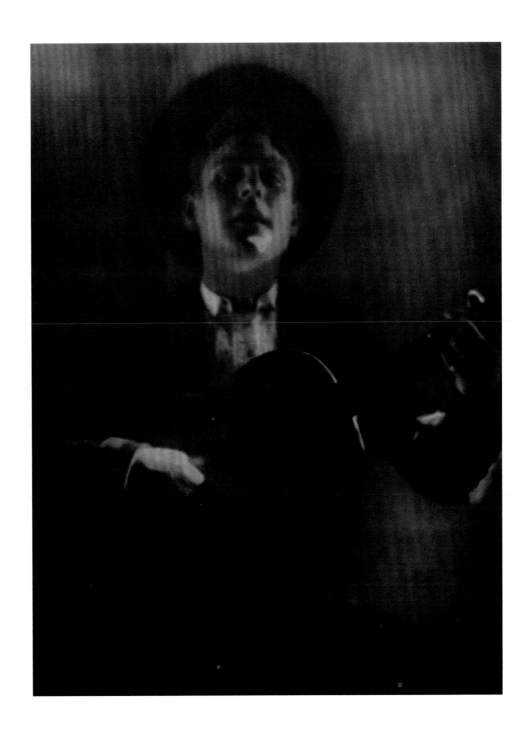

106

ADOLF DE MEYER

AMERICAN, BORN FRANCE, 1868–1946

Guitar Player of Seville, from
Camera Work, No. 24

October 1908 · Photogravure · 12 × 8¼ in. (30.5 × 21 cm)

Chrysler Museum of Art, Museum purchase, 89.124.6

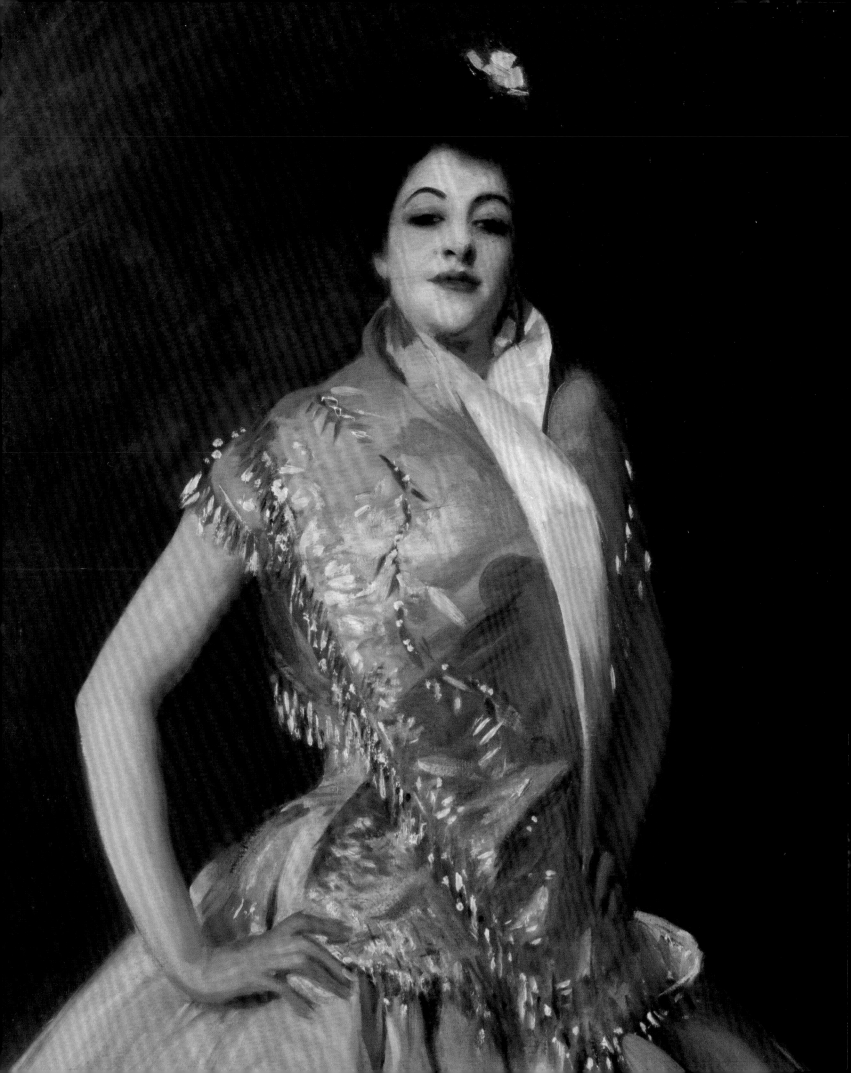

Checklist of the Exhibition

JAMES CRAIG ANNAN (SCOTTISH, 1864–1946)

A Carpenter's Shop—Toledo, from Camera Work, No. 45, January 1914
Photogravure
8¼ × 11¾ in. (21 × 29.8 cm)
Chrysler Museum of Art, Museum purchase
89.143.3

JOSÉ JIMÉNEZ ARANDA (SPANISH, 1837–1903)

Figaro's Shop, 1875
Oil on wood panel
17⁵⁄₁₆ × 22⅝ in. (44 × 57.4 cm)
The Walters Art Museum, Baltimore, Maryland, 37.4

ROBERT FREDERICK BLUM (AMERICAN, 1857–1903)

Spanish Courtyard, 1883
Oil on canvas
29⁵⁄₁₆ × 40⅜ in. (74.5 × 102.6 cm)
Cincinnati Art Museum, gift of Joni Herschede and Museum Purchase with funds from the Fanny Bryce Lehmer Endowment
2002.104

Study of Christ after Ribera, 1882
Oil on canvas
19⅜ × 27¾ in. (49.2 × 70.5 cm)
Cincinnati Art Museum, Gift of Henrietta Haller
1905.144

Toledo Water-Carrier, 1882
Oil on panel
11¾ × 15¾ in. (29.85 × 40 cm)
Baker/Pisano Collection

ELIZABETH BOOTT (AMERICAN, 1846–1888)

The Alhambra, 1881
Watercolor on paper
14 × 10 in. (35.6 × 27.94 cm)
Catherine and Louis Pietronuto

ADOLPHE BRAUN (FRENCH, 1811–1877)

Alhambra at Granada, Hall of Justice, ca. 1880
Vintage carbon print
15⅛ × 18⅝ in. (38.4 × 47.3 cm)
Chrysler Museum of Art, Museum purchase
2019.4

CAMINO (SPANISH, DIED 1888)

Granada, Courtyard of the Lions (Alhambra), ca. 1880
Albumen print from wet collodion negative
10 × 7¹⁵⁄₁₆ in. (25.5 × 20.2 cm)
Chrysler Museum of Art, Museum purchase
2018.38.1

MARY CASSATT (AMERICAN, 1844–1926)

After the Bullfight, 1873
Oil on canvas
32⅛ × 25³⁄₁₆ in. (82.5 × 64 cm)
The Art Institute of Chicago, bequest of Mrs. Sterling Morton
1969.332

Offering the Panal to the Bullfighter, 1873
Oil on canvas
39⅝ × 33½ in. (100.6 × 85.1 cm)
Sterling and Francine Clark Art Institute, acquired by Sterling and Francine Clark, 1947
1955.1

Spanish Girl Leaning on a Window Sill, ca. 1872
Oil on canvas
24⅜ × 19 in. (61.9 × 38.26 cm)
Collection of Manuel Piñanes García-Olías, Madrid

JAMES WELLS CHAMPNEY (AMERICAN, 1843–1903)

A Street in Toledo, ca. 1882, from Elizabeth W[illiams] Champney, *Three Vassar Girls Abroad.* Boston: Estes and Lauriat. Illustrations by J. Wells Champney and others
Wood engraving
8¼ × 6½ in. (20.96 × 16.51 cm)
Private Collection

WILLIAM MERRITT CHASE (AMERICAN, 1849–1916)

The Antiquary Shop, ca. 1879
Oil on canvas
27 × 34½ in. (68.6 × 87 cm)
Brooklyn Museum, Gift of Mrs. Carll H. de Silver in memory of her husband
13.53

Carmencita, 1890
Oil on canvas
69⅞ × 40⅞ in. (177.5 ×
103.8 cm)
The Metropolitan Museum of
Art, Gift of Sir William Van
Horne, 1906, 06.969

Copy of Velázquez's Aesop,
1882
Oil on canvas
70 × 36 in. (177.8 × 91.4 cm)
Courtesy of Steven Israel

Girl in White, 1898–1901
Oil on fabric
84½ × 40½ in. (214.6 ×
102.9 cm)
Collection of the Akron Art
Museum, Bequest of Edwin C.
Shaw

*My Little Daughter Helen
Velázquez Posing as an
Infanta*, 1899
Oil on canvas
30¼ × 24⅛ in. (76.84 ×
61.26 cm)
Courtesy of Joel Strote and
Elisa Ballestas

The Moorish Warrior, ca. 1878
Oil on canvas
59³⁄₁₆ × 94⁷⁄₁₆ in. (150.4 ×
239.9 cm)
Brooklyn Museum, Gift of
John R. H. Blum and Healy
Purchase Fund B
69.43

Outskirts of Madrid, 1882
Oil on canvas
32 × 45¾ in. (81.3 × 116.2 cm)
Yale University Art Gallery,
Gift of Duncan Phillips, B.A.
1908
1939.265

Spanish Girl in White, ca. 1886
Oil on panel
26¾ × 15¼ in. (68 × 38.7 cm)
Wake Forest University, Middleton Collection, Gift of
Philip and Charlotte Hanes
HC2000.2.1

Still Life with Ladle, 1917
Oil on canvas
18 × 32 in. (45.72 × 81.28 cm)
Milwaukee Art Museum,
Maurice and Esther Leah Ritz
Collection
M2004.115

Sunny Spain, 1882
Oil on canvas
19½ × 29 in. (49.5 × 73.7 cm)
Collection of Lois and Arthur
Stainman

*A Tambourine Player;
Mrs. Chase as a Spanish
Dancer (A Madrid Dancing
Girl)*, ca. 1886
Oil on canvas
65 × 30 in. (165.1 × 76.2 cm)
Montclair Art Museum,
Museum purchase; Acquisition Fund
1962.16

CHARLES CLIFFORD
(ENGLISH, 1821–1863)

[Cathedral, Torre del Oro and
Guadalquivir River, Seville],
1862
Albumen silver print
11⅝ × 15½ in. (29.5 × 39.4 cm)
The J. Paul Getty Museum,
Los Angeles
85.XM.367.2

Puerta del Sol, Toldeo, late
1850s
Albumen print
16¼ × 12¹⁄₁₆ in. (41.3 × 30.6 cm)
Chrysler Museum of Art, gift
of Charles Isaacs and Carol
Nigro
97.40.3

CLAUDIO COELLO
(SPANISH, 1642–1693)

*The Vision of Saint Anthony of
Padua*, 1663
Oil on canvas
67 × 50½ in. (170.2 × 128.3 cm)
Chrysler Museum of Art, gift
of Walter P. Chrysler, Jr.
71.542

SAMUEL COLMAN
(AMERICAN, 1832–1920)

*Gibraltar from the Neutral
Ground*, ca. 1863–66
Oil on canvas
26⅛ × 36⁵⁄₁₆ in. (66.4 × 92.2 cm)
Wadsworth Atheneum
Museum of Art, Hartford, CT,
Gallery Fund, 1901.35

Washing Day, Granada,
ca. 1872
Oil on canvas tacked over
panel
30 × 40 in. (76.2 × 101.6 cm)
Private Collection

FELIX OCTAVIUS CARR
DARLEY (AMERICAN,
1822–1888)

Frontispiece, The Alhambra,
from Washington Irving,
The Alhambra, 1851, rev. ed.
New York: G. P. Putnam
Lithograph
15⅜ × 10½ in. (39 × 26.7 cm)
Chrysler Museum of Art,
Jean Outland Chrysler
Library

GUSTAVE DORÉ
(FRENCH, 1832–1883)

Banks of the Darro, 1881, from
Jean-Charles Davillier's
Spain, illustrated by Gustave Doré and translated by
J. Thomson. London: Bickers
and Son
Wood engraving
13¹⁵⁄₁₆ × 10⅜ in. (35 × 26 cm)
From the American Geographical Society Library,
University of Wisconsin-
Milwaukee Libraries

THOMAS EAKINS
(AMERICAN, 1844–1916)

James Carroll Beckwith, 1904
Oil on canvas
83⅜ × 48⅛ in. (211.77 ×
122.24 cm)
San Diego Museum of Art,
gift of Mrs. Thomas Eakins
1937.30

EL GRECO (DOMÉNIKOS
THEOTOKÓPOULOS)
(GREEK, ACTIVE IN
SPAIN, 1541–1614)

Saint Catherine, 1610–14
Oil on canvas
39⁹⁄₁₆ × 25⅛ in. (100.5 ×
63.8 cm)
Museum of Fine Arts, Boston, Bequest of William A.
Coolidge
1993.38

MARIANO FORTUNY
(SPANISH, 1838–1874)

Arab Fantasia, 1867
Oil on canvas
20½ × 26⅜ in. (52 × 67 cm)
The Walters Art Museum,
Baltimore, Maryland
37.191

*The Slaughter of the
Abencerrajes*, 1870
Oil on canvas
29 × 26¾ in. (73.5 × 93.5 cm)
Museu Nacional d'Art de
Catalunya, purchased 1949
Inv. No. 044189-000

FRANCIS FRITH
(ENGLISH, 1822–1898)

*The Ambassadors' Court.
Granada*, ca. 1871
Whole-plate albumen print
from wet collodion glass
negative
6½ × 8 in. (16.51 × 20.32 cm)
Victoria and Albert Museum,
acquired from F. Firth and
Company, 1954
E.208:1533-1994

Gipsy Town. Granada,
ca. 1871
Whole-plate albumen print
from wet collodion glass
negative
6½ × 8 in. (16.51 × 20.32 cm)
Victoria and Albert Museum,
acquired from F. Firth and
Company, 1954
E.208:1528-1994

Porch, Hall of Justice, The Alhambra Granada, ca. 1871
Albumen print
8 × 6½ in. (20.3 × 16.5 cm)
Chrysler Museum of Art, Museum Purchase in memory of Alice R. and Sol B. Frank
2019.27.1

WALTER GAY (AMERICAN, 1856-1937)

Cigarette Girls, Seville, 1895
Oil on canvas
50⅛ × 67⅜ in. (127.3 × 171.1 cm)
Colby College Museum of Art, Waterville, ME, Gift of Mr. and Mrs. Bronson Griscom
1968.008

FRANCISCO DE GOYA (SPANISH, 1746-1828) AFTER DIEGO VELÁZQUEZ (SPANISH, 1599-1660)

Aesop (Aesopus), 1778
Etching
16⅜ × 12¾ in. (41.59 × 32.39 cm)
Milwaukee Art Museum, purchase, with funds in memory of Betty Croasdaile and John E. Julien
M2017.22

WORKSHOP OF FRANCISCO DE GOYA (SPANISH, 1746-1828)

The Duke of Wellington, ca. 1812
Oil on canvas
41⁹⁄₁₆ × 32¹⁵⁄₁₆ in. (105.6 × 83.7 cm)
National Gallery of Art, Gift of Mrs. P. H. B. Frelinghuysen
1963.4.1

GEORGE HENRY HALL (AMERICAN, 1825-1913)

La Feria de Jueves (The Thursday Fair of Seville), 1867
Oil on canvas
40⅛ × 32½ in. (102.3 × 82.1 cm)
Museum of Art, Rhode Island School of Design, gift of Mr. Alfred T. Morris, Sr.
78.145

CHILDE HASSAM (AMERICAN, 1859-1935)

Church Procession, Spain, ca. 1883
Oil on canvas
12½ × 17 in. (31.8 × 43.2 cm)
Private Collection

Plaza de la Merced, Ronda, 1910
Oil on panel
25½ × 20½ in. (64.6 × 52 cm)
Carmen Thyssen-Bornemisza Collection, on loan at the Museo Nacional Thyssen-Bornemisza, Madrid
CTB.1996.22

MARJORIE ORGAN HENRI (AMERICAN, 1886–1931)

Relaxation, 1911
Graphite, ink, wash, colored pencil on paper
18¹³⁄₁₆ × 24¹¹⁄₁₆ in. (481 × 627 cm)
Sheldon Museum of Art, University of Nebraska-Lincoln, Gift of Olga N. Sheldon
U-3502.1984

ROBERT HENRI (AMERICAN, 1865-1929)

Betalo Nude, 1916
Oil on canvas
41 × 33 in. (104.14 × 83.82 cm)
Milwaukee Art Museum, gift of Mr. and Mrs. Donald B. Abert
M1972.24

Betalo Rubino, Dramatic Dancer, 1916
Oil on canvas
77¼ × 37¼ in. (196.2 × 94.6 cm)
Saint Louis Art Museum, Museum Purchase
841:1920

Blind Singers, 1912
Oil on canvas
33¼ × 41¼ in. (84.45 × 104.6 cm)
Hirshhorn Museum and Sculpture Garden, Smithsonian Institution, gift of the Joseph H. Hirshhorn Foundation 1966
66.2434

Gypsy with Guitar (Gitano), 1906
Oil on canvas
78 × 37¾ in. (198.1 × 95.9 cm)
Chrysler Museum of Art, gift of Walter P. Chrysler, Jr.
71.501

María y Consuelo, 1906
Oil on canvas
78 × 38½ in. (198.12 × 96.79 cm)
Sheldon Museum of Art, University of Nebraska-Lincoln, Gift of Mrs. Olga N. Sheldon
U-3362.1982

El Matador (Felix Asiego), 1906
Oil on canvas
78 × 37½ in. (198.12 × 95.25 cm)
Milwaukee Art Museum, Purchase, the Mr. and Mrs. Donald B. Abert and Barbara Abert Tooman Fund and with funds in memory of Betty Croasdaile and John E. Julien
M2019.1

Queen Mariana, 1900
Oil on canvas
91½ × 48 in. (190.82 × 128.59 cm)
The Robert Henri Museum and Gallery, Gift of Janet LeClair, 2019.8.1

Segovia, Spain, 1906
Oil on panel
8 × 10 in. (20.32 × 25.4 cm)
Collection of Stephen and Miriam Seidel

CARRIE HILL (AMERICAN, 1875-1957)

View of Segovia, ca. 1925
Oil on canvas
36 × 30 in. (91.44 × 76.2 cm)
Birmingham Museum of Art; Promised gift of Dr. Julius E. Linn, Jr.

WASHINGTON IRVING (AMERICAN, 1783-1859)

Tales of the Alhambra, 1832, by Geoffrey Crayon, 2 vols. London: Henry Coburn and Richard Bentley
Milwaukee Art Museum Research Center

The Alhambra; with an Introduction by Elizabeth Robins Pennell; Illustrated with Drawings of the Places Mentioned by Joseph Pennell, 1896. London and New York: Mac-Millan
Milwaukee Art Museum Research Center

A History of the Life and Voyages of Christopher Columbus, 1828, 4 vols. London: John Murray
Milwaukee Art Museum Research Center

FREDERICK JUENGLING (AMERICAN, BORN GERMANY, 1846–1889) AFTER WILLIAM MERRITT CHASE (AMERICAN, 1849–1916)

Spanish Peasant, 1883, from George Parsons Lathrop, *Spanish Vistas*. New York: Harper & Brothers
Wood engraving
9 × 6⁹⁄₁₆ in. (22.86 × 16.67 cm)
Private Collection

JEAN LAURENT (FRENCH/SPANISH, 1816–1886)

Córdoba—307. Interior View of the Mosque or Cathedral, Córdoba, 1875
Albumen print
9⅞ × 13⁷⁄₁₆ in. (25.1 × 34.1 cm)
The J. Paul Getty Museum, Los Angeles
84.XA.761.26.2

Granada—232. Fountain and Court of the Lions (Alhambra), ca. 1870
Albumen print from wet collodion negative
9¾ × 13⅜ in. (24.8 × 34.0 cm)
Chrysler Museum of Art, Museum purchase
2018.38.2B

Granada—2191. Patio of a Moorish House in the Albaicín, ca. 1863
Albumen print
Victoria and Albert Museum
E.2966-1995

Segovia—382. General Visit of the Roman Aqueduct, ca. 1870
Albumen print on original mount
9⅞ × 13¾ in. (25.1 × 34.9 cm)
Chrysler Museum of Art, Museum purchase, in memory of Alice R. and Sol B. Frank
2019.27.2

ERNEST LAWSON (AMERICAN, 1873–1939)

Segovia, ca. 1916
Oil on canvas
20 × 25 in. (50.8 × 63.5 cm)
Minneapolis Institute of Arts, The John R. Van Derlip Fund
39.54

JOHN FREDERICK LEWIS (ENGLISH, 1804–1876)

The Mosque at Cordova, 1835, from Lewis, *Sketches and Drawings of the Alhambra, made during a Residence in Granada in the years 1833–34*. London: Hodgson, Boys & Graves
21½ × 15⅝ in. (54.61 × 39.69 cm)
Victoria and Albert Museum
E.1863-1927

Part of the Alhambra from the Alameda del Darro, 1835, from Lewis, *Sketches and Drawings of the Alhambra, made during a Residence in Granada in the years 1833–34*. London: Hodgson, Boys & Graves
21½ × 15⅝ in. (54.61 × 39.69 cm)
Victoria and Albert Museum
E.240-1932

FREDERICK MACMONNIES (AMERICAN, 1863–1937)

Young Chevalier, ca. 1898
Oil on canvas
75⅛ × 50⅝ in. (190.82 × 128.59 cm)
Virginia Museum of Fine Arts, Richmond, J. Harwood and Louise B. Cochrane Fund for American Art
2013.172

ÉDOUARD MANET (FRENCH, 1832–1883)

Dead Toreador, 1867–68
Etching and aquatint
12⅞ × 17⅝ in. (32.7 × 44.77 cm)
Milwaukee Art Museum, purchase, with funds from the Ralph and Cora Oberndorfer Family Trust
M2017.92

The Little Cavaliers, ca. 1860
Oil on canvas
18 × 29¾ in. (45.7 × 75.6 cm)
Chrysler Museum of Art, gift of Walter P. Chrysler, Jr.
71.679

Lola de Valence, 1862–63
Etching and aquatint
10⅜ × 7⅛ in. (26.4 × 18.1 cm)
Milwaukee Art Museum, purchase, with funds from the Ralph and Cora Oberndorfer Family Trust
M2017.91

The Spanish Singer, 1861–62
Etching and bitten tone
17¾ × 12⅞ in. (45.09 × 32.7 cm)
Milwaukee Art Museum, purchase, George B. Ferry Memorial Fund
M1934.104

ATTRIBUTED TO JUAN BAUTISTA MARTÍNEZ DEL MAZO (SPANISH, 1612–1667)

Queen Mariana, ca. 1652–53
Oil on canvas
27 × 23½ in. (68.58 × 59.69 cm)
New-York Historical Society, gift of Thomas Jefferson Bryan
1867.209

ADOLF DE MEYER (AMERICAN, BORN FRANCE, 1868–1946)

Guitar Player of Seville, from Camera Work, No. 24, October 1908
Photogravure
12 × 8¼ in. (30.5 × 21 cm)
Chrysler Museum of Art, Museum purchase
89.124.6

BARTOLOMÉ ESTEBAN MURILLO (SPANISH, 1617–1682)

The Immaculate Conception of El Escorial, 1660–65
Oil on canvas
81 × 56¾ in. (206 cm × 144 cm)
Museo Nacional del Prado, Madrid
P000972

JOSEPH NASH (ENGLISH, 1809–1878), AFTER DAVID WILKIE (SCOTTISH, 1785–1841)

Washington Irving Examining the Spanish Records, 1846, from *David Wilkie's Sketches, Spanish & Oriental*. London: H. Graves, Pall Mall
Lithograph
21¾ × 14¼ in. (55.25 × 36.2 cm)
Milwaukee Art Museum, Deaccession Fund, M2019.106.1

JOSEPH PENNELL (AMERICAN, 1857–1926)

Alhambra, Interior of the Tower of the Captive, 1894; study for Washington Irving, *The Alhambra*, 1896
Pen and ink on paper
16½ × 9⅝ in. (41.91 × 24.45 cm)
Milwaukee Art Museum, gift of The Art Institute of Chicago
M1953.20

Bridge of Alcántara, Toledo,
1904
Etching mounted on board
15 11/16 × 11 3/4 in. (39.8 × 29.8 cm)
Milwaukee Art Museum,
gift of Mr. and Mrs. Walter J.
Goldsmith
M1981.208

The Generalife, Granada,
1894; study for Washington
Irving, *The Alhambra*, 1896
Pen and ink on paper
11 1/8 × 17 1/2 in. (28.26 ×
44.45 cm)
Milwaukee Art Museum,
gift of The Art Institute of
Chicago
M1953.19

In the Garden of the
Generalife, 1894; study for
Washington Irving, *The*
Alhambra, 1896
Pen and ink on paper
18 3/4 × 15 3/4 in. (47.63 × 40.01 cm)
Milwaukee Art Museum,
gift of The Art Institute of
Chicago
M1953.18

One of the Shabbiest Posadas
in Granada, 1894; study for
Washington Irving, *The*
Alhambra, 1896
Pen and ink on paper
13 × 17 1/2 in. (33.02 × 44.45 cm)
Milwaukee Art Museum,
gift of The Art Institute of
Chicago
M1953.17

JUSEPE DE RIBERA (SPANISH, 1591-1652)

Saint John the Baptist in the
Desert, 1641
Oil on canvas
71 3/4 × 59 in. (182 × 150 cm)
Museo Nacional del Prado,
Madrid
P001108

DAVID ROBERTS (SCOTTISH, 1796-1864)

The Fortress of the Alhambra,
Granada, 1836
Oil on canvas
18 1/4 × 44 7/16 in. (46.3 × 112.8 cm)
Harvard Art Museums/Fogg
Museum, Gift of Richard L.
Feigen
1967.72

Remains of a Moorish Bridge
on the Darro, 1835, from
Thomas Roscoe, *The Tourist*
in Spain. Granada
Wood engraving
9 1/2 × 12 1/2 in. (24.13 × 31.75 cm)
Chrysler Museum of Art,
Jean Outland Chrysler
Library

JOHN SINGER SARGENT (AMERICAN, 1856-1925)

La Carmencita, 1890
Oil on canvas
90 × 54 1/4 in. (228.6 ×
134.22 cm)
Musée d'Orsay, Paris
RF746

Head of Aesop, 1879
Oil on canvas
18 5/16 × 14 5/8 in. (46.4 × 37.2 cm)
Ackland Art Museum, The
University of North Carolina
at Chapel Hill, Ackland Fund
75.16.1

Ilex Wood, Majorca, 1908
Oil on canvas
22 1/2 × 28 in. (57 × 71 cm)
Carmen Thyssen-
Bornemisza Collection, on
loan at the Museo Nacio-
nal Thyssen-Bornemisza,
Madrid
CTB.1997.34

Moorish Courtyard, 1913
Oil on canvas
28 × 36 in. (71.1 × 91.4 cm)
Myron Kunin Collection of
American Art, Minneapolis,
Minnesota

Ramalho Ortigão, 1903
Graphite on paper
15 1/8 × 9 7/8 in. (38.42 × 25.08 cm)
Milwaukee Art Museum,
gift of Candy and Bruce
Pindyck in honor of her
mother Beth Wolan Rogovin
M1990.117

Spanish Convalescent,
ca. 1903
Watercolor and pencil on
paper
18 × 12 in. (45.7 × 30.5 cm)
Collection of Macon and
Joan Brock

Spanish Window, 1908
Watercolor on paper
13 3/4 × 10 in. (35 × 25.4 cm)
Collection of the Columbus
Museum, Georgia, Gift of
Dr. and Mrs. Louis Hazouri
G.1980.50

Study for 'Spanish Dance,'
ca. 1879-1880
Oil on canvas
28 1/2 × 19 in. (72.3 × 48.2 cm)
The Nelson-Atkins Museum
of Art, Kansas City, Missouri
gift of Julia and Humbert
Tinsman
F83-49

Untitled (Spanish Dancer),
ca. 1879
Graphite on paper
14 1/2 × 10 in. (36.83 × 25.4 cm)
Milwaukee Art Museum, gift
of Karen Johnson Boyd in
honor of Russell Bowman
M2002.68

RAFAEL SEÑAN (SEÑAN Y GONZALEZ) (SPANISH, ACTIVE CA. 1900)

Granada, Alhambra, Door of
Justice, ca. 1895
Albumen print
10 3/8 × 8 in. (26.4 × 20.3 cm)
Sheldon Museum of Art, Uni-
versity of Nebraska-Lincoln,
Anna R. and Frank M. Hall
Charitable Trust
H-2279.1978

JOAQUÍN SOROLLA Y BASTIDA (SPANISH, 1863-1923)

Copy of a Fragment of a
Portrait of Queen Mariana of
Austria after Velázquez, 1883
Oil on canvas
21 5/8 × 25 1/4 in. (55 × 64 cm)
Museo Sorolla, n° inv. 00023

Court of the Dances, Alcázar,
Seville, 1910
Oil on canvas
37 1/2 × 25 in. (95.3 × 63.5 cm)
The J. Paul Getty Museum,
Los Angeles
79.PA.151

Hall of the Ambassadors,
Alhambra, Granada, 1909
Oil on canvas
41 × 32 in. (104.1 × 81.3 cm)
The J. Paul Getty Museum,
Los Angeles
79.PA.154

Ralph Clarkson, 1911
Oil on canvas
32 × 23 in. (81.3 × 58.5 cm)
Courtesy of the Oregon
Public Library and Gallery

Street in Granada, ca. 1909
Oil on canvas
41 3/8 × 28 3/8 in. (105 × 72 cm)
Museo Sorolla, n° inv. 00856

THOMAS SULLY (AMERICAN, 1783-1872)

The Gypsy Girl, 1839
Oil on canvas
29 7/8 × 24 7/8 in. (75.88 ×
63.8 cm)
Los Angeles County Museum
of Art, Gift of Dr. and
Mrs. James K. Weatherly,
Houston, Texas
M.82.161

MARY BRADISH TITCOMB (AMERICAN, 1858–1927)

The Alhambra, ca. 1906
Oil on canvas
22¼ × 18¼ in. (56.52 × 46.36 cm)
Chrysler Museum of Art, Museum purchase with funds given in memory of Joan Foy French by her daughters Wendy and Christina
2018.25.1

DIEGO VELÁZQUEZ (SPANISH, 1599–1660)

Portrait of a Man, ca. 1651–52
Oil on canvas
25¼ × 17½ in. (64.1 × 44.5 cm)
Chrysler Museum of Art, gift of Walter P. Chrysler, Jr.
83.587

EDWIN LORD WEEKS (AMERICAN, 1849–1903)

Interior of a Mosque at Cordova, ca. 1880
Oil on canvas
56⅛ × 72⅝ in. (142.56 × 184.47 cm)
The Walters Art Museum, Baltimore, Maryland, 37.169

JOHN FERGUSON WEIR (AMERICAN, 1841–1926)

The Alhambra, Granada, Spain, ca. 1901
Oil on canvas
36¼ × 46½ in. (92.1 × 118.1 cm)
The Metropolitan Museum of Art, Gift of David T. Owsley, 1964
64.119

JAMES MCNEILL WHISTLER (AMERICAN, 1834–1903)

Arrangement in Black, No. 3: Sir Henry Irving as Philip II of Spain, 1876, reworked 1885
Oil on canvas
84¾ × 42¾ in. (215.3 × 108.6 cm)
The Metropolitan Museum of Art, Rogers Fund, 1910
10.86

Brown and Gold, 1895–1900
Oil on canvas
37½ × 20¼ in. (95.8 cm × 51.5 cm)
The Hunterian Museum and Art Gallery, University of Glasgow, GLAHA: 46376

Nocturne, The Solent, 1866
Oil on canvas
19¼ × 35½ in. (48.9 × 90.2 cm)
Gilcrease Museum, Tulsa, Oklahoma, 01.1185

DAVID WILKIE (SCOTTISH, 1785–1841)

Christopher Columbus in the Convent of La Rábida Explaining His Intended Voyage, 1834
Oil on canvas
58½ × 74¼ in. (148.6 × 188.6 cm)
North Carolina Museum of Art, gift of Hirschl & Adler Galleries
G.57.17.1

Washington Irving in the Archives of Seville, 1828–29
Oil on canvas
48¼ × 48¼ in. (122.6 × 122.6 cm)
New Walk Museum & Art Gallery, Leicester, purchased from Mr. Thomas McLean, 1890
L.F2.1890.0.0

IGNACIO ZULOAGA Y ZABALETA (SPANISH, 1870–1945)

My Uncle Daniel and His Family, 1910
Oil on canvas
80¾ × 114 in. (205.1 × 289.5 cm)
Museum of Fine Arts, Boston, Caroline Louisa Williams French Fund
17.1598

CIRCLE OF FRANCISCO DE ZURBARÁN

Still Life with Glass, Fruit, and Jar, ca. 1650
Oil on canvas
15½ × 24½ in. (39.4 × 62.2 cm)
North Carolina Museum of Art, Purchased with funds from the North Carolina State Art Society (Robert F. Phifer Bequest)
G.52.9.171

Index

Photography Credits

Every effort has been made to identify, contact, and acknowledge copyright holders for all reproductions. The following credits apply to all images that appear in this catalogue for which acknowledgment is due. All rights reserved except where noted below.

Institutions alphabetically

Ackland Art Museum: cat. no. 74; The Art Institute of Chicago/Art Resource, NY: cat. no. 77; Baker/ Pisano Collection/Photo, Ed Watkins Photography: cat. no. 41; Birmingham Museum of Art/Photo, M. Sean Pathasema: cat. no. 30; © Carmen Thyssen-Bornemisza Collection, on loan at the Museo Nacional Thyssen-Bornemisza, Madrid: cat. nos. 32, 50; Chrysler Art Museum/Photo, Ed Pollard: fig. 4; cat. nos. 15, 26, 27, 28, 35, 37, 58, 60, 66, 69, 71, 88, 93, 99, 106; Courtesy Cincinnati Art Museum: fig. 16; cat. nos. 42, 73; Image courtesy Clark Art Institute, clarkart. edu: cat. no. 78; Photo: Colby College Museum of Art, Waterville, ME: cat. no. 46; Image © The Columbus Museum: cat. no. 49; Courtesy Fundació Gala-Salvador Dalí: fig. 26; Gertrude Vanderbilt Whitney Studio, New York/© Lexi Campbell and the New York Studio School: fig. 46; The J. Paul Getty Museum, Los Angeles/Digital image courtesy of the Getty's Open Content Program: cat. nos. 38, 55, 62, 64; © Gilcrease

Museum, Tulsa, OK: cat. no. 10; Granada Fine Arts Museum/Photo © Javier Algarra: fig. 27; Harvard Art Museums/Fogg Museum/ © President and Fellows of Harvard College: cat. no. 7; Hirshhorn Museum and Sculpture Garden/ Photo, Lee Stalsworth: cat. no. 102; Photo courtesy The Hispanic Society of America, New York: fig. 36; Image © The Hunterian, University of Glasgow: cat. no. 13; Image copyright: © The Metropolitan Museum of Art. Image source: Art Resource, NY: cat. nos. 14, 16, 29; Milwaukee Art Museum/Color transparency, Larry Sanders: fig. 1/Photo, John R. Glembin: front cover, figs. 3, 29, 30, 31, 32, 33, 34; cat. nos. 5, 19, 22, 23, 24, 25, 48, 67, 68, 86, 90, 91, 97, 100, 104, 105; Milwaukee Art Museum Research Center/Photo © 2020 Milwaukee Art Museum, Institution Archives: fig. 2/Photo, John R. Glembin: cat. nos. 20, 107, 108; © Minneapolis Institute of Arts, The John R. Van Derlip Fund, 39.54/ Photo, Minneapolis Institute of Arts: cat. no. 31; Musée d'Orsay/ © RMN-Grand Palais/Art Resource, NY/Photo, Gerard Blot: fig. 20; cat. no. 17; Photo © Museum Associates/ LACMA: cat. no. 12; Photography © 2020 Museum of Fine Arts, Boston: figs. 23, 40; cat. nos. 2, 89; Photograph © The Museum of Fine Arts, Houston: fig. 44; © Museo Sorolla: fig. 17; cat. nos. 53, 94; © Museo Nacional del Prado: figs. 21,

35, 53; cat. nos. 75, 76; © Museu Nacional d'Art de Catalunya, Barcelona 2020: figs. 22, 24, 25; cat. no. 52; Myron Kunin Collection of American Art, Minneapolis, MN/ Photo, Minneapolis Institute of Arts: cat. no. 44; Photo courtesy National Gallery of Art, Washington: cat. no. 3; Image courtesy Nelson-Atkins Museum of Art, Media Services/Photo, Jamison Miller: cat. no. 18; New Walk Museum & Art Gallery, Leicester/UKPhoto © Leicester Arts & Museums/Bridgeman Images: cat. no. 4; Photography © New-York Historical Society: cat. no. 70; North Carolina Museum of Art/Bridgeman Images: cat. nos. 6, 87; Oregon Public Library and Gallery/Photo, Bob Logsdon: cat. no. 1; Penrose Heritage Museum/© El Pomar Foundation: fig. 50; Photo courtesy of the RISD Museum, Providence, RI: cat. no. 11; Image courtesy Robert Henri Museum and Art Gallery, Cozad, NE: cat. no. 95; © Sheldon Museum of Art: fig. 51; cat. nos. 57, 98, 101; Telfair Museums/Photo, Richard Echelmeyer: fig. 47; Courtesy University of Wisconsin-Madison: fig. 10; Courtesy University of Wisconsin-Milwaukee Libraries: figs. 11, 12, 18, 19; Photo © Victoria and Albert Museum, London: fig. 15; cat. nos. 8, 9, 43, 54, 56; © Virginia Museum of Fine Arts/Photo, Travis Fullerton: cat. no. 84; Wadsworth Atheneum/Photo, Allen Phillips: cat.

no. 34; Wake Forest University Hanes Collection/Photography by Ken Bennett: cat. no. 81; Photo: The Walters Art Museum: cat. nos. 45, 51, 61; Photo: Widener Library, Harvard Library: figs. 8, 9, 13, 14.

Private collections; alphabetically by last name

Collection of Macon and Joan Brock/© 2013 Christie's Images Limited: cat. no. 47; Collection of Russell and Judy Eaton/© Craig A. Benner: fig. 45; Steven Israel/Photo, Ed Watkins Photography: cat. no. 72; LeClair Family Collection/ © Mitchell Kearney Photography: figs. 42, 43, 52; Catherine and Louis Pietronuto/Photo, Reagan Upshaw: cat. no. 59; Collection of Manuel Piñanes García-Olías/© Cuauhtli Gutierrez: back cover, cat. no. 79; Private Collection/© CAMERARTS, Inc.: cat. no. 33; Private Collection/ © 2003 Christie's Images Limited: fig. 5; Private Collection/© 2006 Christie's Images Limited: fig. 6; Private Collection/© David Bonet Ensenyat: fig. 28; Private Collection/Photo, Jamie M. Stukenberg/ Professional Graphics Inc., Rockford, IL: cat. no. 36; Collection of Stephen and Miriam Seidel/Photo, Rick Echelmeyer: cat. no. 96; Collection of Lois and Arthur Stainman/ © 1994 Christie's Images Limited: cat. no. 39; Terry and Margaret Stent Collection/Photo courtesy the High Museum of Art: fig. 49.

This book is published in conjunction with the exhibition *Americans in Spain: Painting and Travel, 1820–1920*, presented at Chrysler Museum of Art, February 12–May 16, 2021, and Milwaukee Art Museum, June 11–October 3, 2021.

NATIONAL
ENDOWMENT
FOR THE
HUMANITIES

Americans in Spain: Painting and Travel, 1820–1920 has been made possible in part by a major grant from the National Endowment for the Humanities: Exploring the human endeavor.

THE EXHIBITION AND CATALOGUE HAVE BEEN REALIZED WITH GENEROUS SUPPORT FROM:

Henry Luce Foundation
Wyeth Foundation for American Art
Gladys Krieble Delmas Foundation
Christie's
Furthermore: a program of the J. M. Kaplan Fund

This exhibition is supported by an indemnity from the Federal Council on the Arts and the Humanities.

TERRA
FOUNDATION FOR AMERICAN ART

A generous gift from the Terra Foundation for American Art helped support curatorial staff at the Milwaukee Art Museum and *Americans in Spain* during the COVID-19 pandemic.

Published by the Milwaukee Art Museum and the Chrysler Museum of Art

Milwaukee Art Museum
700 N. Art Museum Drive
Milwaukee, Wisconsin 53202
www.mam.org

Chrysler Museum of Art
One Memorial Place
Norfolk, Virginia 23510
www.chrysler.org

Distributed by Yale University Press
302 Temple Street
P.O. Box 209040
New Haven, Connecticut 06520-9040
www.yalebooks.com/art

Library of Congress Cataloging-in-Publication Data
Names: Ruud, Brandon K., 1968– | Piper, Corey. | Afinoguénova, Eugenia. | Boone, Mary Elizabeth. | Leeds, Valerie Ann, 1958– | Quílez Corella, Francesc M. | Milwaukee Art Museum, organizer, host institution. | Chrysler Museum, organizer, host institution.
Title: Americans in Spain : painting and travel, 1820–1920 / Brandon Ruud and Corey Piper ; with contributions by Eugenia Afinoguénova, M. Elizabeth Boone, Valerie Ann Leeds, Francesc Quílez Corella.
Other titles: Americans in Spain (Milwaukee Art Museum)
Description: Milwaukee, Wisconsin : Milwaukee Art Museum ; Norfolk, Virginia : Chrysler Museum of Art, [2020] | Includes bibliographical references and index.
Identifiers: LCCN 2020022593 | ISBN 9780300252965 (hardcover) | ISBN 9781938885136 (paperback)
Subjects: LCSH: Painting, American—19th century—Exhibitions. | Painting, American—20th century—Exhibitions. | Painting, American—Spanish influences—Exhibitions. | Painters—Travel—Spain—Exhibitions.
Classification: LCC ND210 .A757 2020 | DDC 759.13074/77595—dc23
LC record available at https://lccn.loc.gov/2020022593

Produced by Lucia | Marquand, Seattle
www.luciamarquand.com

Edited by Melissa Duffes
Designed by Ryan Polich
Typeset in Sagona by Maggie Lee
Proofread by Bruno George
Indexed by Enid Zafran
Color management by iocolor, Seattle
Printed in China by C&C Offset Printing Co., Ltd.

Details: pp. 2–3: cat. no. 34; p. 4: cat. no. 45; pp. 6–7: cat. no. 33; p. 8: cat. no. 3; pp. 18–19: cat. no. 10; p. 20: cat. no. 4; p. 40: cat. no. 31; p. 74: cat. no. 46; p. 102: cat. no. 51; p. 124: cat. no. 84; p. 142: cat. no. 150; p. 180: cat. no. 97; pp. 218–219: cat. no. 44; p. 220: cat. no. 17